100
HIMALAYAN FLOWERS

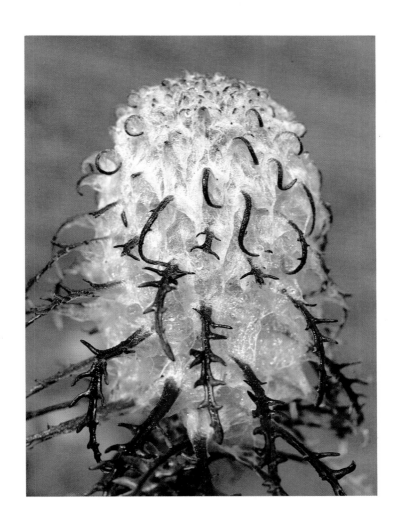

100 HIMALAYAN FLOWERS

Ashvin Mehta

Text by
Prof. P. V. Bole

The Vendome Press
New York

For Ben
this bouquet from the Himalayan wilderness
with *pranam*

Ashvin

This book has been made possible
with support from Excel Industries Ltd.

First published in the United States of America in 1991 by
The Vendome Press, 515 Madison Avenue, New York, NY 10022
by arrangement with
Grantha Corporation, 80 Cliffedgeway, Middletown, NJ 07701
Simultaneously published by
Mapin Publishing Pvt. Ltd.
Chidambaram, Ahmedabad 380 013, India.

ISBN 0·86565·124·8
LC 91·8314

Editorial Consultant : Gauri Dange
Design : Vala/Mapin Studio

Typeset in Schneidler and Cartier by Fotocomp Systems, Bombay
Printed and bound by
Toppan Printing Co. (S) Pte. Ltd., Singapore
Library of Congress Cataloging-in-Publication Data
Mehta, Ashvin.
100 Himalayan Flowers / Ashvin Mehta : text by P.V. Bole.
p. cm.
ISBN 0·86565·124·8 : $30.00
1. Wild flowers—Himalaya Mountains—Pictorial works. I. Bole,
P.V. II. Title. III Title : One Hundred Himalayan Flowers.
QK341.M44 1991
582.13 095496—dc20 91·8314
 CIP

Acknowledgments

I thought of photographing the wild flowers of the Himalayas, when I was working on my book *'Himalaya: Encounters with eternity'* (Thames & Hudson, London, 1985). I am thankful to all those who helped in *'Himalaya'*, and whom I have acknowledged on page 6 of the book (1985 edition).

I am very grateful to the late Mr. K.N. Vaid of the Forest Research Institute, Dehradun, with whom I had spent many a day, a few months before his sudden death, identifying the flowers in the herbarium housing the biggest collection of Himalayan flowers. In particular, I will always remember and cherish the painstaking thoroughness with which he accomplished the task without any pressed specimens on hand, relying solely on my photographs and verbal descriptions. How I wish he was alive to see this book in print!

My gratitude to Mr. Kantisen Shroff of Excel Industries Ltd., Bombay, for sponsoring the publication of this book by undertaking to donate a large number of copies to the libraries of colleges and universities of the country, with the noble intention of arousing the interest of the future custodians of Himalayan flora, and through this drawing them to the wider problems of preserving the fragile eco-system of the Himalayas.

ASHVIN MEHTA

Many flowers from many valleys

I photographed the wild flowers of the Himalayas for the first time nearly 20 years and 12 treks after my first visit. This was because the flowers usually appear with the rains, or, in higher valleys, after the snows thaw. With the execption of Kashmir, I had made all the treks either in May or in October, the months considered ideal for walking in the mountains, with clear views of the snow peaks, and had rarely encountered any massive or colourful display of these flowers. In Kashmir, I was so captivated by the overall charm of the higher valleys that, in those younger days, I had failed to see the flowers as anything but a part of the general landscape.

Every Himalayan valley has its own micro-weather, but most of the precipitation occurs during the monsoon, which starts in late June and ends by early October, with a variation of seven to ten days on either end. Like weather all over the world — mostly due to the 2,000 odd atomic tests that have been carried out — rains in the Himalayas have become more and more erratic over the years, but so far the cyclic rhythms of flowers do not seem to have been affected. In the coming decades, some species may undergo major genetic changes to adapt to the ever-increasing atmospheric pollution, or may even get wiped out. In the Swiss Alps, it is evident that this process has already set in, with greater and greater tourism-oriented use of land and pollution of the environment inevitably linked with a highly industrialised and wasteful society.

I launched my project to photograph the Himalayas at Harkidun in Garhwal, Uttar Pradesh. It was mid-June, and a small room in the ramshackle Forest Rest House was to be my abode for two weeks. The light pink Podophyllum flowers (plate 11) growing shyly amidst rocks were the first to startle me with their delicate beauty and unusual leaf-formation. White and yellow Marsh Marigolds (plate 1) literally carpeted the valley all around and made it look yellowish-green from a distance. There were patches of blue Lax Asters (plate 40) on tiny islands formed by innumerable streams and rivulets. Wagtails and thrushes, finches and redstarts, and, in particular, forktails announced in no uncertain notes that I was to witness a great spectacle called Spring in the Himalayas, sitting in the viewing gallery of a typical valley stretching from 10,000 ft to 12,000 ft. Soon I decided to photograph the flowers, in addition to other aspects of the Himalayas, published later as *Himalaya: Encounters with Eternity* (1985).

The famous British mountaineer, Frank Smythe, returning from an expedition in the Garhwal Himalayas, crossed a pass and entered the Bhyundhar Valley. This was in August, some 60 years ago, and he was stunned at the beauty and richness of wild flowers. His accidental discovery of the 'Valley of Flowers' and the book he wrote on the Valley were instrumental in making many a trekker and mountaineer aware of the existence of this unique world of form and colour. Till then, most of them were too occupied with either reaching a particular destination or climbing a mountain. Quite unintentionally, Smythe did more in

those years than all the nature clubs, like the Sierra Club or Audubon Society, put together had done. He refined the sensibilities of an entire lot of raw, athletic men doggedly pursuing their favourite hobby of trekking or climbing! After that, over the years, the Valley of Flowers has become synonymous with Himalayan flowers, and most people think it is the only valley of its kind in the entire Himalayas! Indeed, very few know that each and every valley in the Himalayas, between 9,000 ft and 13,000 ft becomes a valley of flowers sometime between June and September.

There also exists a relationship between the time of flowering and the altitude/latitude at which a particular flower grows. This not only applies to flowers growing in different valleys of the Himalayas, but also to alpine flowers in general, because rarely does a flower grow exclusively in a region of a mountain range (i.e. say Kumaon or Kashmir in the Himalaya), or in a particular mountain range (i.e. say in the Himalaya and not in the Alps or the Andes).

In Switzerland, I came across Crocus flowers similar to saffron (C. Sativus) in early May, growing above Zermatt at over 9,500 ft altitude and at approximately 48°N latitude, near the tree-line, at the foot of the Matterhorn. In Kashmir, cultivated commercially for their fragrant styles, the saffron grows at a much lower height (about 5,000 ft) and at a latitude of approximately 35°N, as late as in early November. The 'Heemkamal' (plate 48), or the Saussurea gossypiphora, I photographed above Hemkund in the Garhwal Himalayas, over 14,000 ft altitude and approximately 30°N latitude, in August, also grows in the Arctic in early summer. The Arctic variety, though slightly smaller in size, grows almost at sea level because of the high latitude (70°N +). There are many similarities between say Primulas or Anemones, Geraniums or Columbines, as they grow in different valleys of the Himalayas, and between those growing in the Himalayas and say in the Alps. If one keeps in mind these factors of altitude and latitude, and that true uniqueness is a rare phenomenon, one is not surprised to find the same or similar flowers in widely separated mountain ranges or in different valleys or regions of the same mountain range.

Photographing these flowers of the Himalayas was for me the most satisfying and enjoyable assignment I had set for myself. Many valleys were literally beds of roses, but there were problems of rain, weak and unpredictable light, rocky or slippery terrain, and the frustrating phenomenon of flocks of sheep grazing on flowers before one could get to them! And yet, whenever I see these photographs, or, even otherwise, I often get lost in the pleasant memories associated with photographing each one of them. The great order which manifests itself in the seasonal cycles of flowers — their regular flowering and withering, year after year — extends to our lives and to everything which pulsates with life. The realisation of this truth lends an unreal glow to my memories, and I am enveloped by a nameless bliss, not less tender or timeless than the flowers which have evoked it. Yes, timeless, because these ephemeral flowers have been asserting themselves every Spring, even before the first homo sapiens ever trod this planet or set eyes on the abundance of the Himalayas.

ASHVIN MEHTA

Introduction

The ancient scriptures of India invariably point to the Himalayas as a fountainhead of the highest spiritual knowledge. Salvation, purification of the soul and solace of the mind could be achieved, they believed, by a pilgrimage to these lofty mountain ranges. Seekers of knowledge aspired to retire to this abode of the Gods in search of enlightenment.

The Himalayas control the vital, life-giving elements of the Indian sub-continent, air and water. They protect the Indian land mass from the onslaught of the cold northern winds and act as repositories of water for the major rivers of India. It is little wonder, then, that the sages of olden times were so awestruck by the Himalayas and considered them to be the source of all bounty.

Joseph Dalton Hooker, the botanist author of the Himalayan Journal(s), on first sight of the snowclad splendour of these mountains marvelled: "The most eloquent descriptions I have read, fail to convey to the mind's eye the forms and colours of these snowy mountains to my imagination, the sensation and impressions that rivet my attention to these sublime phenomena when they are present in reality." Similarly, Nicholas Roerich — 'the Russian artist with the Indian soul' — was mesmerized when he observed these mighty mountains and eulogises their magnificence in his notes and paintings. According to him, they provided a splendid environ to accomplish supreme achievements.

Every 'pilgrim' to the Himalayas has felt impelled to express a sense of upliftment, whether in song, words or image. In this work, Ashvin Mehta expresses his feelings through a photographic record of the beauty that he perceived during his frequent treks in the subtropical and temperate Himalayan regions and etches them in everlasting memory.

Created by the reverberations in the earth's vast innards, the Himalayas are of comparatively recent origin — not more than one hundred million years old. (The Nilgiris, by comparison, are more than five hundred million years old and other land-masses in India may be over two to three thousand million years old.) This abode of snow is the loftiest mountain range on earth. Its highest peak is the mighty Mount Everest. The Himalayas extend from Afghanistan in the east up to south-east Tibet, a distance of over 2,400 km in length and 250 to 400 km in breadth. There are several ranges of mountains forming the Himalayas, mostly running south-east to north-west forming sort of an arc facing Tibet in the north. To the south of the Himalayas lies the fertile Indo-Gangetic plain gently sloping towards the Indian Ocean.

The Himalayas provide a wealth of varied scenery — the snow-clad peaks all through the year, the barren crags and cliffs, the serpentine and fast-flowing rivers, lakes and waterfalls, marshes, meadows and alpine pastures. Here, a very wide range of habitats for plants and animals is to be found. The Himalayas possess a rich, profuse and varied flora. This is mainly a consequence of the variations in

climate and habitat under different topographical conditions. Climatic conditions range from warm tropical at the base, the terai, to subtemperate or below -40°C in regions such as Ladakh. The absence of cataclysmic changes for a very long period in much of the Himalayan region has rendered stability to the substratum and allowed the vegetation types to survive and develop to their climax.

The Himalayas' infinite variety and charm is on show for trekkers within a short compass. The eastern parts of the Himalayas at lower altitudes of up to about 1,500 m are moist areas — these are in fact the regions of the highest rainfall on earth. Here, the forests are impenetrable, reminding one of the jungles of equatorial Africa or South America. The western parts are, on the other hand, dry and cold deserts where plant and animal life is active only for 10 to 12 weeks of the year. In the middle, in eastern Nepal and Sikkim, can be seen a blend of these extremes. In fact, this region is considered the meeting ground of eastern and western floristic elements — the Indo-Malayan flora and the temperate Eurasian type. Botanically, this region enjoys the best of both worlds.

The woody flora — trees and shrubs — flower earlier in Nepal and Sikkim than in the western Himalayas. One can visit these places in April-May to see the trees in their full splendour before the onset of the monsoon. In the west the monsoon lingers, and the fury of the rains abates when the trees bloom in August. To Europeans conversant with their flora, there will be many familiar trees — oak, maple, birch, hazel, chestnut, poplar, cherry, hawthorne, oriental plane, cedar, cypress, yew, apple, pear, fir and spruce, either in the wild or in cultivation. However, what is likely to win their hearts is the splendour of the rhododendrons, magnolias and michelias in their native homes.

Among the most beautiful Himalayan trees are the rhododendrons, of which the greatest concentration occurs in the eastern Himalayas. About 110 species are found wild in India, of which only four occur in the western Himalayas. Several rhododendron species are widely cultivated for their brilliant and variously coloured flowers and evergreen foliage. Many hybrids are produced and have been extensively cultivated in Europe and America. Of these, *Rhododendron arboreum* Sm. is perhaps the most widely distributed and is the national flower of Nepal, locally called 'Lali gurans'. It is also called 'tree-rose'. It can reach 2-4 m in girth and 14 m in height, and is seen at an altitude of 1,200 to 2,000 m from Kashmir to Bhutan and Assam. The flowers vary in colour from red to pink, spotted to white. The under-surface of the leaf also varies in pigmentation from silvery to brown. It grows in well-drained soil and is said to be averse to calcareous ground. The full beauty of the Himalayas cannot be experienced until one has seen rhododendrons, wreathed in colour, festooning the mountain ranges.

In this region, one cannot fail to notice the richness of orchids perched on trunks and branches of trees, beckoning visitors with their enchanting flowers. But the

very beauty of their flowers has been their undoing. Flower lovers and commercial poachers have robbed this region of most of the showy orchids, necessitating a ban on the collection of these plants from the wild. At higher altitutdes, we noticed that the trees become stunted and scarce near the snow-line, beyond which the mountains are covered with permanent snow. To reach here, one passes through the temperate coniferous forests of pine, deodar, spruce, fir, cypress and yew.

Beyond these forests lies a fairyland of alpine meadows. When the snow begins to melt in May-June, alpine plants begin to unfurl and are in full bloom in July and August. These meadows provide grazing grounds for sheep and cattle during these months. This is a fascinating region for flower lovers. We have the Himalayan poppies, anemones, primroses, paeonies, monkshood and meadow rue, buttercups and black pea, spurges and columbine, salvia and saxifrage, thistle and heather, thyme and mentha, balsam and gentian, campanula and chrysanthemum, orchids and lilies, and many others. In fact, there are several fairly extensive areas where, at times, it is almost impossible to step without crushing some of the lovely flowers carpeting the ground. The sudden outburst of bird-song, the herdsman's flute caressingly and hauntingly playing love songs, the tinkling of cow bells or pealing of temple bells and their reverberations, the scent-laden invigorating air, are experiences that linger longer in the mind than the passing joys of everyday life.

The Himalayan region, with its great variety, offers an excellent field for the study of the earth sciences, life sciences and human sciences. During a seminar titled 'Himalayas — the Ecology and Ethnology' (CNRS) held at Paris in December 1976, it was pointed out that the rate of endemism in the Himalayas was very high, particularly in certain groups of animals (occasionally as high as 50 per cent). Among plants, the rate was 30-35 per cent. What is remarkable, however, is that the rate of speciation and evolution of species in the Himalayas seems to be very rapid. Genetic diversity is rapidly promoted there. On the other hand, it was also vividly shown that human interference through exploitation of vegetation to its very limit on account of population pressure is causing rapid depletion of the Himalayan forests. This is affecting the ecological balance both in the hills and the terai regions, with obvious consequences for the population there, resulting in social tensions and adversely affecting the cultural systems. Grave apprehensions were expressed about the very existence of contemporary flora and fauna. An urgent and eloquent plea was made for their conservation. Let this book remind us of our heritage and let all lovers of beauty in nature join the brave band of conservationists of the Himalayas to bring these magnificent mountains back to their pristine glory.

The scientific names of plants given in this book are the ones currently given in relevant floristic works. The common or English names are mostly taken from *Standardized Plant Names* (2nd edition) by Kelsey, H.A. et Dayton, W.I.A. Where the common English names are not available, they have been adapted by an English translation of the scientific epithets of the binominal, or by associating the name of the scientist who christened the plant. The sequence of families is one that is generally seen in the floristic works (used in the Indian sub-continent) on the Himalayan region.

We are grateful to the scientists of the Botanical Survey of India and Forest Research Institute, Dehra Dun, and of the Regional Research Laboratory, Srinagar branch (Kashmir), who have unhesitatingly helped in identifying or confirming the identities of several of these photographs. The identification of plants from photographs without relevant specimens of the plants is not always easy and in spite of these excellent pictures and all possible care to identify them, we realise that there remains a possibility of error. The author (PVB) takes full responsibility for errors, if any, and would feel highly grateful if these are pointed out to the publishers for correction in a possible reprint or in another edition.

<div align="right">
P.V. BOLE

President

Bombay Natural History Society
</div>

30 December 1989

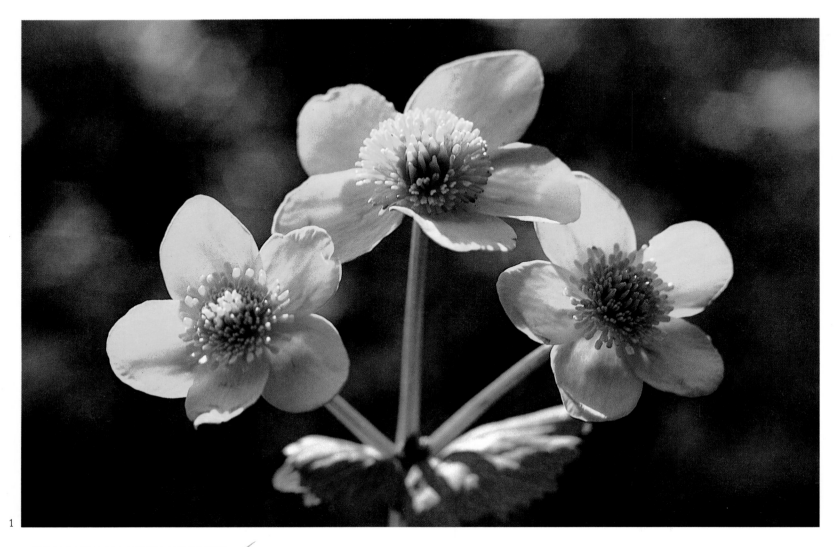

1

1 HIMALAYAN MARSH MARIGOLD ✓

Caltha palustris Linn. var. *himalensis* (D.Don)
Mukerjee
Ranunculaceae

"Winking mary-buds begin to open their
golden lips"
— Shakespeare in *Cymbeline*

The buds of the European marsh marigold
soaked in vinegar are recommended as a
substitute for capers, although the plant is
considered toxic or irritant. The home of this
plant is along marshes from Kashmir to Bhutan
at 2,500-4,000 m. It leads a long procession of
different flowers as the season rolls by the
streams. A perennial herb, it spreads
vegetatively by stout, fibrous, creeping
root-stocks which are considered poisonous
and used locally in eye ailments. The

heart-shaped leaves with long stalks grow
mostly from the freshly developing branches
and are 5-15 cm across. The yellow cup-like
flowers are 2 cm across with 5-8 petals which
are entire and ovate; they appear from
May-August. The fruits are in a bunch of
follicles with persistent styles, variable in
number and length.

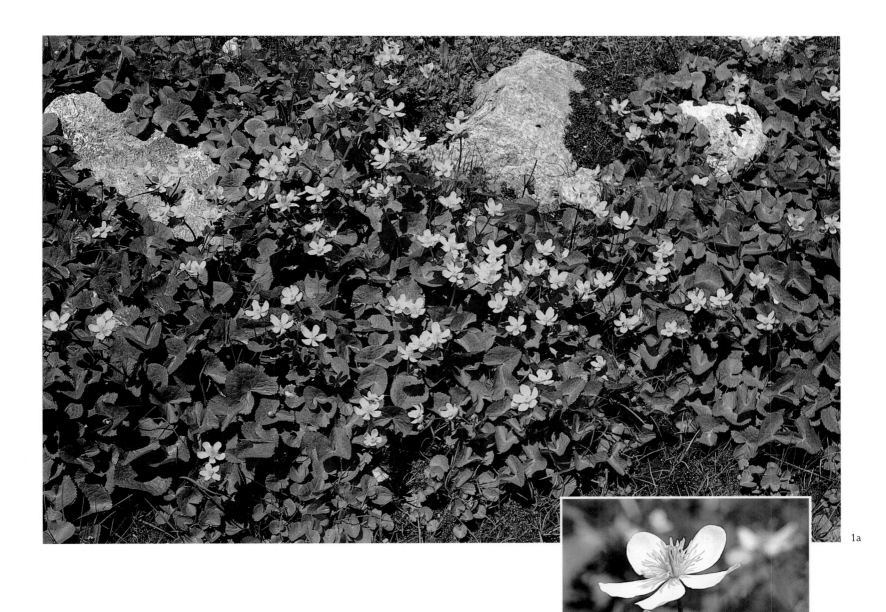

1a

1b

1a The picture shows a carpet of flowers by the banks of streams and around rocks. They are pollinated by bees and flies.

1b The picture shows the white variety of Marsh Marigold — *Caltha palustris* Linn. var *alba* Hk. f. & Th.

13

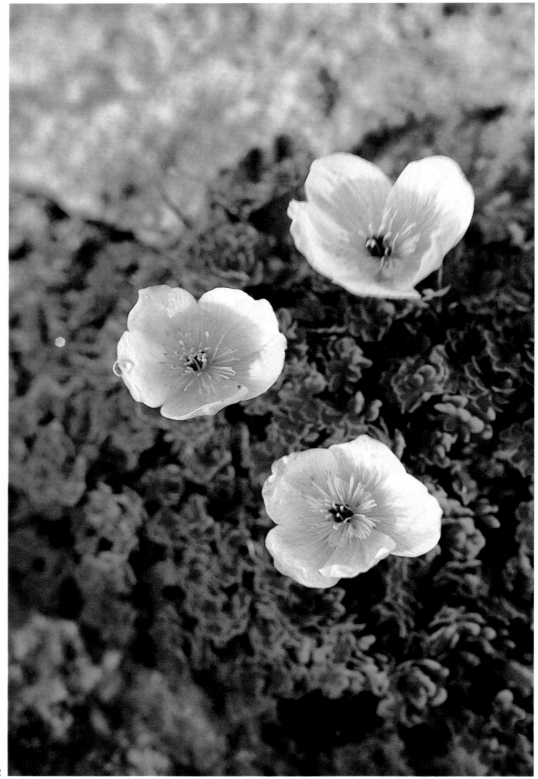

2

2 ROCK ANEMONE

Paraquilegia microphylla (Royle) J.R. Drum.
= *P. grandiflora* auct non J.R.Drum. & Hutch.
Ranunculaceae

A very distinctive and beautiful herb, it is seen
in rock crevices from Kashmir to Tibet at
3,500-4,000 m. A perennial, it grows in tufts
from creeping root-stocks. The compound
leaves grow on long stalks bearing deeply
segmented leaflets. The flowers, which bloom
in June and July, are solitary, generally white,
at times lilac or blue; they are cup-shaped
2-3.5 cm across, with yellowish centres formed
of stamens and carpels. The fruits are in a
bunch of 5-7 follicles, each 0.5-1 cm long, with
persistent styles.

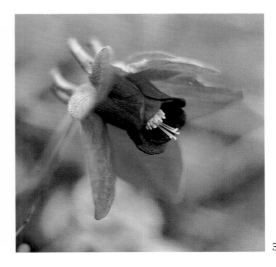

3

3 SNOWY COLUMBINE

Aquilegia nivalis Falc. ex Jackson
= *A. vulgaris* ssp. *jucunda* Hk.f & Th.
Ranunculaceae

As its botanical name indicates, it is related to the snow (nivalis) and is pleasant (jucunda). Its abode is hill slopes, screes and rocks from Kashmir to Himachal Pradesh at 3,000-4,000 m. A perennial herb, its 10-20 cm, erect, unbranched stem bears a flower at the tip. It has few, biternately compound leaves which grow on short stalks from the root-stock. The leaflets are kidney shaped, three-lobed and with a coarsely crenate margin. The solitary flowers on the leafless stalk are deep purple with bluish-purple centres, with short, incurved spurs, and bloom from June-August. The fruits are in a bunch of 5 follicles with many seeds.

3a The picture shows the full plant and a lighter colour of flowers.

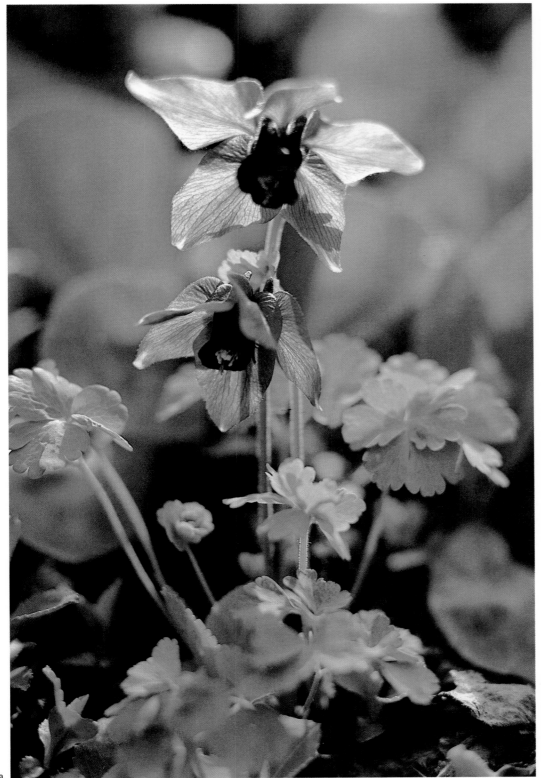

3a

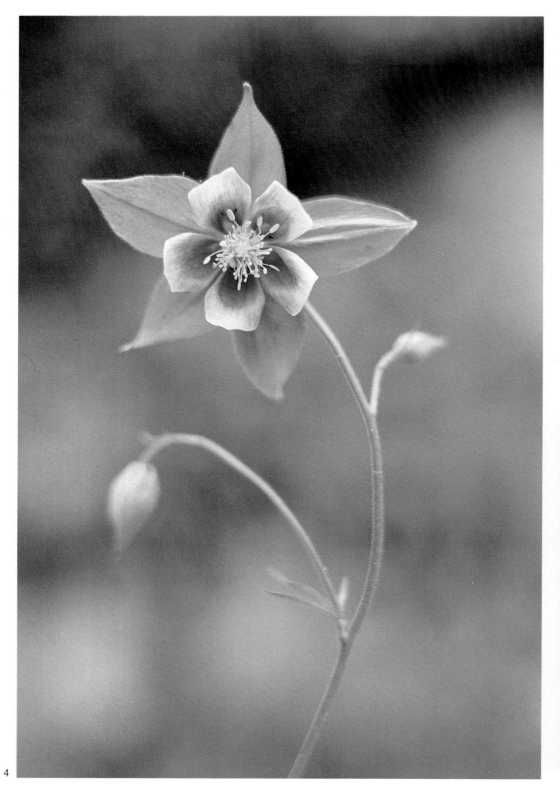

4

4 COLUMBINE
Aquilegia pubiflora Wall. ex Royle
Ranunculaceae

Found on alpine and sub-alpine hill slopes, from Pakistan to Nepal at 3,000-4,000 m, this is a very graceful, perennial herb, softly pubescent or glandular, often glaucous. The leaves are biternately compound, with incised lobes and a hairy underside. The flowers, which bloom from June-August, are lilac-purple, often white, sweet- scented, 3-4 on a spike; the outer petals are tapering to narrow and much longer than the inner ones which are strongly incurved, sometimes with whitish edges. The many-seeded fruits are in the form of 5 follicles.

4a Picture shows a slightly different form

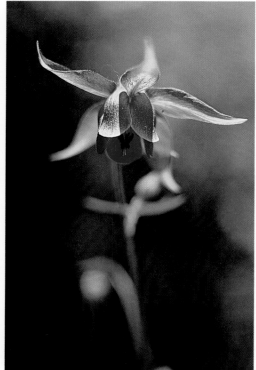

4a

4b FRAGRANT COLUMBINE
Aquilegia fragrans Benth.

Found on open grasslands from Kashmir to Garhwal at 2,000-3,000 m, this is a perennial herb up to 70 cm tall, branching from above and terminating in a few flowers. The leaves are compound, twice branching, 3-lobed, with hairy undersides. The fragrant flowers, which bloom from June-August, are creamy white; the outer petals have a tinge of blue; the blunt or acute spurs are hooked. The fruits are in the form of 6-9 densely hairy follicles with long styles.

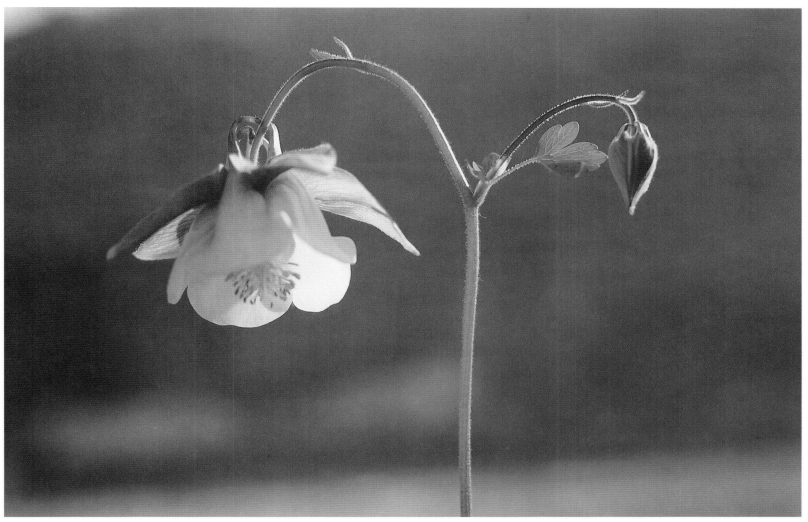

4b

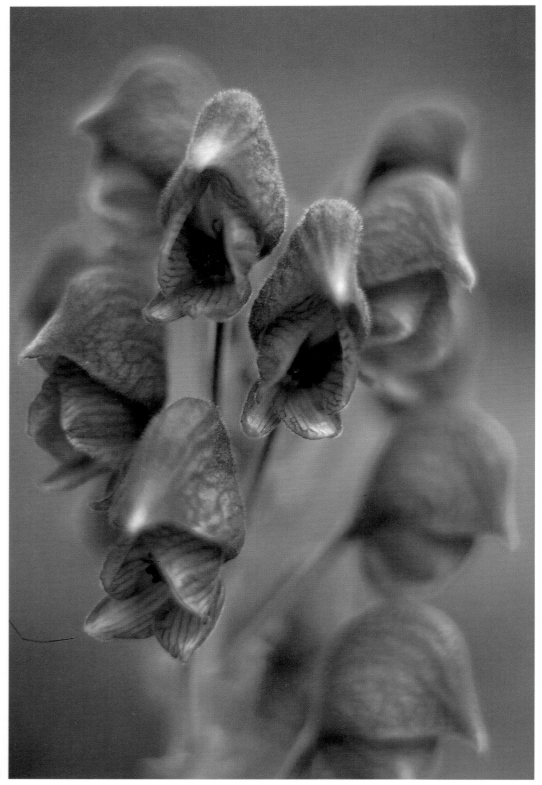

5 HIMALAYAN MONKSHOOD OR WOLFBANE

Aconitum heterophyllum Wall. ex Royle
Ranunculaceae

Called 'Atis' or 'Ativish' (highly toxic) locally, the roots of this plant are used medicinally. All aconites are toxic because of the presence of alkaloids in varying quantities in their roots. Some of these roots were used as arrow poisons in Europe in the Middle Ages, and hence the name 'Wolfbane'.

Seen from Kashmir to Nepal in the damp deciduous woodland at 2,400-4,000 m, this is a graceful and robust herb; 30-60 cm tall, it has 2 oblong, oval tubers of light ash colour outside and white inside with a very bitter taste. The lower leaves are long-stalked, ovoid or heart-shaped or like an arrowhead with long tips; they have 5 or more ribs, a lobed or dentate margin and a smooth surface; the upper leaves generally have short stalks or are stalkless and serrated. The greenish purple flowers are in axillary or terminal racemes, and are 2.5 to 3 cm across and bracteate. The helmet is broad, arched, convex, with a slightly acuminate tip. The wings are as big as the helmet, orbicular or triangular. The spur is short, egg-shaped and blunt, forming a small arc. There are many stamens, and five ovaries. The flower appears in August and September. The fruits are in a bunch of 5 downy follicles with many smooth seeds.

5

6 SMOOTH LARKSPUR

Delphinium denudatum Wall. ex Hk. f. & Th.
Ranunculaceae

Locally called 'Nirbisha', (without toxicity), and used in local medicine, it is the commonest larkspur of the lower Himalayas. It occurs on grazing ground from Kashmir to Kumaon at 2,400-3,500 m. About 60 to 90 cm tall, it has a panicle of blue to violet flowers. The leaves arise from the ground, and are 8-15 cm across with 8-9 cm often doubly-segmented linear lobes with an entire or toothed margin; the upper leaves are fewer and smaller. The flowers, in bloom from June-August, are about 2.5 cm across, on a stalk, in a loose raceme, with one petal whitish and the other four blue; the spur points outwards, and is as long or longer than the petals. The fruits appear as 3 follicles, nearly hairless, and inflated.

6a HIMALAYAN LARKSPUR

Delphinium himalayi Munz.

This is one of the endemic Himalayan larkspurs limited to west and central Nepal. It occurs on open hill-slopes at 2,400-4,300 m. It is distinguished by its purplish or blue flowers, seen in July and August, in loose spikes 10-15 cm long. The petals are hairy outside but smooth inside; the inner petals are blackish.

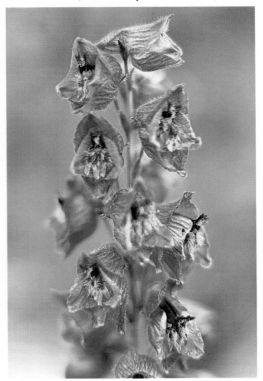

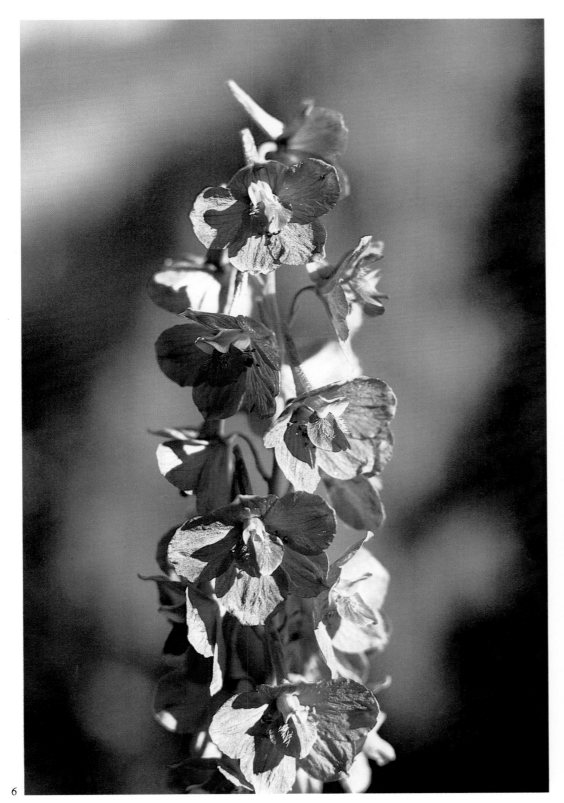

6

6a

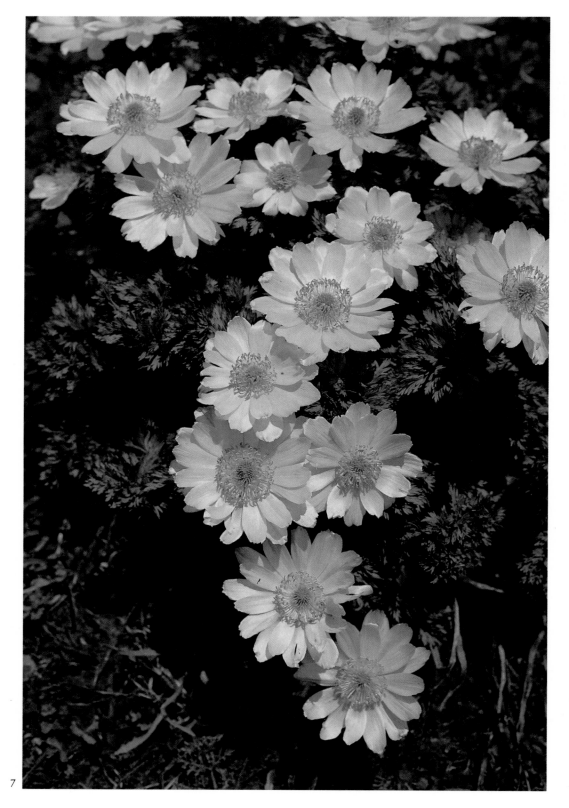

7 GOLDEN ADONIS
Adonis chrysocyathus Hk. f. & Th.
Ranunculaceae

The flowers of this herb appear on the damp slopes soon after the snows melt, at 3,500-4,300 m from Kashmir to Tibet. A pretty perennial, about 25-30 cm tall when in flower and fruit, it has a horizontal root-stock covered by scales. The leaves are ferny or feathery, 8-15 cm long and highly divided into deltoid segments of 5-10 mm each. The golden yellow flowers, conspicuous against the ferny green background of leaves, are about 5 cm in diameter, with 16-24 petals and many stamens, and in bloom from June-September. The fruits are smooth achenes in a dense head.

7

8 ROCK/CLIFF ANEMONE OR MALEBUM ANEMONE

Anemone rupicola Camb.
Ranunculaceae

"Large white anemone with golden centre which covered the hillside in its millions"
— F. S. Smythe

Seen at 3,600-4,800 m, from Central Nepal to Sikkim, the flowers of this gregarious plant are visible from a distance when in full bloom. A delicate herb, it is up to 20 cm tall. Its leaves are basal; long stalks bear a three-lobed leaf, each lobe divided in three segments, with a sharply dentate margin. The flowers, which appear in June and July, are solitary, large, and conspicuous, each with a single whorl of five ovate white petals, 2-4 cm long. The buds appear on a long silky stalk, and are pinkish on the outside. The fruits are achenes in cluster, embedded in woolly hairs.

Overleaf

9 ROUND-LOBED ANEMONE (COLUMBINE)

Anemone obtusiloba D.Don
Ranunculaceae

This is the commonest of the Himalayan anemones, occurring throughout the temperate and alpine Himalayas at 2,000-4,000 m. Known locally as 'Ratanjot', the root is considered medicinal and toxic. It is a highly variable perennial herb. All the leaves growing from the root-stock are 2-5 cm across and divided into three segments which are more or less rounded. One, two or three flowers bloom on a leafless 10-25 cm tall stalk originating from an underground stem; they are 2 to 3 cm across, white or blue or even yellow at higher altitudes, and bloom from April-June. The fruits are a cluster of many achenes, not embedded in woolly mats.

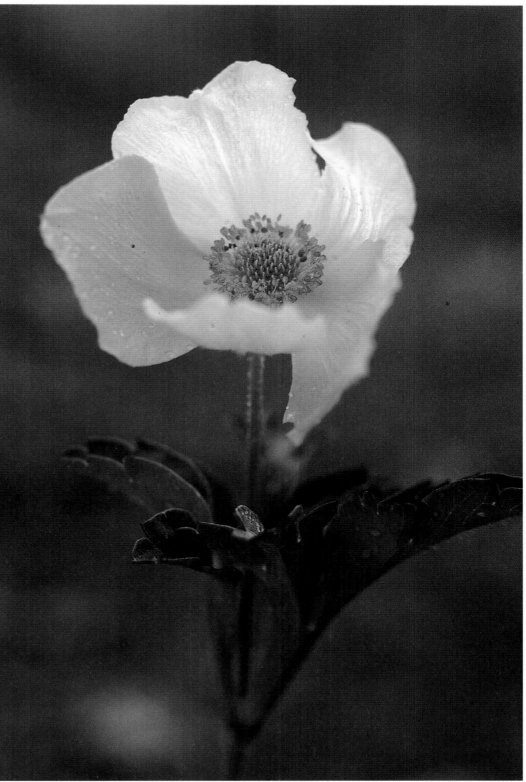

8

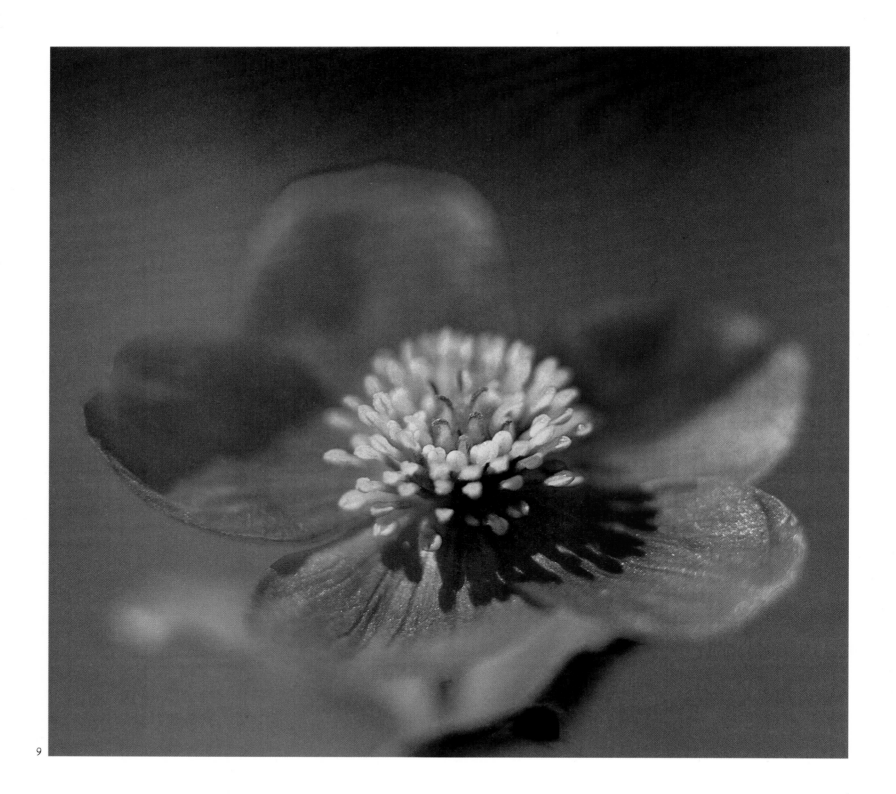

9

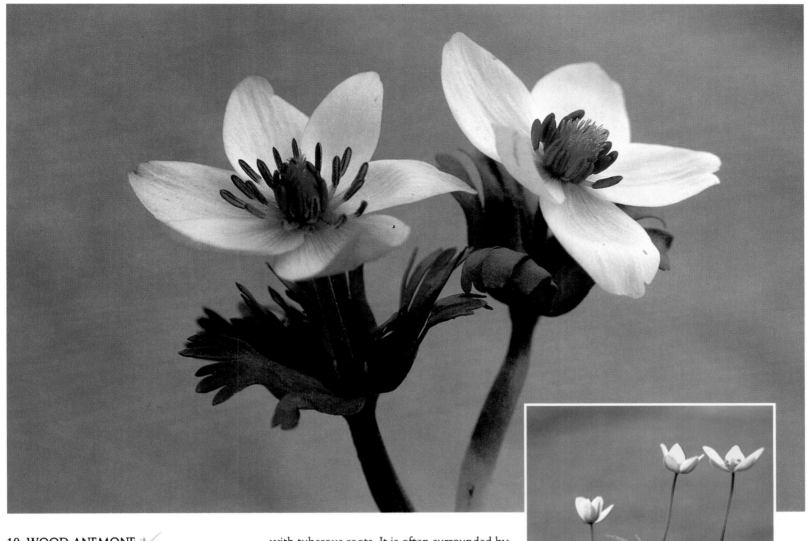

10

10 WOOD ANEMONE ✓

Anemone biflora DC.
Ranunculaceae

Anemone, according to legend, was a nymph beloved of Zephyr, god of the West Wind. Flora, the queen, jealous of her beauty, banished her from her court, transforming her into a flower.

Anemone means wind, and Pliny believed that these flowers bloom only when the wind blows.

"That never uncloses
Her lips until they are blown on by the wind."
— Horace Smith apostrophising the 'coy anemone'

Found from Afghanistan to Kashmir at 1,500-2,500 m, this is a small herbaceous plant with tuberous roots. It is often surrounded by snow when in flower. The lower leaves are deeply incised in three lobes, on a long stalk. The fragrant flower, which blooms from February-April, has white petals flushed with violet on the outside, which turn dull red with age.

10a BROOK ANEMONE

Anemone rivularis Buch. Ham. ex DC.

This anemone is seen in meadows and grazing grounds at 2,000-3,000 m from Kashmir to Tibet. The silky, pubescent herb grows to a height of 0.5 m or more. The leaves are deeply three-lobed, 10-15 cm long, with soft hair on both surfaces, and are dentate. The flowers, which bloom from May-August, are white, tinged with violet outside, and on long stalks. The fruits are achenial and hairy.

10a

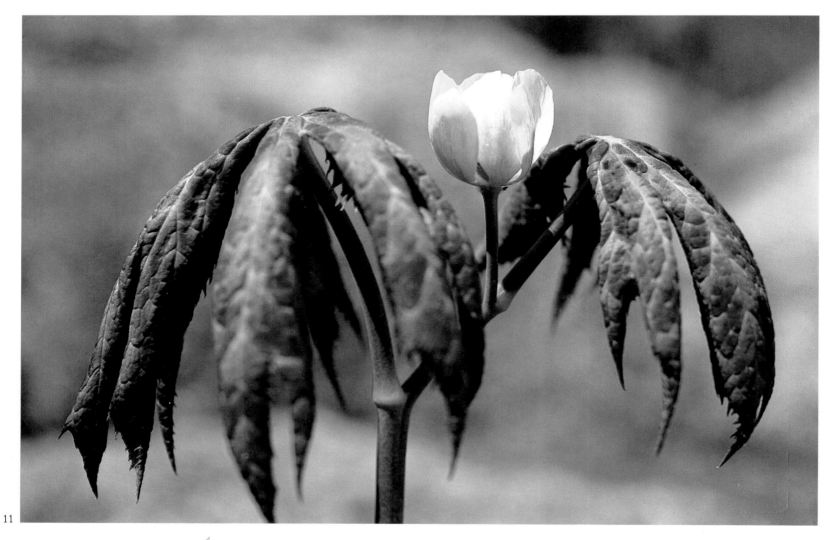

11

11 HIMALAYAN MAYAPPLE

Podophyllum hexandrum Royle
Podopyllaceae

Shady damp spots in light forests at altitudes of 2,400-4,500 m from Afghanistan to China are the favourite home of this perennial herb. The rhizome and roots contain a resinous substance which has a chemical compound recently considered to be useful in the treatment of leukemia. It is also used in liver ailments. The root-stock bears many fleshy roots. Two 15-20 cm long leaves with 3-5 ovate lobes and a dentate margin arise on a long stalk. The flowers are solitary, 2-4 cm across, pink, cup-like, with four to six petals and six stamens, and grow on the tip of the stem. The 3-5 cm long egg-shaped fruit, which is seen from May-August, is large, scarlet, fleshy, with many seeds embedded in the pulp, and is relished by monkeys.

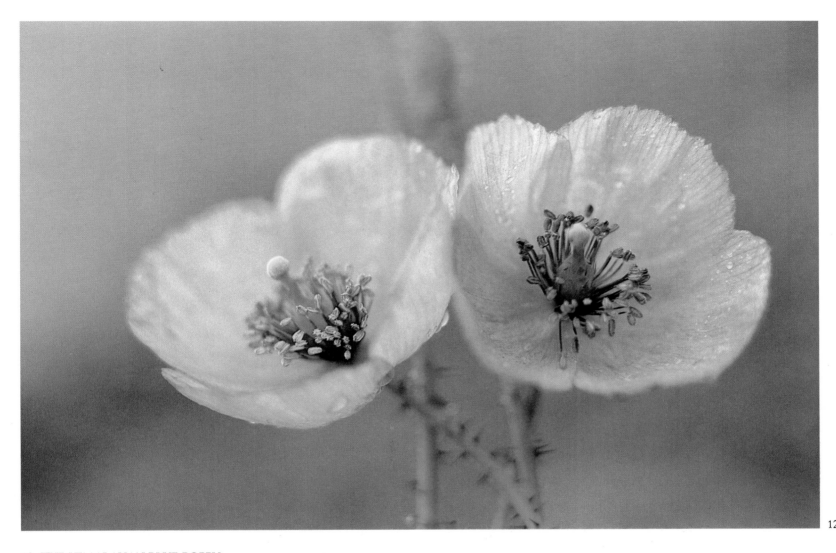

12 THE HIMALAYAN BLUE POPPY

Meconopsis aculeata Royle
Papaveraceae

To Ceres, the mythological goddess of agriculture, we owe poppies. Despairing of rejoining her daughter Proserpina, carried off by Pluto, the god of the underworld, she created a Poppy (opium) with the magic power of bringing sleep to help her forget her grief.

Seen on slopes among rocks from Kashmir to Garhwal at 3,000-4,000 m, this is the more widespread of the Himalayan Blue Poppies with one of the most beautiful sky-blue flowers. A 25-50 cm tall, graceful herb, it has a long, tapering root, and is prickly; the root is considered narcotic and toxic. The leaves grow mainly from the base; they are 10-20 cm long, deeply incised, long-stalked with a sheathing base; the upper leaves are smaller and stalkless. The pretty sky-blue flowers are solitary, axillary or terminal on a long stalk, sometimes purplish or reddish. There are two sepals which are caducous (falling off early) and prickly. The flowers, seen in July and August, have four obovate and roundish petals, many stamens, which are darker than the petals, with yellow anthers, and an oblong ovary; the flowers do not last for a long time on the plant. The fruits are ovate to oblong capsules, 1.5 cm long, with a beak, and with many seeds.

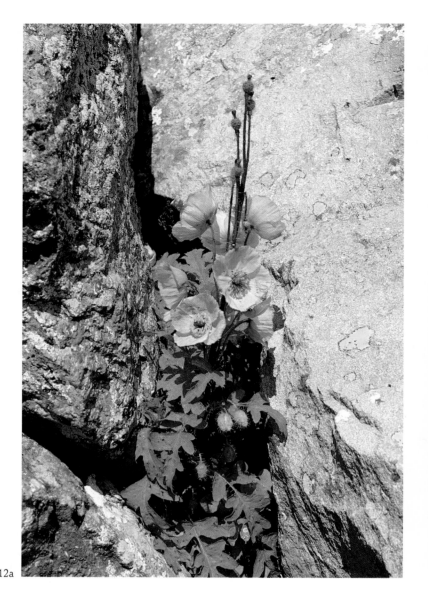

12a

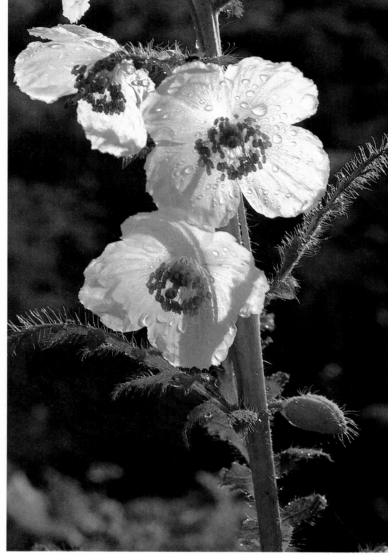

12b

12a Picture shows the famous Himalayan blue poppy in its natural terrain — in rock crevices on damp ground.

12b LARGE YELLOW POPPY

Meconopsis paniculata **Prain**

One of the comparatively stout poppies, it is about 2 m tall, bristly, gregarious, and found near grazing and camping grounds from Garhwal to Tibet at 3,000-4,000 m. Its roots are considered narcotic and toxic.

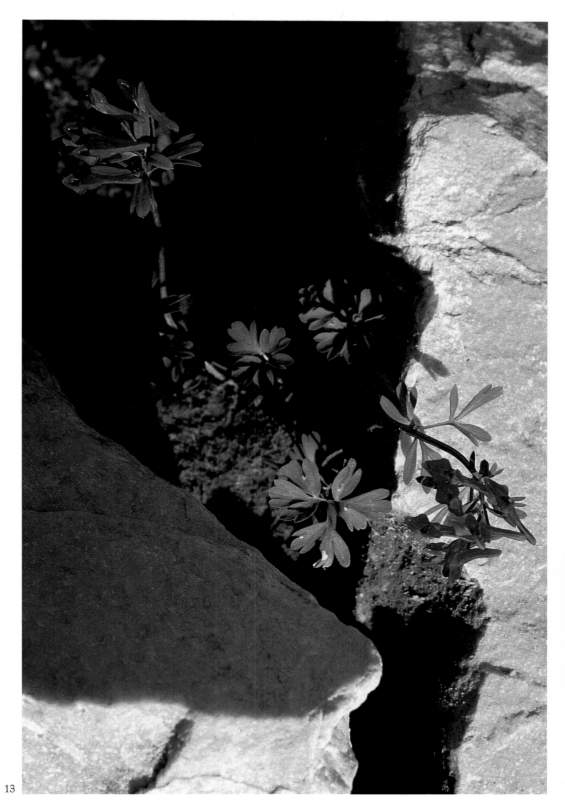

13

13 KASHMIR CORYDALIS

Corydalis cashmeriana Royle
Fumariaceae

"Delicate and beautiful flowers, they might
have been made for Pan."
— F. S. Smythe

Seen among dark purple monkshood and the
white umbels of anemones, between boulders,
at 3,000-4,000 m from Kashmir to Tibet, this is
a small, unbranched herb, 5-15 cm high, with
tuberous roots. The leaves are basal, 1 cm
across, and three-lobed; the upper leaves are
smaller, with narrower lobes. These herbs are
often only single to a few or gregarious.
Smythe noticed "a sheet of blue on the hill
side" in the Valley of Flowers. The long,
narrow, pipe-like bi- lipped flowers are
1.5-2 cm across and each includes a spur; they
bloom from May-August. The fruits are
two-valved, linear capsules, on spreading
stalks.

13a A close-up of the sky blue, bi-lipped
Kashmir corydalis. The upper lobe with a long
spur, and the lower forms a shape like the keel
of a boat.

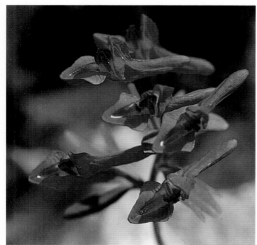

13a

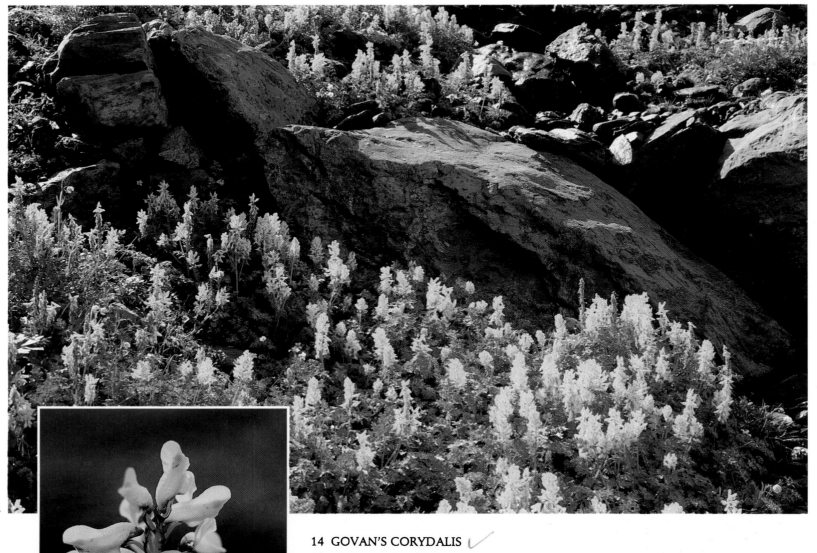

14

14a

14 GOVAN'S CORYDALIS ✓

Corydalis govaniana Wall.
Fumariaceae

"The hill people, who are superstitious, as mountain people of any part of the world, use the root called 'Bhoot Keshi' as a charm against influence of evil spirits. It (the root) varies from a few inches to nearly a foot."
— J. F. Royle

Seen on open slopes among boulders at 2,500-4,500 m from Pakistan to western Sikkim, the root of this plant is also used medicinally in mental disorders. A common alpine herb, it grows 15-20 cm tall, in dense clusters. The leaves are 1-1.5 cm long, highly dissected, and pinnately segmented. The flowers, which bloom from May-August, are 2-2.5 cm long, bi-lipped and bright yellow. The spur is slightly curved or straight. The outer petals form wings. The fruits are a two-valved capsules, 1-2 cm long with a curved remnant of the style.

14a A close-up of the golden yellow flowers — 2-2.5 cm across, on an erect stalk over 10 cm long, showing a short, curved spur.

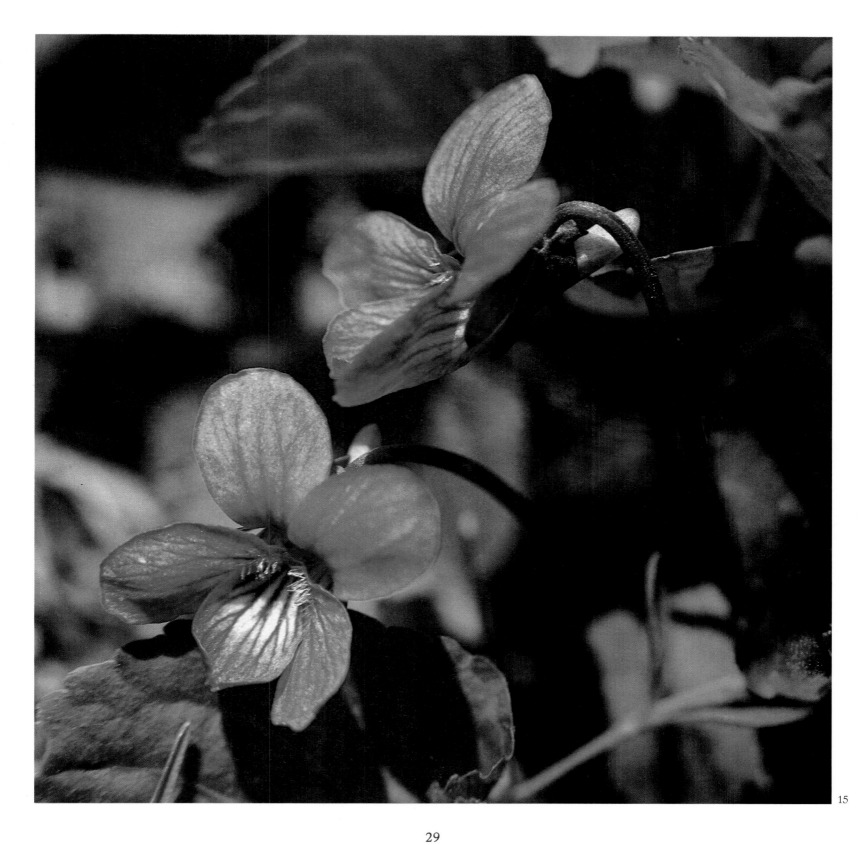

15

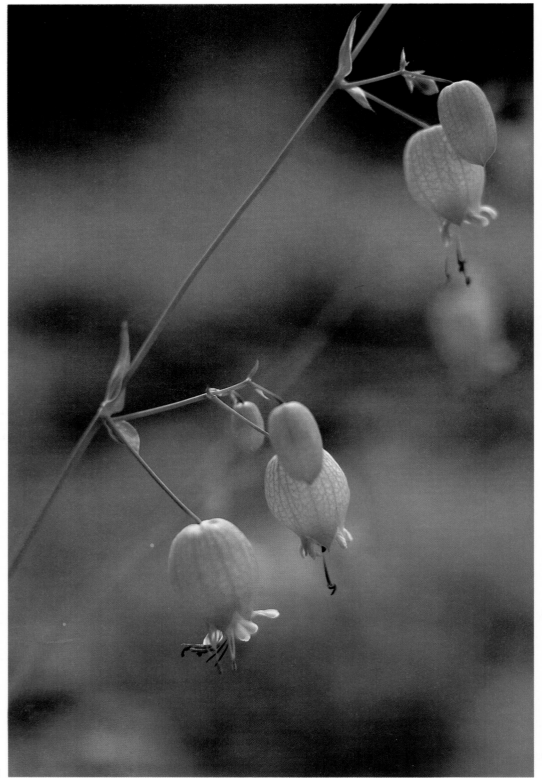

Previous page

15 FRAGRANT VIOLET ?

Viola suavis Bieb.
= *v. odorata* Linn. var. *suavis* Bieb.
Violaceae

"Lay her in the earth
And from her fair and unpolluted flesh,
May violets spring."
— Shakespeare

"May boast itself the fairest flower
In glen, in copse or forest dingle."
— Sir Walter Scott

Poets have portrayed the violet as a symbol of
virtue and modesty. "Violets dim" were
Shakespeare's favourite flowers. John Gerard,
the herbalist, long ago spoke of how the mind
received a peculiar pleasure and recreation by
smelling and handling violets.

A perennial herb, with runners, it makes its
home among shady banks of streams from
Kashmir to Bhutan at 1,500-2,400 m. Its leaves
are reniform to cordate, crenate or obscurely
dentate. The blade is succulent or thick with
grey-hairs on the upper surface, and on a long
stalk. The flowers are pale violet with dark
streaks and centres, about 1 cm across, with a
short, blunt spur, and are in bloom from
March-May. The fruit is a three-valved hairy
capsule which splits open and ejects its seeds.

16 BLADDER CAMPION

Silene inflata Sm.
Caryophyllaceae

Found in meadows among rocks from Pakistan
to Nepal at 2,000-4,000 m, and also in Siberia
and Caucasus, this perennial herb is 30 to
100 cm tall, erect, almost glabrous, and
branching. The leaves are ovate, obtuse, 3-7 cm
long, and glaucous. The lower ones are on
short stalks and the upper are stalkless. The
flowers, which bloom from June-August, are
greenish white, 2-2.5 cm long, usually in
branched clusters. The bracts are reddish when
young. The calyx is inflated, with white and
green stripes. The petals are deeply lobed; the
lobes are triangular. The fruit is a globular
capsule on a long stalk, encircled by an inflated
calyx covered with tubercles in lines.

16

30

17 FALSE TAMARIX

Myricaria elegans Royle
Tamaricaceae

This plant is found at altitudes of about 3,000 m from Pakistan to Tibet (Mansarovar), and is common in Ladakh, Siberia, and cold deserts. Its leaves are applied to bruises. An erect, branching shrub, it is 1-2 m tall, with purplish brown stems with lax bunches of flowers. The leaves are 1-2 cm long, elliptic and glandular. The pink-white flowers, which bloom in June and July, are borne on terminal drooping branches formed of many lateral spikes. The fruits are spindle-shaped capsules less than 1 cm long, with a hairy, persistent style.

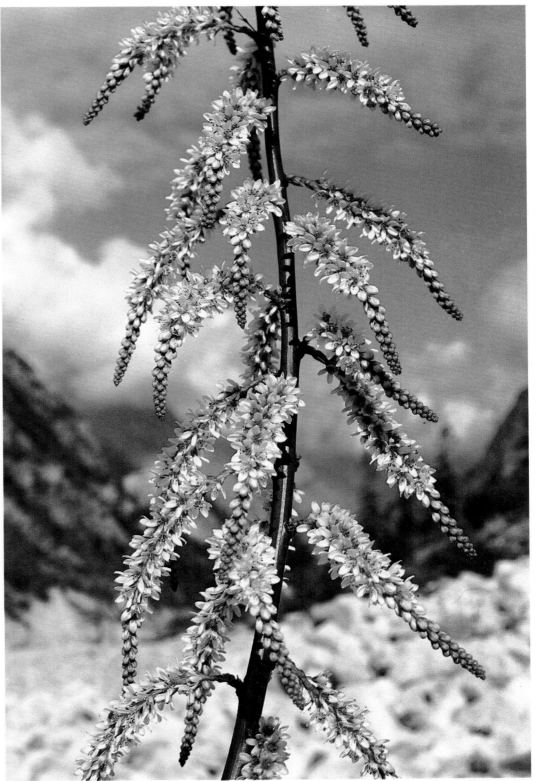

17

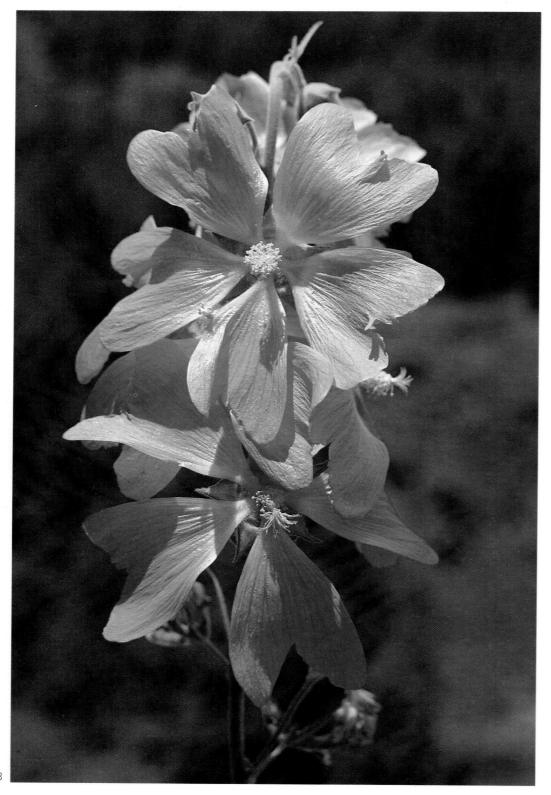

18 KASHMIR TREE MALLOW
Lavatera kashmiriana Camb.
Malvaceae

Seen from Pakistan to Garhwal between 2,000 to 3,500 m in meadows and clearings, this plant is sometimes cultivated in Nepal. A branching, villous perennial, it grows up to 2 m tall. The leaves are alternate, orbicular, 3-5 lobed; the upper ones, with long stalks, are hairy beneath and glabrous above. The bright pink flowers, with darker streaks, are 5-8 cm across with bifid petals, and appear on a terminal spike from July-September. The fruits are formed of many, black, kidney-shaped carpels, each containing a single seed surrounding a conical torus.

18

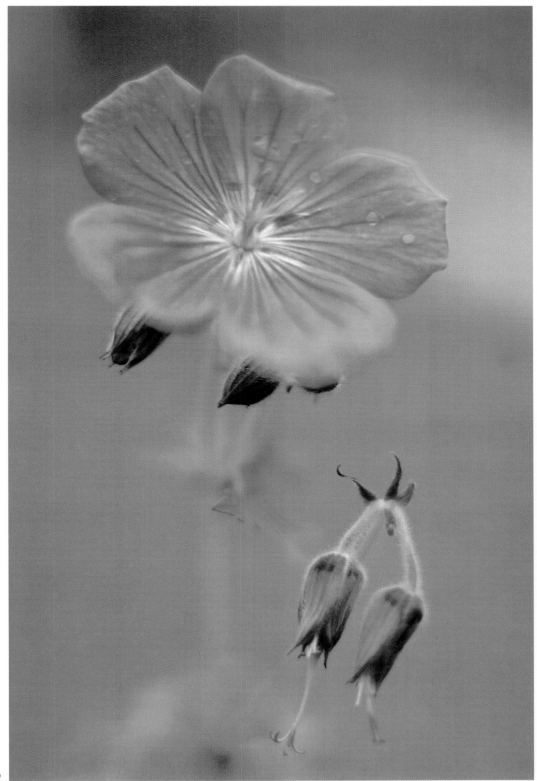

19 WALLICH'S CRANESBILL
Geranium wallichianum Sw.
Geraniaceae

This plant is found at 2,400-3,000 m on slopes from Afghanistan to Bhutan. The root of this plant, often called 'Lal Jhari' (red root), is used medicinally as a substitute for *Coptis teeta* in eye ailments and toothache. A trailing herb with many branches, it grows up to 1m tall. The leaves are 4-8 cm in diameter and 3-5 lobed; the lobes are further lobed and toothed, often fine-pointed. The stipules are distinctive, large, ovate, united in pairs and often coloured. The flowers, which bloom from June-September, are paired and 2.5-4 cm across; they are pink to red, or purple with a pale centre. The sepals are bristly, non-glandular hairs on veins. The fruits are capsular and five-valved, each with one seed, and covered by sepals.

19a The picture shows blue and red flowers together. Red seems to turn to blue on ageing.

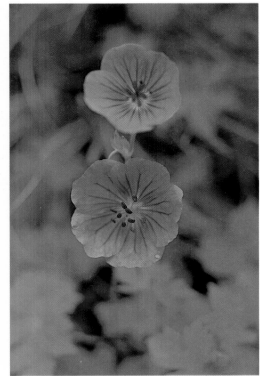

19

19a

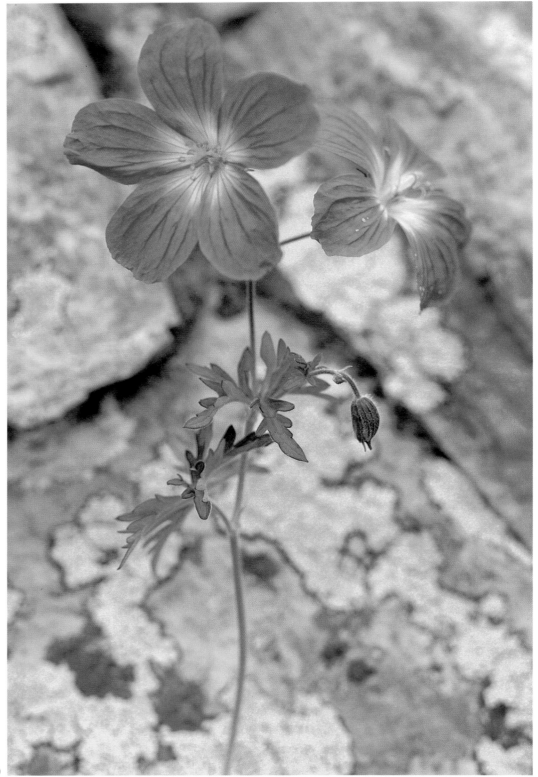

20 MEADOW CRANESBILL

Geranium pratense Linn.
Geraniaceae

Geranios means crane, and *pratense* means meadow. The fruit resembles a crane's bill, hence the name.

The plant occurs frequently along water courses and hill slopes at 3,000-4,500 m from Pakistan to Central Nepal. A tall, stout herb, up to 1 m tall, it is profusely branched. The leaves are stalked, rounded, 5-8 cm in diameter and deeply divided. The stipules are awl-shaped to lance-shaped. The flowers, which bloom from June- August, are in pairs on long stalks, 3-5 cm in diameter, and bluish with purple veins with a lighter centre; the colour varies from reddish to whitish; the stalks are deflexed when the petals fall. The fruits are 3 cm-long capsules containing five one-seeded chambers, and are covered by hairy sepals including an awl-like lip.

20a HIMALAYAN CRANESBILL

Geranium himalayense Klotzch

This differs from the meadow cranesbill in its bigger, bluish flowers with purple streaks, which bloom from June-August.

20

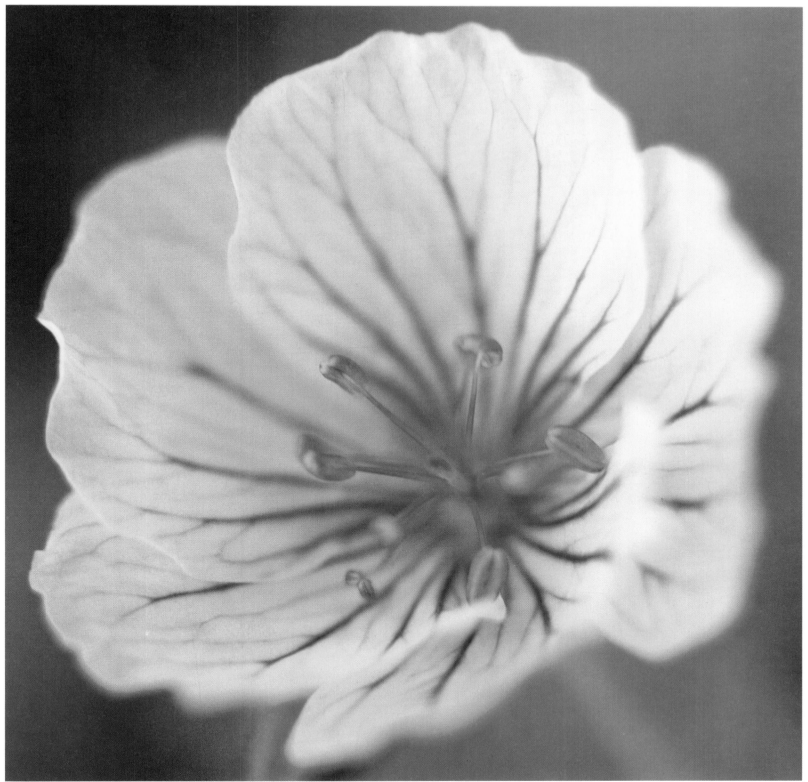

20a

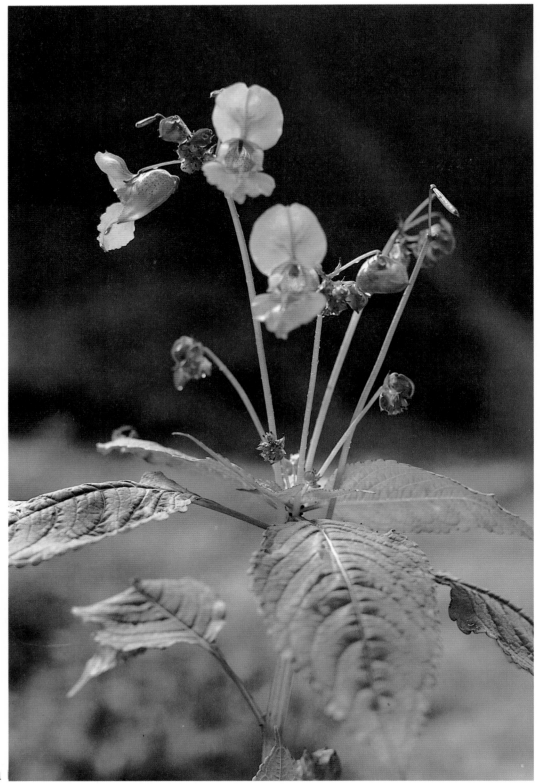

21

21 ROYLE'S SNAPWEED (BALSAM)

Impatiens glandulifera Royle
= *I. roylei* Walp.
Balsaminaceae

Seen on grazing grounds in the western
Himalayas from Pakistan to Garhwal at
1,800-4,000 m, this is a handsome, often
gigantic herb, up to 3 m tall, with a thick
succulent stem. The leaves are usually opposite
or whorled, and are very variable in breadth,
length of petiole and margin. The base is round
or acute. The stipules are glandular and hairy.
The flowers, which bloom in July and August,
are on long peduncles up to 12 to 15 cm long;
they are red-purple, pink and sometimes
white. The spur is short; the standard is two-
lobed, and the lip saccate. The fruits are
clavate, beaked, up to 2 cm long, turgid in the
middle; the large, broadly obvoid seeds are
considered edible.

21a "With heavy grazing, the pasture lands
soon get stripped of the more tender and
smaller plants and are replaced by tall
knotweed *(Polygonum polystachyum)* and even
taller balsam *(Impatiens roylei)*. Once these two
plants get hold of the ground, pasture land is
permanently ruined. This tall balsam covers
acres and acres in a sheet of bloom — a
wilderness of flowering balsam."
— F. S. Smythe

21b ROUGH SNAPWEED (BALSAM)

Imaptiens scabrida DC.

Another of the 40 or more balsams of the
Himalayas, it is even larger than Royle's
balsam, with golden yellow flowers on a
peduncle. It is seen at slightly lower elevations
of 1,200-3,600 m from Kashmir to Bhutan,
from May-September.

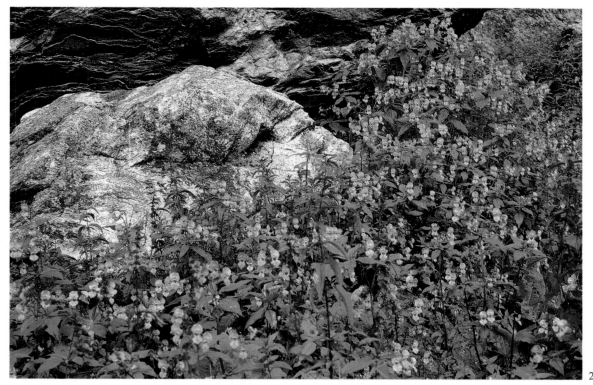

21a

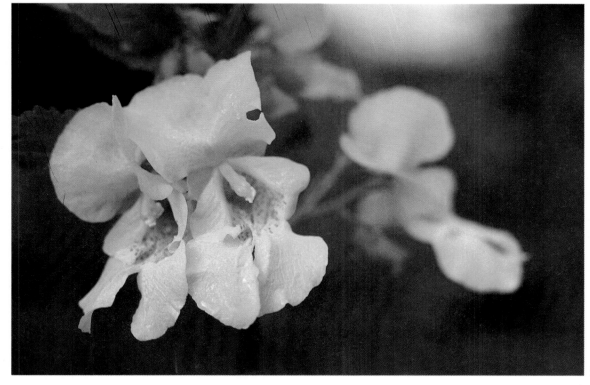

21b

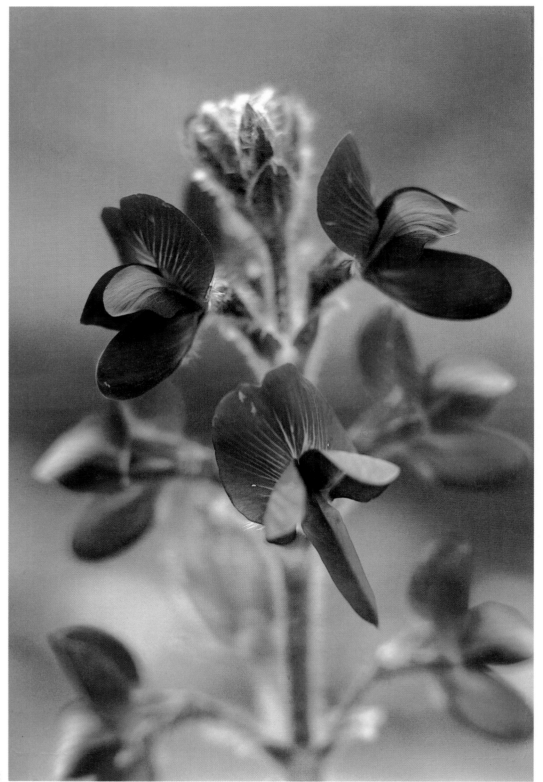

22 BARBED THERMOPSIS OR BLACK PEA

Thermopsis barbata Royle
Papilionaceae

Seen in the temperate and subalpine
Himalayas from Kashmir to Sikkim at
3,000-4,600 m on open hill slopes, this is a
rather rare, leguminous, 15-45 cm tall
branching herb. The leaves are trident- like,
with three leaflets, stalked, and covered
densely with rust- coloured hair; the stipules
are leafy, almost as long as the leaflets. The
flowers, which bloom from May-July, are
papilonaceous (like the pea flower), 2-3 cm
across, and dark purple, which gives them the
common name 'Black Pea'. The calyx is hairy.
The fruit is a 2.5-3.5 cm hairy-pod.

23 LARGE-LEAVED ROSE

Rosa macrophylla Lindley
Rosaceae

Found on sloping pasture grounds at
2,000-3,800 m from Afghanistan to Tibet, this
is a slender, erect shrub, 3-5 m tall, with few
prickles and purplish branches. The leaves are
alternate and compound, with 7-11 leaflets,
elliptic with rounded tips and finely serrated
margins. The flowers, which bloom from June
to July, are solitary, red or bright pink, 5-7 cm
across, with five or more obcordate petals. The
sepals are longer, with a feathery, linear tip.
The fruit is flask shaped and red, up to 5 cm
across, bristly and edible.

22

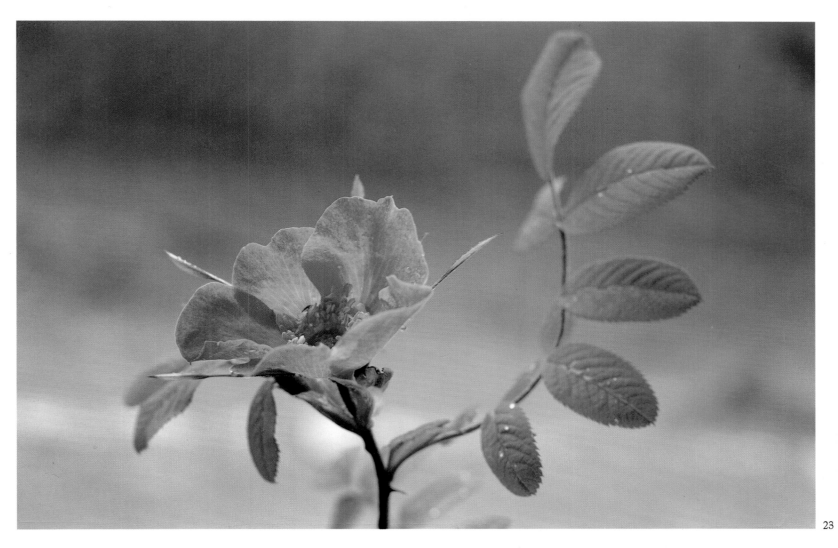

23

23a There are many forms of this rose; some have ligther pink flowers, as in this picture. The leaves are also variable, and the flowers often develop in a cluster.

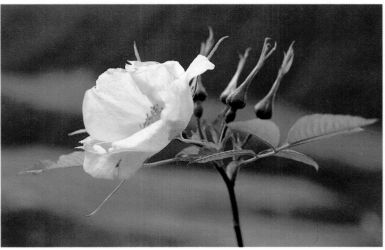

23a

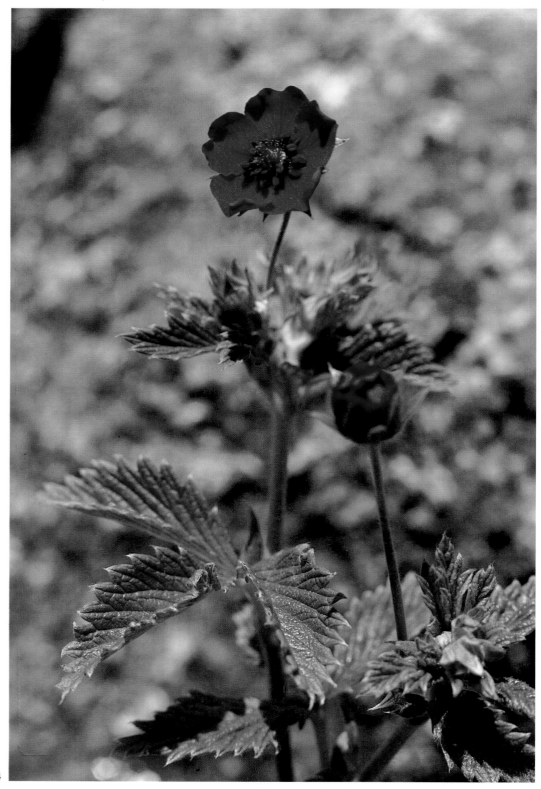

24 RED NEPALESE POTENTILLA/CINQUEFOIL ✓

Potentilla nepalensis Hk.
Rosaceae

A species that for long has been cultivated in English gardens and is much-hybridized, it is seen in open glades and grassy hill slopes from Kashmir to Kumaon at 1,000 to 3,000 m, and is used in local medical practice. A very variable, perennial herb, up to 1 m tall, it has a woody root-stock. The leaves are long stalked, digitately divided, with three to five leaflets which are egg-shaped, with a coarsely sharp-toothed margin. The flowers, which are in bloom from June-September, are dark crimson, but are variable from red to yellowish, 2-3 cm in diameter, with five inversely heart-shaped petals which are longer than the sepals. The fruits appear as many achenes on a globose hairy base.

24

25 ARUNCUS

Aruncus dioicus (Walter) Fernald
Rosaceae

Seen in both western and central Himalayas at
3,500 to 4,000 m in forests, this is a slender
herb, 1-1.5 m tall, with a stout, perennial
root-stock bearing a spire of pinkish white
flowers. The leaves are alternate, twice
divided, up to 1 m long. The leaflets are ovate,
with a double serrate margin, and an acute
apex, 2.5-6 cm long. The flowers, which bloom
in July and August, are densely crowded,
unisexual, with a globular calyx, five petals,
five stamens, and three or four shining carpels.
The fruits are achenes, glabrous when ripe.
Sometimes confused with *Astilbe rivularis*
(Saxifragaceae) which it greatly resembles.

25

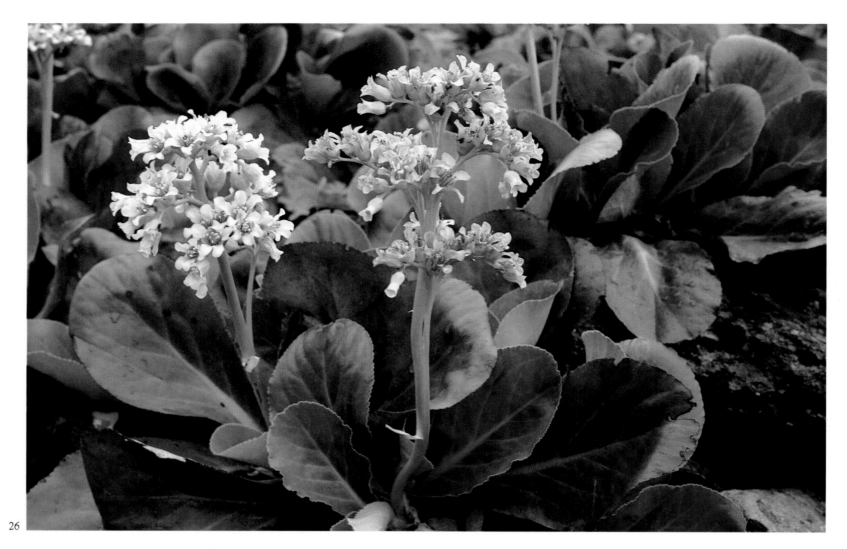

26

26 STRACHEY'S BERGENIA ✓

Bergenia stracheyi (Hk.F. & Th.) Engl.
Saxifragaceae

Found at 3,300 to 4,500 m from Kashmir to
Kumaon, this is a perennial herb with a stout,
woody root-stock. The leaves are fleshy,
obovate, 5-10 cm long during florescence, and
later grow up to 30 cm, with an almost entire,
ciliate or finely-toothed margin; the stalk is
sheating. The flowers appear from June-August
on leafless stalks up to 30 cm tall, in
umbrella-shaped, hairy clusters. Their colour
varies from pink to white. This picture shows
light pink and white flowers together. In the
Kumaon region, they are mostly pink. The
fruits are egg or lance-shaped, with a long
stylus on an erect stalk.

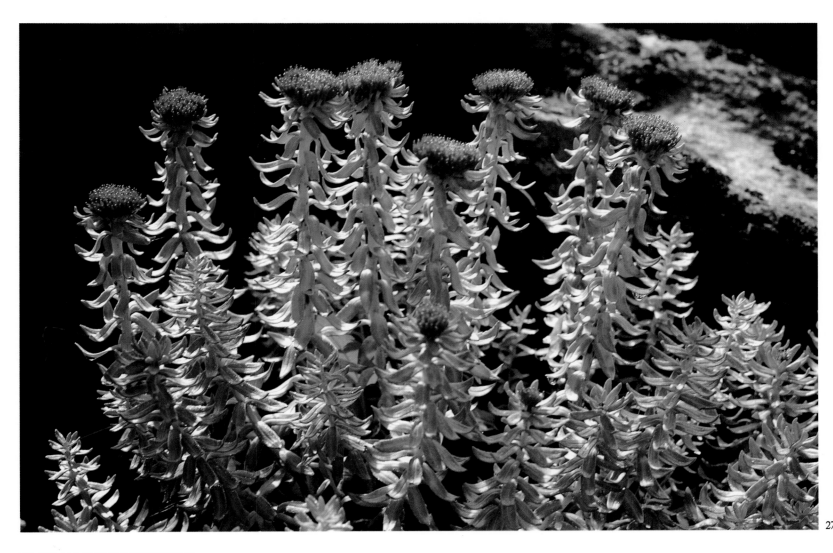

27 HIMALAYAN STONECROP

Rhodiola imbricata Edgew.
= *Sedum rhodiola* auct non DC.
Crassulaceae

Seen on the drier rocky slopes from Kashmir to
Nepal at 4,000 to 5,000 m, thisis a perennial
rock herb with a stout root-stock, 2-2.5 cm
across, without suckers, with annual erect
branches. The leaves are imbricate, 1.5-to 3 cm
long, oblong to narrow-elliptic, on erect
branches carrying terminal clusters of flowers.
The flowers, which bloom in June and July, are
unisexual, pale yellow with greenish or reddish
sepals (the colour changes on ageing), in dense
clusters arising from an involucre of leaves,
with four petals. The fruits are follicles in
groups of 4 or 5, with many seeds.

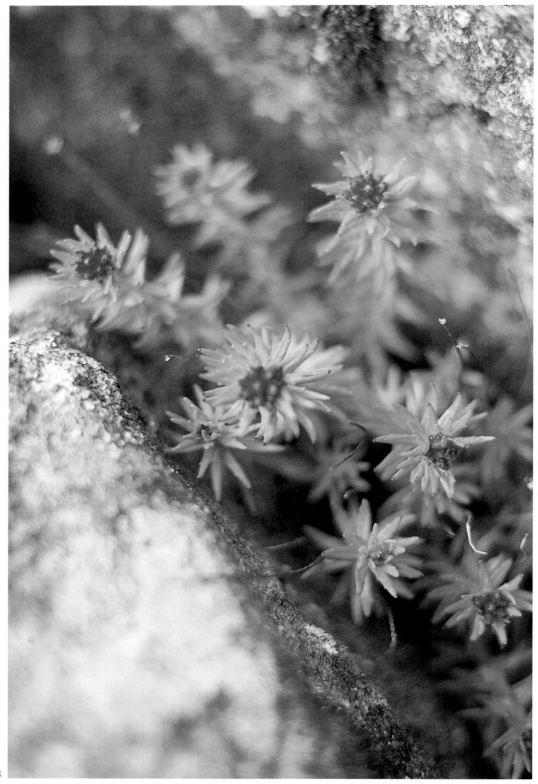

28

28 SIKKIM STONECROP

Rhodiola crenulata (Hk. f.& Th.) Ohba
= *Sedum crenulatum* Hk. f.& Th.
Crassulaceae

The stonecrop is also known as 'Live long', as it keeps fresh for long after being gathered. It is seen in the Sikkim and Garhwal Himalayas at 3,500 to 5,000 m on stones or on the mossy covering of stones. A succulent herb, perennating with a root-stock, it has annual branches, which are 8-18 cm tall and erect. The leaves are elliptic, crenulate, glabrous, and stalkless, turning ruddy chestnut on drying. The flowers, which bloom during June and July, are in stalkless clusters, enclosed by upper leaves and outer leaf-like bracts, with red to pink petals. The sepals are purple, narrow and oblong. Fruits are follicles in groups of 4 with many seeds.

29 ROESEBAY WILLOW-HERB

Epilobium angustifolium Linn.
Onagraceae

Seen from Afghanistan to Tibet at 3,000 to
4,300 m on hill slopes, this is an erect perennial
herb, 1-2 m tall with a long, terminal leafless
pyramidal spike of red/pink flowers. The roots
and leaves are considered astringent. The
leaves are alternate, narrow, lanceolate, and
almost glabrous beneath; the nerves are
prominent. The flowers, which bloom in June
and July, are 2-2.5 cm across, with four dark
purple and spreading sepals, four red and pink
petals, eight stamens, and an erect style
bearing four stigmas. The fruits are 2.5-7 cm
hairy capsules with many seeds.

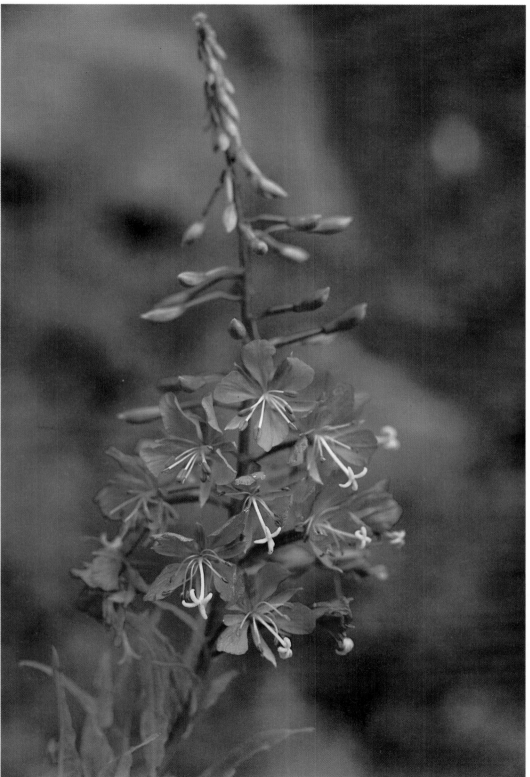

29

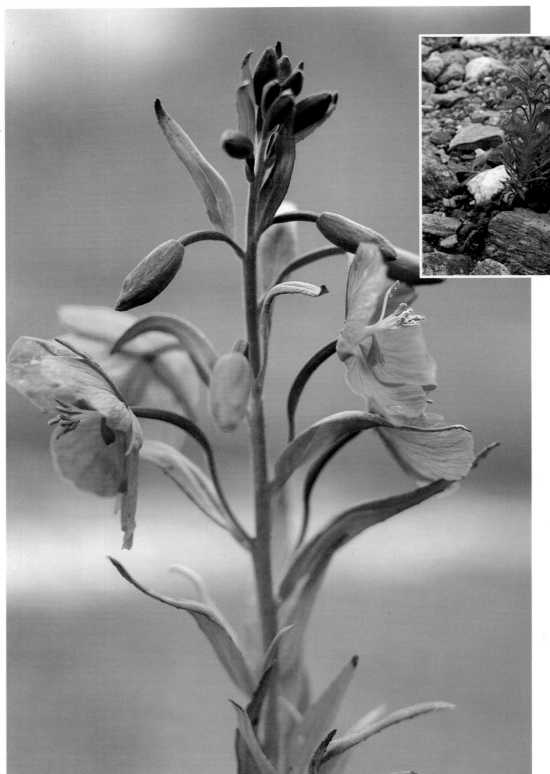

30a

30 BROAD-LEAVED WILLOW-HERB
Epilobium latifolium Linn.
Onagraceae

"There is an elegance in the rusticity of this herb, a loveliness in its flower seldom surpassed by the choicest gift of Flora."
— M. Woodward

Epilobium means 'upon a pod'; willow-herb because the leaves resemble those of the willow.

Found in damp places among rocks at 3,500 to 4,500 m from Afghanistan to Kumaon, this is an erect herb, about 30 cm tall, with a terminal spike arising out of leafy bracts. The leaves are elliptic, lanceolate with acute apex, 4-8 cm long and hairy on the lower surface. The flowers are axillary, arising from leafy bracts borne on a spike, and bloom in July and August. The inferior seed vessel, purple in bloom, gracefully holds the blossom of four pink sepals and petals, with a short style, usually bent, with four stigmas. The fruit is a capsule with four valves held on a prominent stalk.

30a The picture shows the terrain where this elegant plant grows, often near streams.

30

31 LAX WILLOW-HERB

Epilobium laxum Royle
Onagraceae

Found in the temperate Himalayas in damp places at 2,000 to 3,500 m from Kashmir to Garhwal, this herb is about 60 cm, erect or semi-erect, with a round stem that is purplish when young. The leaves are opposite, lance-shaped or ovate, with elongated apex, cripsed, pubescent on mid-rib, very shortly stalked or stalkless. The flowers, in bloom in July and August, are axillary, regular, solitary or in spikes, arising at the end of branches; the petals are pale pink with a purplish tinge, with 4 or 8 shorter stamens. The fruits are 4-5 cm long capsules in clusters, ellipsoid and pappilose.

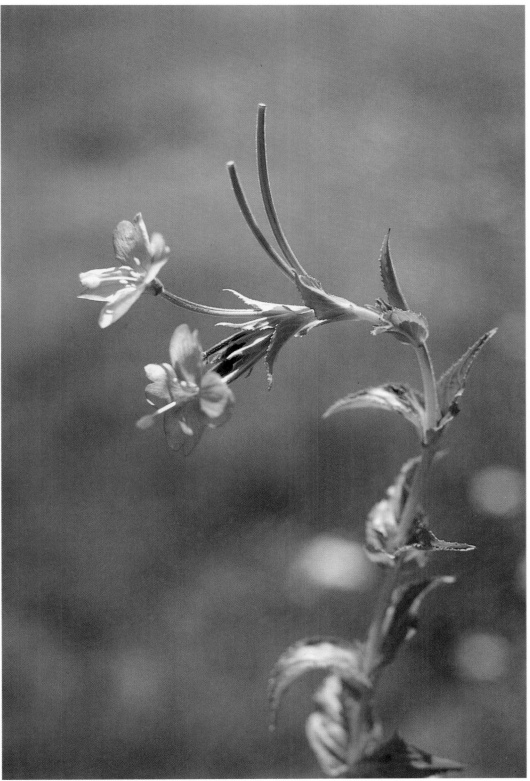

31

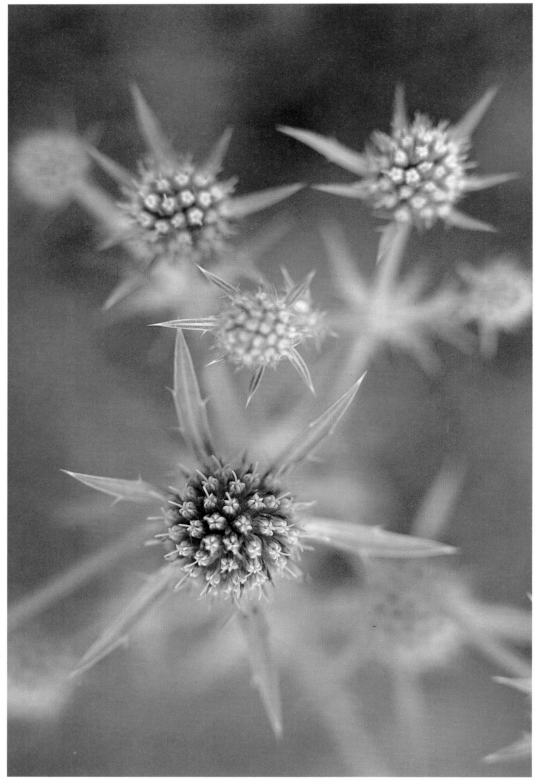

32 KASHMIR ERYNGO

Eryngium biebersteinianum Nevski ex Bobrov
Umbelliferae

Seen on wastelands in the Kashmir Valley at 1,500 to 1,900 m, this species is closely allied to *E. billardieri* Del., which is also a common weed.

A perennial herb of the spring, it is 50-90 cm tall, branching near the top, and bluish all over. The basal leaves are 5-10 cm in diameter, oblong to heart-shaped, coarse toothed, with a distinct stalk. There are 7-8 bracts, 2.5 cm long, linear with a spiny margin. The flowers, which bloom in July and August, are in compact, globular heads, 1.5 cm across; the calyx tube is scaly. The petals are white, narrow and erect. The fruit is ovoid, flattened, about 1 cm long; the primary ridges are obtuse.

32

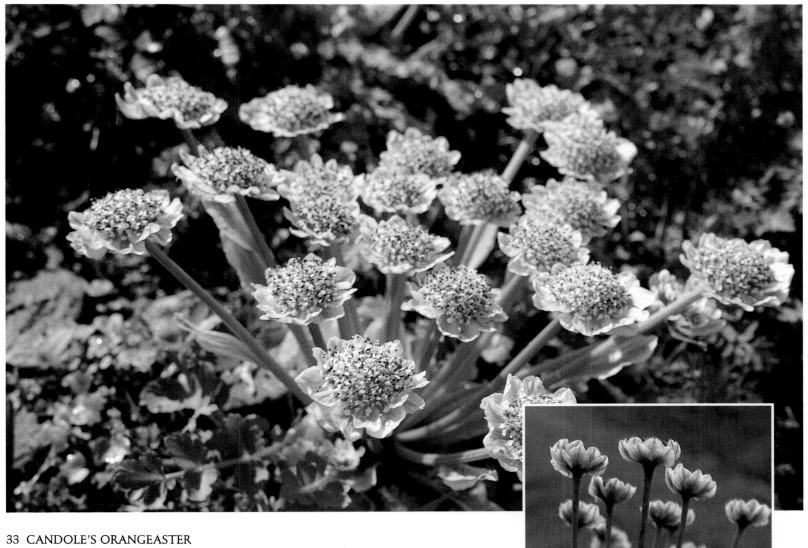

33 CANDOLE'S ORANGEASTER

Pleurospermum candolei (DC.) C.B.Cl.
Umbelliferae

"The most striking flower of all. Of the many flowers that I saw in Garhwal, there was none that attracted me more. You must see this plant on a misty day, when it seems to attract the distant sunlight to itself so that it is then almost transparent; petals glow as though illumined from behind. Even if you have little or no interest in flowers, it demands that you pass and pay tribute to its beauty and to the divinity that raised it among the barren rocks..."
— F. S. Smythe

Seen from Kashmir to Kumaon at 3,600 to 4,500 m on Alpine slopes, this is a short, stout herb, less than 30 cm tall. The hollow stem is covered with persistent leaf bases. The leaves are pinnate, opposite, three-lobed and dentate, with sheathing bases; the leaflets are ovate. The flowers, which bloom in August and September, are umbels with 5-20 primary rays radiating outwards with a broad white margin longer than the flowers; they are white, delicately fringed at the edges and with numerous stamens ending in dark coloured anthers. The fruits are oblong, spongy, about 5 mm long, with narrow, winged ribs broadening at the end.

33a Picture shows the flowers in full bloom

33a

49

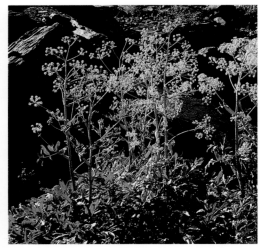
34a

34 KASHMIR GIANT FENNEL
Ferula jaeschkeana Vatke
Umbelliferae

Allied to asafoetida from Afghanistan and
Kashmir *(Ferula assafoetida* Linn. and *F. narthex*
Boiss.), this species is seen on open grounds
and slopes around Dras in Ladakh at 2,400 to
3,500 m. It is generally used as a fodder plant.
A perennial herb, it is up to 2 m tall with thrice
divided leaves up to 40 cm in length; the upper
leaves are very much reduced and have large,
sheathing leaf-bases. The flowers arise in large
umbels of yellow in May and June. The fruits
are flat, 1-1.5 cm in diameter, with lateral
wings.

34a Picture shows the full Kashmir giant
fennel.

34b PRANGOS
Prangos pabularia Lindley

This is another allied species with highly
divided dissected linear segments as in the
Fennel, and fruits with wavy wings. The roots
and fruits are used in local medicine. The
whole plant is dried and stored as cattle feed
(pabularia = fit for fodder). The decoction of
the plant destroys snails and repels insects.

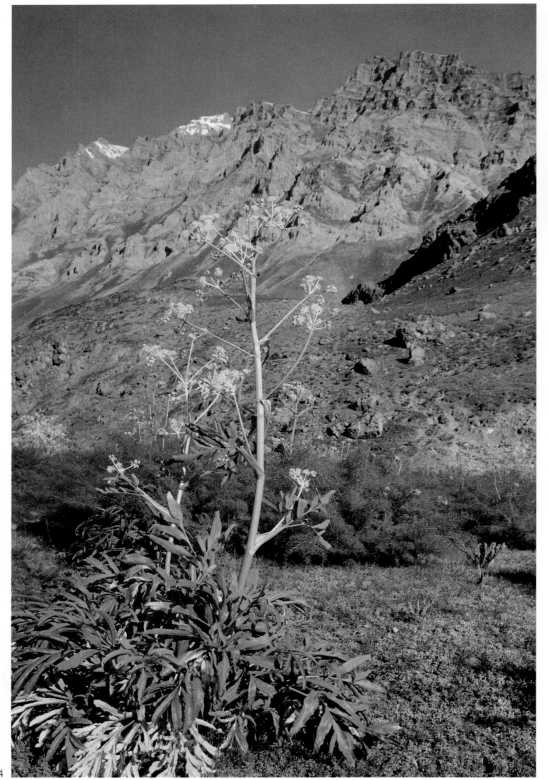
34

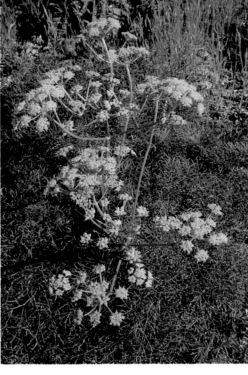

34b

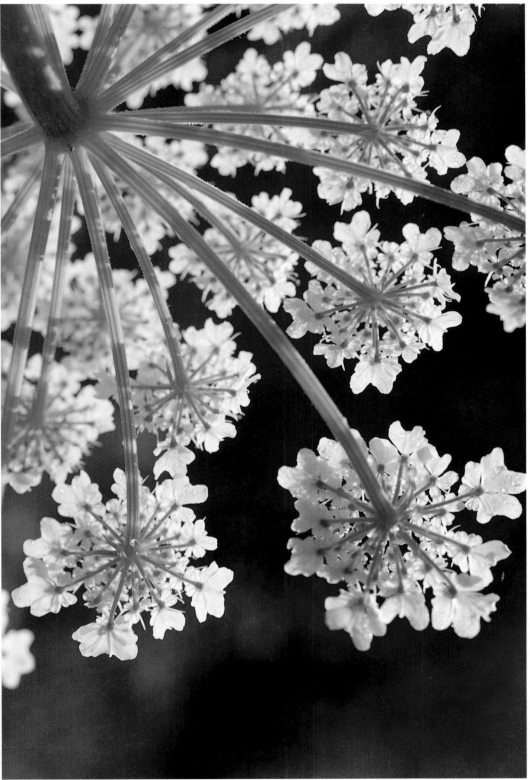

35 HIMALAYAN HOGWEED/COW PARSNIP

Heracleum candicans Wall ex DC.
Umbelliferae

Common on open slopes in dry situations at 2,000 to 4,000 m from Kashmir to Kumaon, the root of this plant contains photosensitive compounds like psoralin, used in the treatment of vitiligo. A robust, perennial herb, up to 2 m tall, all its parts are more or less villous. The leaves are large, 20-60 cm long, pinnately lobed, elliptic-ovate with a crenate or toothed margin. The leaflets are 7-10 cm long, white and villous on the underside; the upper leaves have channeled sheaths. The flowers, which bloom in June and July, have no bracts, and have white umbels with 10-40, hairy primary rays. The secondary umbels are about 3 cm across. The petals are bi-lobed. The fruits are flattened, obovate, 1 × 0.95 cm, minutely hairy, with lateral wings and dorsal ribs.

35

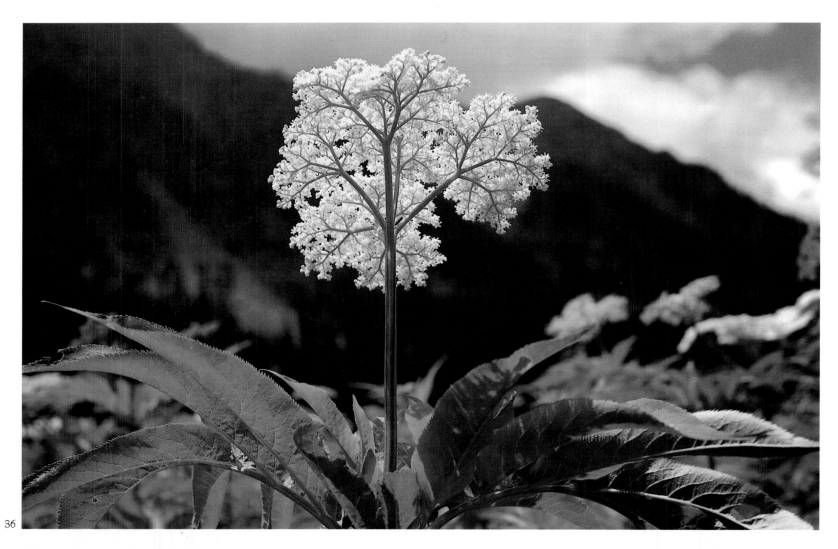

36

36 WIGHT'S ELDER

Sambucus wightiana Wall. ex Wt. et Arn.
Sambucaceae

Found from Afghanistan to Himachal Pradesh
at 2,000 to 3,500 m on overgrazed slopes, this
plant emits a disagreeable odour when bruised.
The leaves and fruits are said to have purgative
properties. A perennial herb, it is 1-1.5 m tall,
forming clumps of green stems which hold a
large bunch of tiny white flowers. The leaves
are pinnate, dark green, and gracefully held,
with 5-9 large leaflets which are lanceolate
with an elongated apex. The margin is serrate
and the stipules leaf-like. The flat-topped
bunch of tiny and numerous, white, fragrant,
flowers bloom in July and August. The fruits
are globular, 4-5 mm long berries, turning red
to black on maturity.

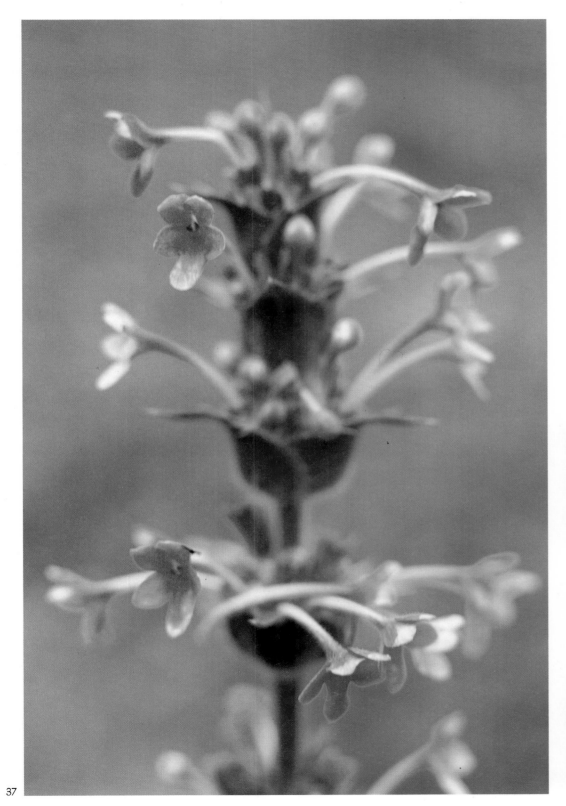

37 LONG-LEAVED MORINA
Morina longifolia Wall.
Morinaceae

Seen in the alpine regions from Afghanistan to Bhutan at 3,000 to 4,000 m, this is a perennial herb which looks like a thistle, bearing stately spires of pink flowers. The leaves are linear and lanceolate, 15 × 3 cm, doubly spinous, toothed, and in whorls; the young leaves are slightly pubescent. The pink flowers bloom from June-September in interrupted whorls on a purple peduncle. The corolla tube is 2-3 cm long with five lobes, often white, but mostly pink. It has involucral hairy bracts with a broad sheathing base and spiny tip. The fruits are 5 mm achenes, with oblique apices, free in the base of the involucel.

37a The picture shows the whole plant of Long Leaved Morina.

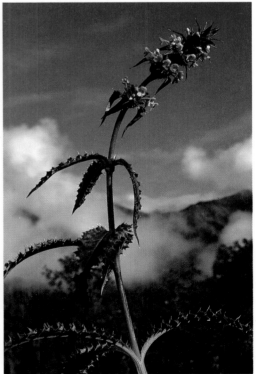

37

37a

53

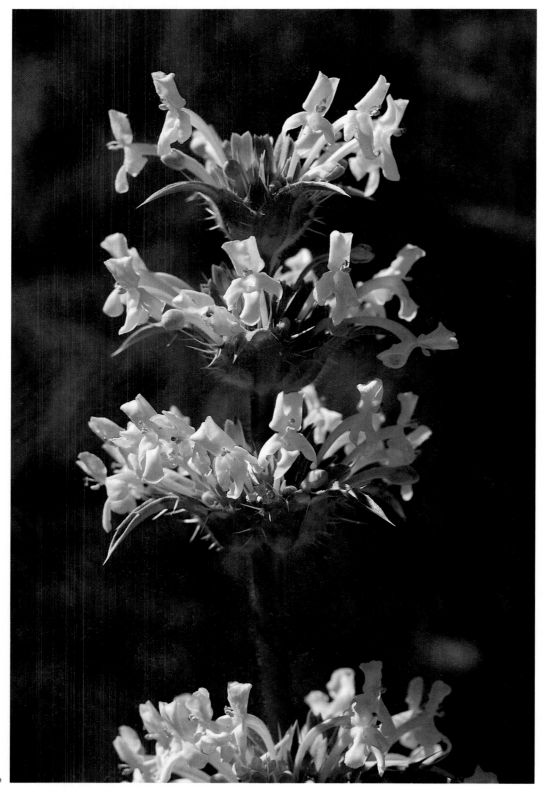

37b YELLOW MORINA
Morina coulteriana Royle
Morinaceae

This robust herb is similar to the Long Leaved Morina, but has yellow flowers. It is seen at a slightly lower altitude from Kashmir to Kumaon and also in Iran and neighbouring regions.

37b

38 GOLDEN ROD OR WOUNDWORT

Solidago virgo-aurea Linn.
Compositae

This plant is found in temperate Himalayan regions from Kashmir to Assam at 1,500 to 2,000 m. This species is also seen in many parts of the world. A perennial herb, it is erect, about 50-60 cm tall, and bearing a leafy rod of golden spikes of flowers. The lower leaves are 9-12 cm long with a stalk; the upper are narrower, stalkless and pubescent. From June-September, the flower heads radiate yellow ray florets; 1 to 4 heads are held on a short axillary stalk, and are carried at intervals on a long, leafy panicle. The fruits are glabrous or puberlous achenes.

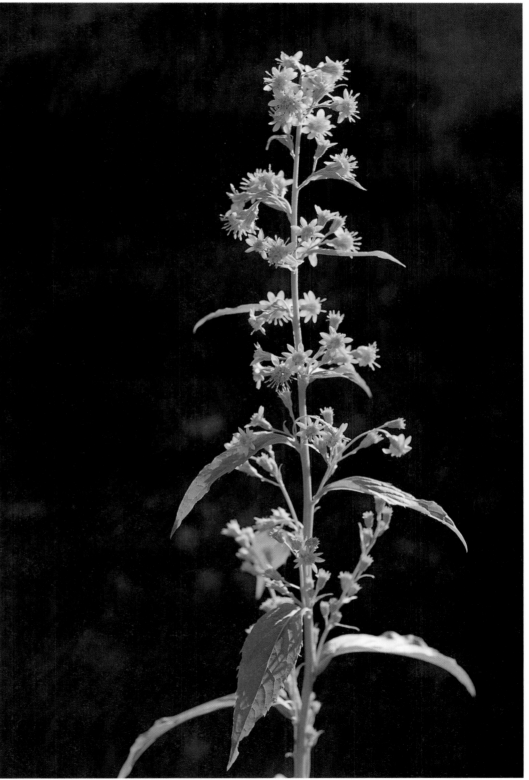

38

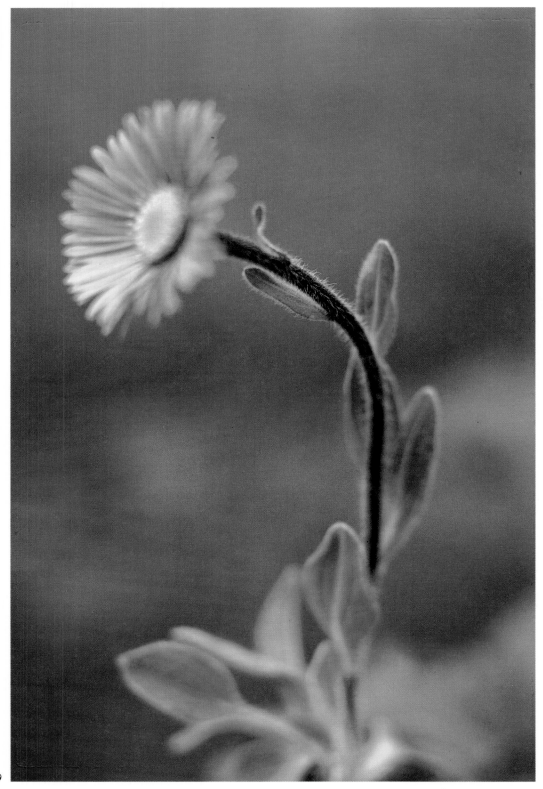

39 OTTO'S ASTER

Aster asteroides (DC.) O. Kuntze
= *Heterochaeta asteroides* DC.
Compositae

A variable plant, it closely resembles the
European *Aster alpinus* Thom., but differs from
it in the double pappus. J. D. Hooker
comments in the *Flora of British India* that there
is considerable confusion in the naming and
distribution data of single-flowered Himalayan
asters and *Erigeron multiradiatus* Benth. collected
from the Himalayan regions.

Seen from Kashmir to Tibet at 3,600-4,800 m
in close proximity with *Aster flaccidus* in moist
or swampy situations, this is a tomentose
perennial species with a tuberous root-stock
and erect leafy 15-35 cm tall stem. The basal
leaves are 2.4 cm long, but the leaves on the
erect stem are smaller. The flower heads, seen
from May-July, are 1-1.7 cm across, solitary,
with purple or mauve rays. The fruit is
achenial, 0.5 cm long, smooth, or with a
sparsely silky covering with double pappus,
which is white or yellowish.

39

40 LAX ASTER

Aster flaccidus **Bunge**
Compositae

Seen on open screes and grassy hill slopes at 3,500 to 5,000 m from Kashmir to Bhutan, this is a perennial herb, about 15 cm tall, growing in clumps. The leaves are alternate, lanceolate or oblanceolate, with a pointed apex, and have short stalks or clasp the stem with their base. The mauve flowers, which bloom from July-September, are on comparatively large flower heads, with spiralling, linear rays, 12-15 mm long. The fruits are achenial, bristly-hairy.

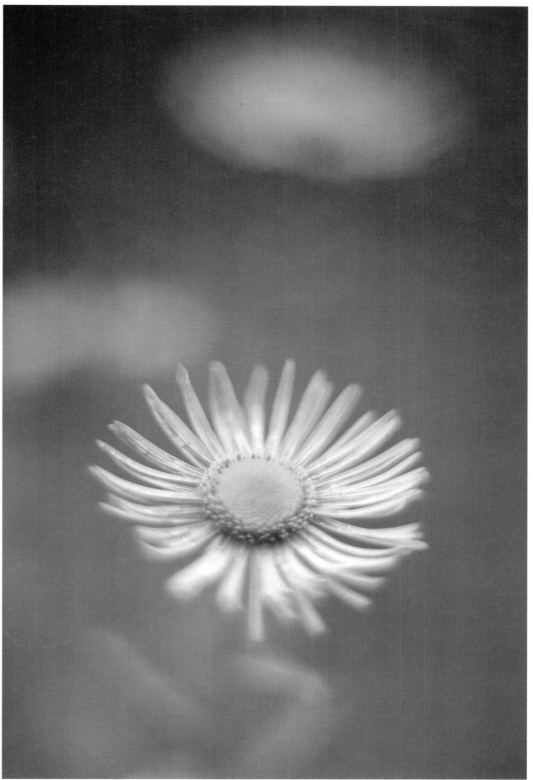

40

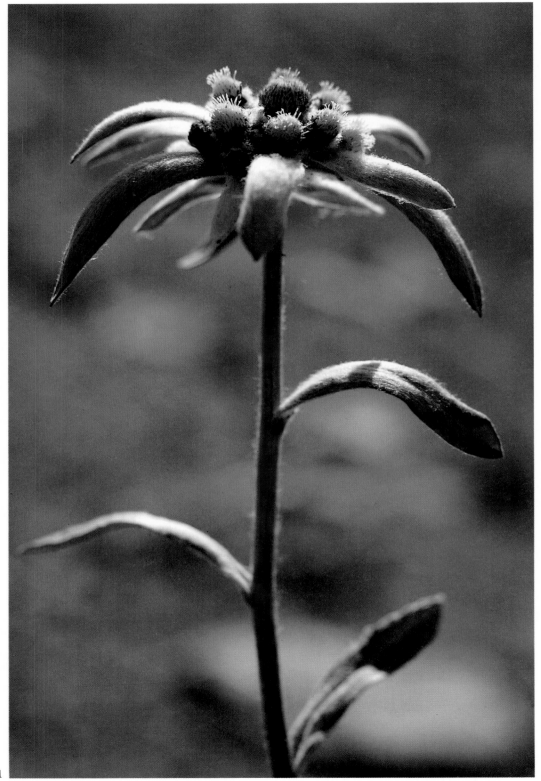

41 HIMALAYAN EDELWEISS
Leontopodium himalayanum DC.
Compositae

Quite common on slopes from Kashmir to
Tibet at 3,000-4,500 m, among dreary wastes
without a tree or shrub but with furze bushes,
this woolly plant is closely allied to the
European Edelweiss, but seems a little
different. The root-stock is covered with old
leaf bases. The woolly leaves are linear, and
2-3 cm long; the basal ones form a rosette
around the terminal heads. The flowers, which
bloom from July-October, are 5 cm across, in
whitish bunches, turning brown; each head is
6 mm across, with purplish involucral bracts.
The fruits are achenial, pappilose if fertile,
smooth if sterile.

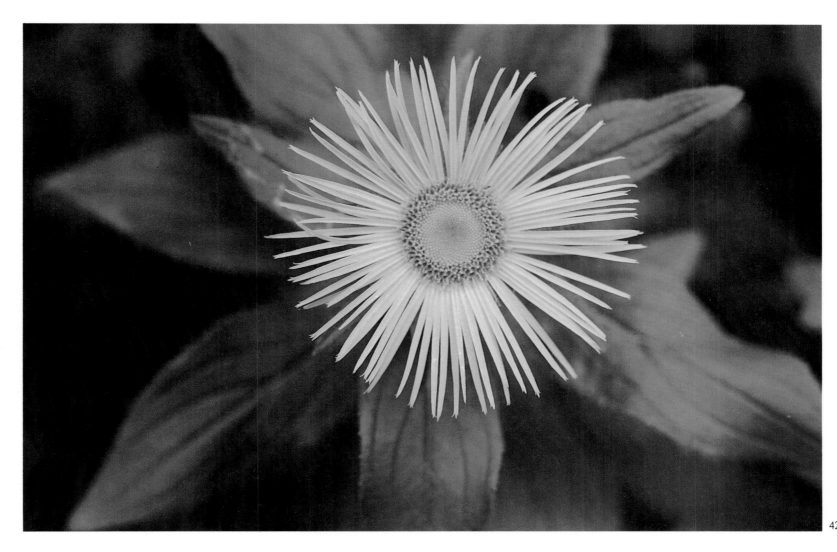

42 LARGE-FLOWERED INULA

Inula grandiflora Willd.
Compositae

Commonly seen in the undergrowth in light forests in Kashmir and Himachal Pradesh at 2,000-3,000 m, this annual herb comes up soon after the snows thaw. Unbranched and leafy, it is 30-45 cm tall. The leaves are oblong-lanceolate, 5-7.5 cm long, broader at the base with oblique nerves, and with bristly hair on the margin. The flowers, which bloom from July-September, are on terminal, solitary heads with golden yellow rays and florets; the rays are many, narrow, about 2 cm long, with a trident-like tip. The fruits are nearly glabrous achenes.

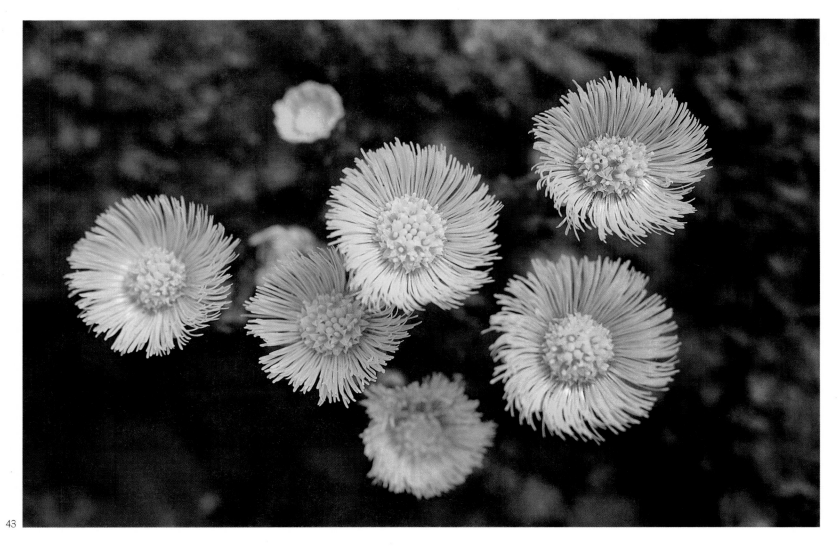

43

43 COMMON COLTSFOOT

Tussilago farfara Linn.
Compositae

Valued as a cure for cough (tussis = cough), the name Coltsfoot comes from the peculiar shape of its leaves. The plant looks different in different seasons. Its flower is one of the harbingers of spring, appearing soon after the snows thaw in the western Himalayas, from Kashmir to Kumaon at 2,000 to 3,500 m. The leaves and roots are used in treating pulmonary ailments.

A white, woolly, scapigerous herb, its leaves, which arise from the fat corm, are curiously angular in form, with a sharp-pointed margin separated by concave curves; they are long-stalked, the blade is 8-25 cm broad, cobwebby above, and white tomentose on the underside. From March-September, a 10-25 cm long tomentose, scaly scape bears bright yellow heads of flowers; the buds are drooping. The flowers disappear before leaves are developed. The fruits are achenial, linear, 5-10 ribbed, with slender, rough-haired pappus. Some achenes have scanty pappus.

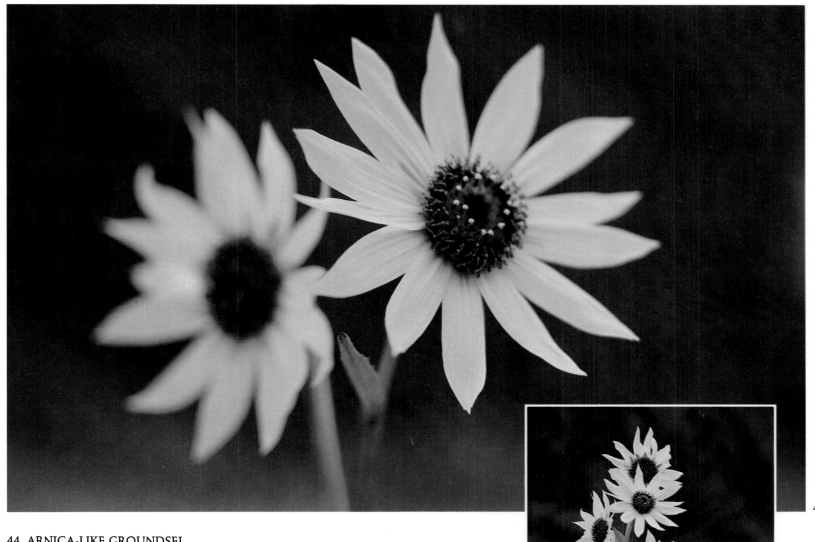

44

44 ARNICA-LIKE GROUNDSEL

Cremanthodium arnicoides (DC. ex Royle) R.
Good
Compositae

Seen on open hill slopes from Kashmir to Tibet
at 3,300-4,800 m, this is a stout, annual herb,
glabrous or sparingly cottony on the upper
surface, erect, up to 60 cm tall. The leaves are
ovate or elliptical, up to 30 cm long, coarsely
toothed, and progressively smaller on the stem
towards the tip. The flower heads, which
bloom from July-September, are held on a
terminal spike-like cluster of several heads;
each head is about 5 cm across with 15-20
golden yellow ray florets up to 1.5 cm long.
The fruits are achenial, elongate, 5-6 mm long,
shorter than the white pappus.

44a Picture shows the terminal cluster of
heads of the arnica-like groundsel arising from
the axils of bracts with downy pubescence.

44a

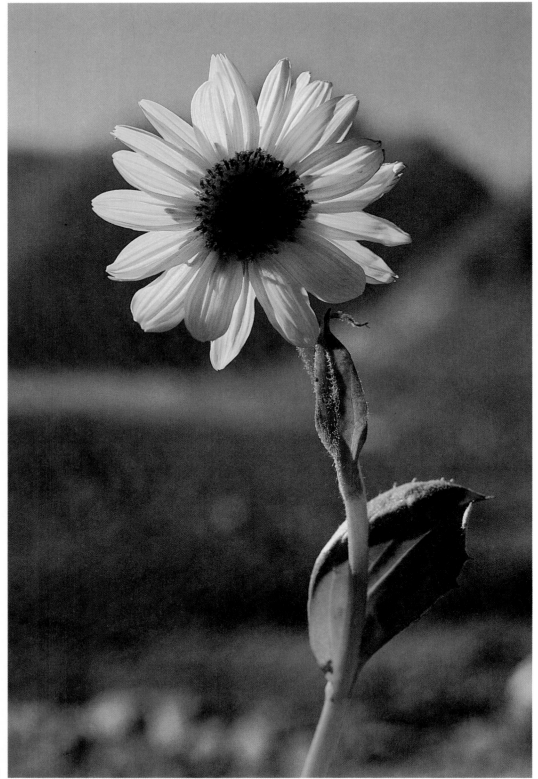

45 ELLIS'S GROUNDSEL

Cremanthodium plantagineum Maxim
forma *ellisi* (Hk.f.) — R.Good

= *Cremanthodium ellisii* (Hk.f.) Kitamura
= *Werneria ellisii* Hk.f.
Compositae

Seen on screes and open slopes from Ladakh to
Tibet at 3,600 to 4,800 m, this is a stout,
perennial, erect herb, about 30 cm tall, glabrous
or sparingly cottony. The leaves are not purple;
the basal ones are oblong, ovate or elliptic with
a winged petiole, 3-12 cm long, obtuse, with a
toothed margin; the upper leaves are stalkless,
with a sheathing base; the upper surface has a
cottony tomentum. The flower heads which
bloom from July-September are solitary,
nodding, about 4-7 cm across, on a 30 cm tall
scape, with bracts, and 2-5 cm long golden
yellow rays with dark disc florets; the
involucre has dark woolly hair. The fruits are
achenial, with a longer white pappus.

45

46 SHEATHING GROUNDSEL

Ligularia ampexicaulis DC.
Compositae

Found on clearings in light forests, at
3,000-4,300 m from Kashmir to Bhutan, this is
a stout perennial herb. The upper leaves have
very well-developed, broad, boat shaped
sheaths; the basal ones are broadly
ovate-cordate, 15-29 cm across, with winged
leaf-stalks. In bloom from July-September, the
flowers appear in a flat-topped cluster of many
flower heads held on a short peduncle, each
head about 4 cm across; the golden-yellow
rays are about 2 cm long. The fruits are
achenial, with rufous pappus.

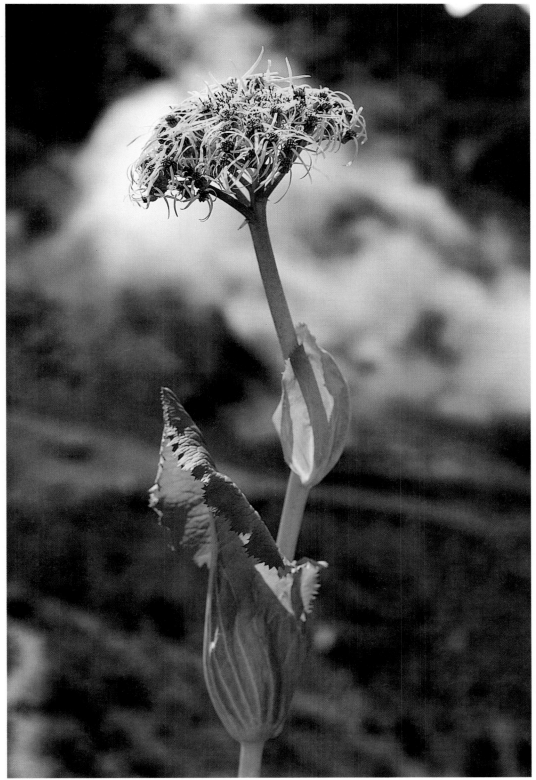

46

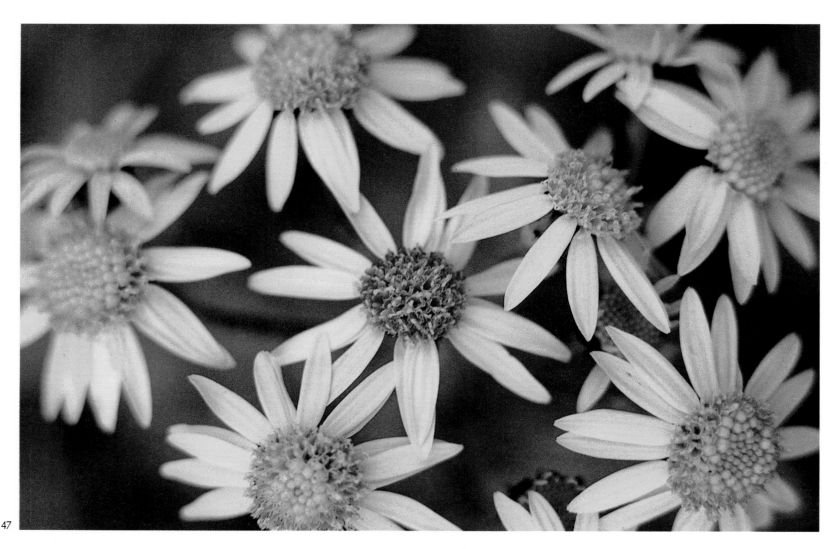

47

47 CHRYSANTHEMUM-LIKE GROUNDSEL

Senecio chrysanthemoides DC.
Compositae

A commonly-seen plant on hill slopes, in the
open, at 2,300-4,000 m from Kashmir to Tibet,
this is a tall perennial herb, up to 2 m tall,
branching above. The leaves are pinnately
incised, with a large terminal lobe, several
lateral lobes, and a toothed margin. The flower
heads, seen in August and September,are held
at the top of the plant in flat-topped yellow
clusters, with many ray florets surrounding a
central yellow disc of florets. The fruits are
achenial, ribbed, and with pappus of rough
hairs.

48 'HEEM KAMAL', COTTONY SAUSSUREA

Saussurea gossypiphora D.Don
Compositae

In 1921, on a British Everest expedition, A.F.R. Wallaston observed that the cone-like flower head of this herb has an aperture at the top, through which the bumble bee visits and presumably pollinates this flower. Seen on screes in the alpine Himalayas from Kashmir to Tibet at 4,000-5,000 m, this is one of the most amazing of Himalayan plants. It is a strange-looking perennial herb with a short, hollow stem, 10-20 cm long, covered by rough, cottony or woolly grey indumentum, and a spongy, fusiform root. The leaves are narrow, 12-15 cm long, pinnatisect, sharply-toothed, like the thistle leaf; the bases are shiny and black. Many almost cylindric 1-2 cm long flower heads bloom from July-September, and are deeply embedded in a matted woolly covering; the involucral bracts are also woolly, covering purple florets — the cotton wool covering is an additional insulation against extreme cold. The fruit is achenial, about 7 mm long, 4-5 angled, and compressed, with a scanty scabrid pappus.

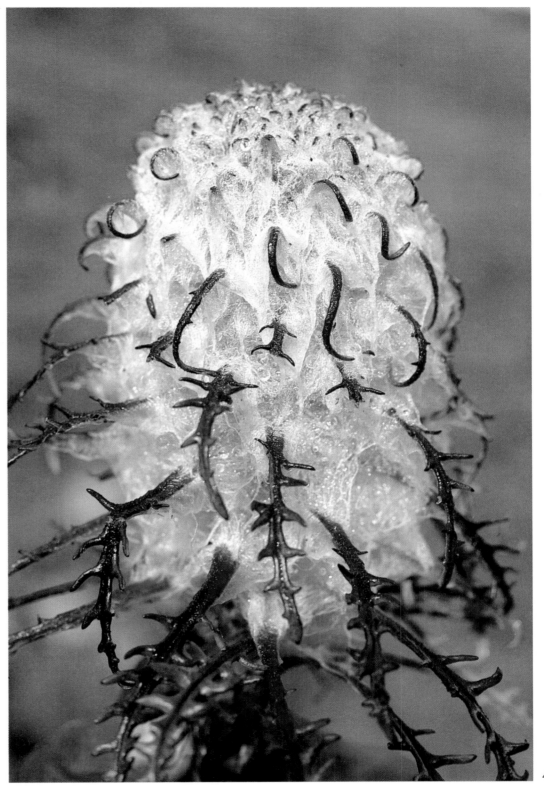

48

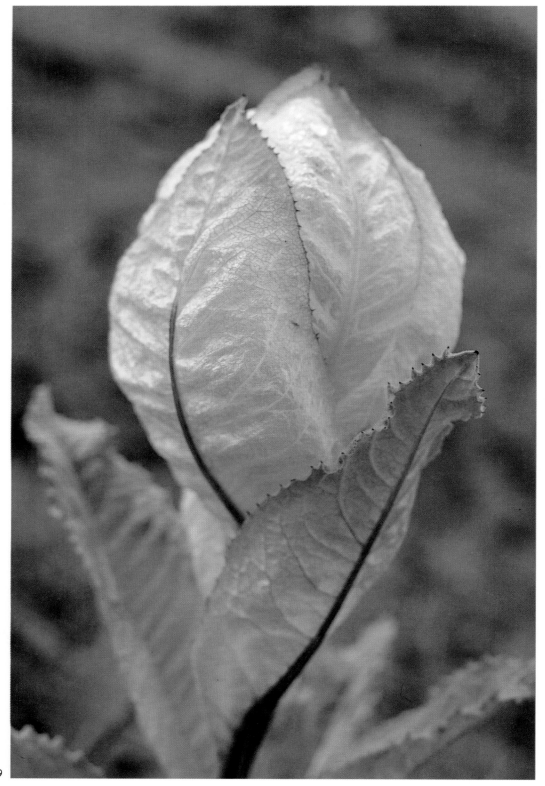

49 'BRAHMA KAMAL'
Saussurea obvallata (DC.) Edew.
Compositae

The lotus-like inflorescence of this unique plant is offered to Lord Shiva at the Kedarnath shrine. Its heady fragrance is said to cause palpitation, giddiness and vomiting. Found from Kashmir to central Nepal and more commonly in Garhwal at 3,600-4,500 m, this perennating herb grows 70 to 80 cm tall with its inflorescence formed of a large, greenish yellow, inflated, bladdery covering, 8-15 cm in diameter. The root-stock is very thick, and covered with the remains of leaf bases. The purple flower heads, seen from July-September, form a compact structure, each head 1-2 cm long, with involucral bracts with black margins and tips. The fruits are achenial, obvoid, flattened, ribbed, with brown pappus.

49a Picture shows the terrain on which the 'Brahma Kamal' grows — along streams and on open screes. The red-flowered knotweed, a plant of damp situations, is often an associate.

49

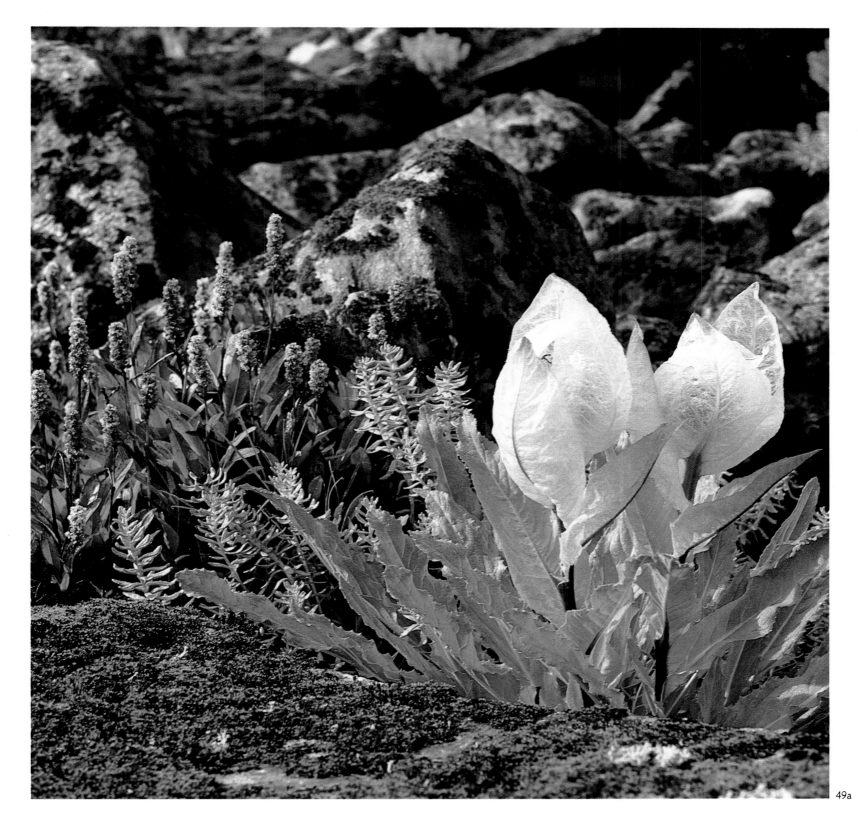

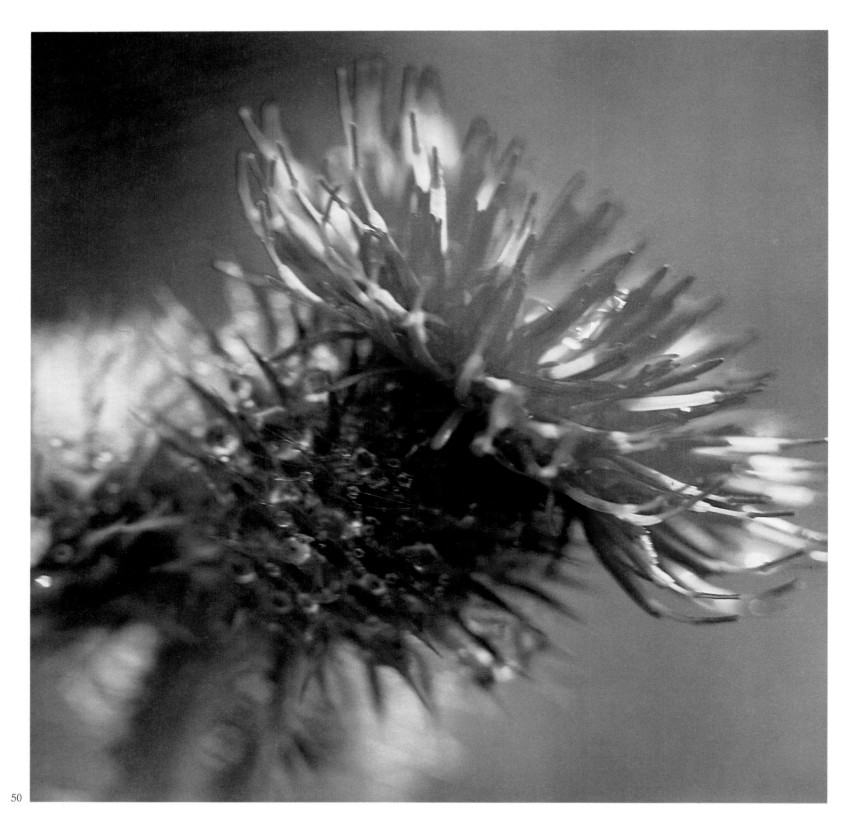

50

50 HIMALAYAN THISTLE

Carduus edelbergii Rech. f. ssp. *lanatus* Kazmi
= *C. nutans* Linn. var. *lucidus* DC.
Compositae

Carduus in Greek means to pierce or wound, and is used here to describe the prickly character of this herb. Commonly seen from Pakistan to Tibet at 1,400 m to 4,000 m near habitations or disturbed open places, it is a tall, stout spiny thistle, 30-90 cm tall, with a grooved and winged stem, and is used medicinally. The leaves are variable, alternate, 15-30 cm long, pinnatifid, with a spiny margin. The usually solitary pink flower heads are about 3-4 cm across, with erect or recurved involucral bracts, and bloom from June-August. The achenial fruits are pale brown and glabrous.

51 CHICORY, SUCCORY, BLUE SAILORS

Cichorium intybus Linn.
Compositae

"Succoury to match the sky"
— Ralph Waldo Emerson in *Humble Bee*

Virgil, caught in a prosaic, practical mood, wrote of its weedy character: "And spreading succ'ry chokes the rising field."

Introduced from the Middle East, probably for its use in medicine, and known by its Arabic name, 'Indiba' or 'Hindba', this herb is locally called 'kasnee'. Hamilton called it *Cichorium casnia*. It has run wild as a weed in Punjab and is extensively cultivated in many parts of India for its roots (chicory) used in blending coffee. The seeds are considered medicinal.

A perennial, erect, glabrous or hispid herb, 30-40 cm tall, it has an angled or grooved stem, with rigid, spreading branches; the tap root is fleshy and over 90 cm long. The leaves are oblong and lanceolate. The basal leaves are incised; the upper are cordate, sheathing, bract-like. The bright blue flower heads are solitary and terminal or axillary, and arranged along leafless spreading branches, appearing from July-September. The fruits are achenial, angled, pale and mottled.

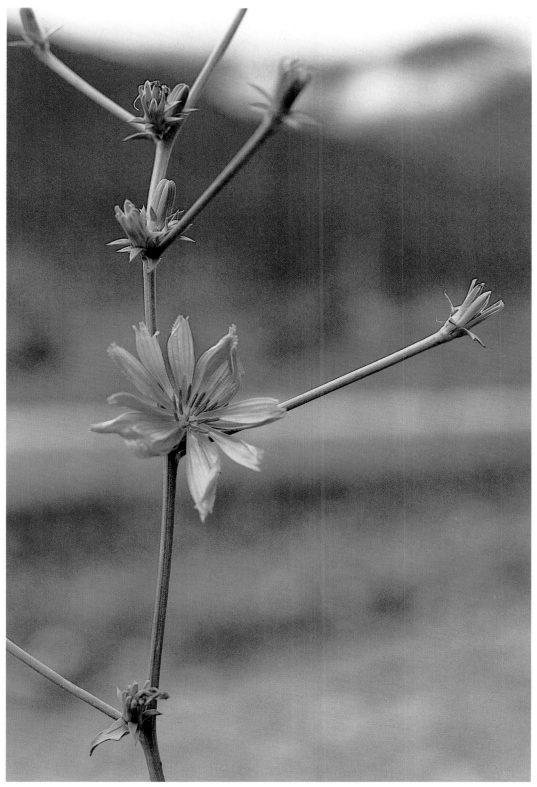

51

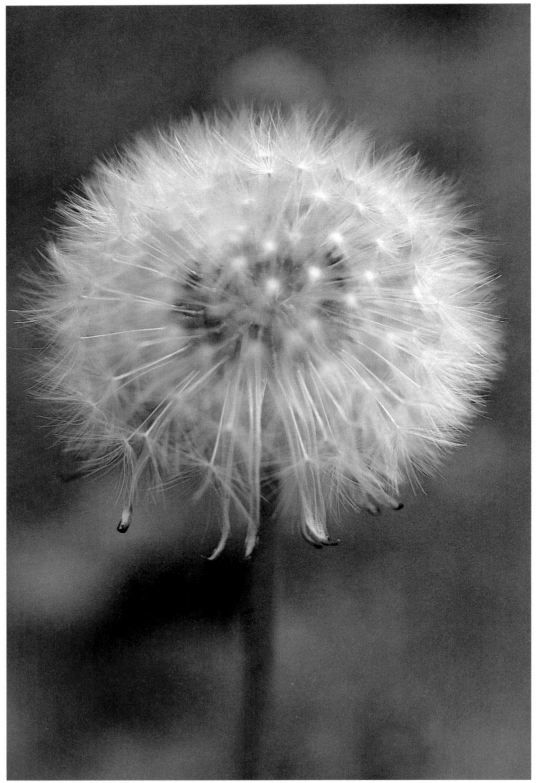

52 COMMON DANDELION

Taraxacum officinale Wigg.
Compositae

Dandelion = dent-a lion. The name comes either because of the whiteness of the root, or the auriferous hue of the flowers resembling the golden tooth of the heraldic lion, or from the jagged leaf somewhat like a lion's tooth.

The dandelion is the sunflower of spring; never-say die is its motto.

"Dandelion with a globe of down
School boys clock in every town
Which the truant puffs amen
To conjure lost hours again"
— William Howitt

"Dear common flower that grow'st beside the way
Fringing the dusty road with harmless gold"
— M. Woodward

Seen throughout the western and central Himalayas at 500 to 5,500 m, on cultivated soil, meadow and waste land , this is a scapigerous, milky herb, up to 50-60 cm tall, highly variable in habit leaf size and indumentum. It has a straight root, and is considered useful in medical practice. The leaves are linear pinnatifid or runcinate with acute lobes, and are more or less denticulate. The flowers, which bloom in June and July, are solitary, ligulate, yellowish heads; the involucral bracts are linear, often thickened or clawed at the tip; the outer ones are ovate. The fruits are achenial, obvoid, with muricate ribs, and constricted abruptly in a beak bearing silky white pappus.

52

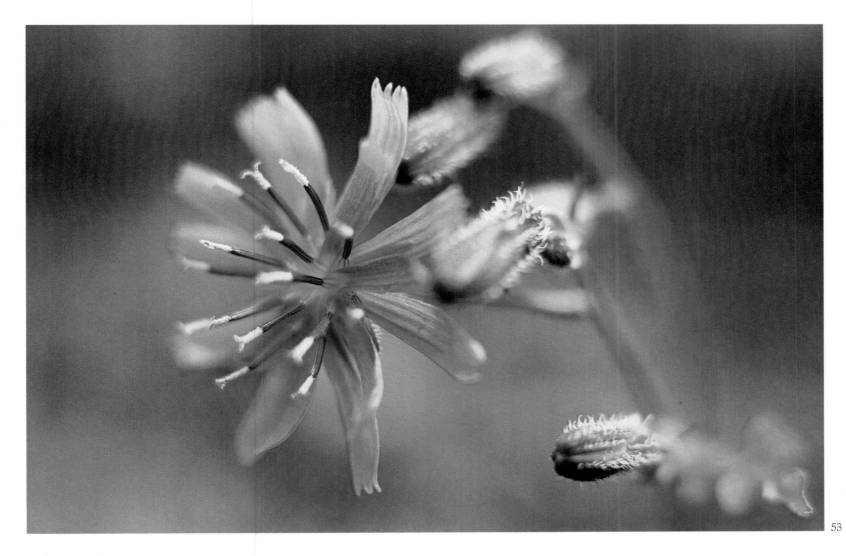

53 SOW THISTLE

Cicerbita macrorhiza (Royle) Beauv.
= *Lactuca macrorhiza* (Royle) Hk. f.
Compositae

Found in rocky places and on steep slopes from Pakistan to Tibet at 2,000-4,000 m, this is a perennial, tuberous rooted, milky herb, with soft, tufted, much-branched stems, and grows up to 60 cm tall. The leaves are variable, membranous, linear or elongate obvate, and pinnatifid; the upper ones are entire or toothed and with numerous lobes. The 1-2 cm long flower heads appear from July-September at the end of the branches, drooping or inclined; the rays are strap- shaped and finely toothed at the apex. The disc florets are mauve to bluish and the involucral bracts bristly haired. The fruits are 4-6 mm long achenes, flat, elliptic, lanceolate, smooth, narrowing into a white beak; the pappus is as long as the achene.

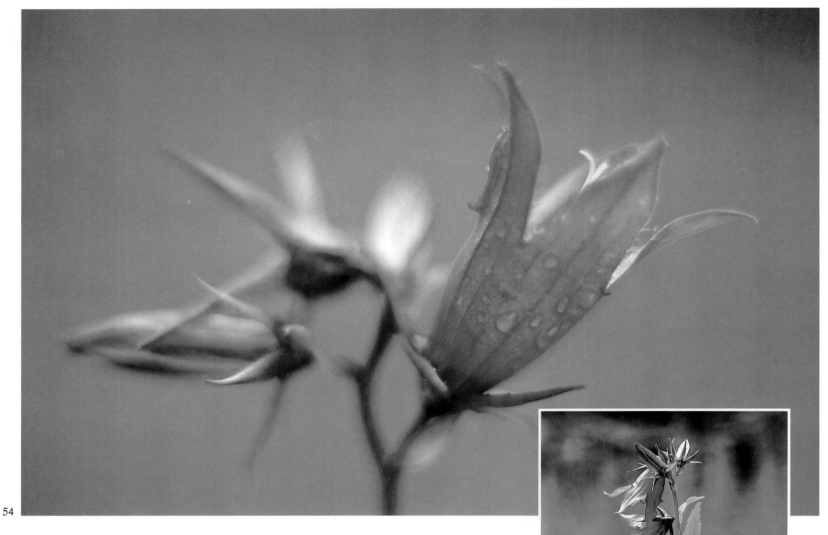

54

54 LARGE BELL FLOWER

Campanula latifolia Linn.
Campanulaceae

Seen on slopes in light forests from Kashmir to Kumaon at 2,000- 3,000 m, this is a pretty, erect, perennial herb, up to 1.5 m tall, with ascending branches. The upper leaves are 7 × 3.5 cm, ovate or lanceolate, rounded at the base, creante-serrate, and pubescent; the lower are broader and bigger. In bloom in July and August, the nodding, bell-shaped, dark blue to purple flowers are 4 cm or more across, arising from axils almost in a line of 7-10 flowers at the ends of branches. The fruits are globose capsules, 3-5 celled, opening by apical or basal pores, on a recurved short stalk, glabrous and with many seeds.

54a The picture shows almost the full plant; it is generally found associated with gentiana, rose, violet and *Gallium* species.

54a

55 ROUNDLEAF ASIABELL
Codonopsis rotundifolia Benth.
Campanulaceae

This plant makes its home in light forests and meadows in moist places among rocks from Kashmir to Nepal at 1,800-3,500 m. It is a perennial herb that twines itself about the stalks of larger plants like Primulas and Bergenias. The leaves are very variable in size, usually about 5 cm long, alternate, ovate, with a rounded base and a crenate or toothed margin; they are glabrous or sparingly hairy. In bloom in July and August, the flowers are shaped like a Chinese lantern, on a thin stalk, coloured bluish-grey with a purple centre. The calyx teeth are prominently spread out. The fruits are hemispherical capsules with beaks and a persistent calyx.

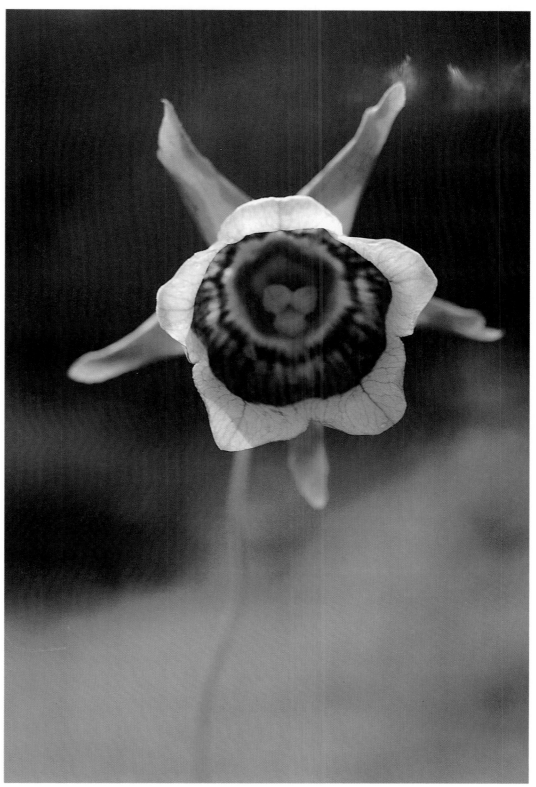

55

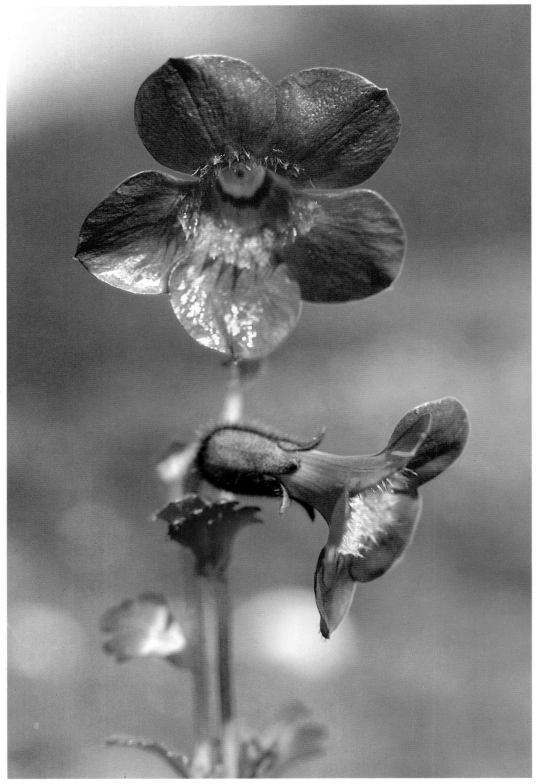

56 LOBED CYANANTHUS

Cyananthus lobatus Wall. ex Benth.
Campanulaceae

Found on stony hill slopes on drier ground from Himachal to Tibet at 3,500-4,500 m, this herb is seen with the yellow saxifrage. Perennating by its root-stock, it has a simple stem terminating in a flower. It is 10-40 cm tall, pubescent above, with a few, weak, rambling branches near the base. The leaves are ovate or wedge shaped, deeply lobed in 3-5 segments, each lobe 1-2.5 cm long. Each bright blue or purple, 3 cm long solitary flower, in bloom from July-September, is held on a stout, erect peduncle; the calyx is cup-shaped, covered with blackish hair; the corolla is tubular and funnel-shaped; the lobe ovate, spreading and hairy in the throat. The fruits are ovoid, nodding 1.2 cm capsules, with a 1-2 cm persistent calyx; the seeds are narrowly oblong and ellipsoid.

56

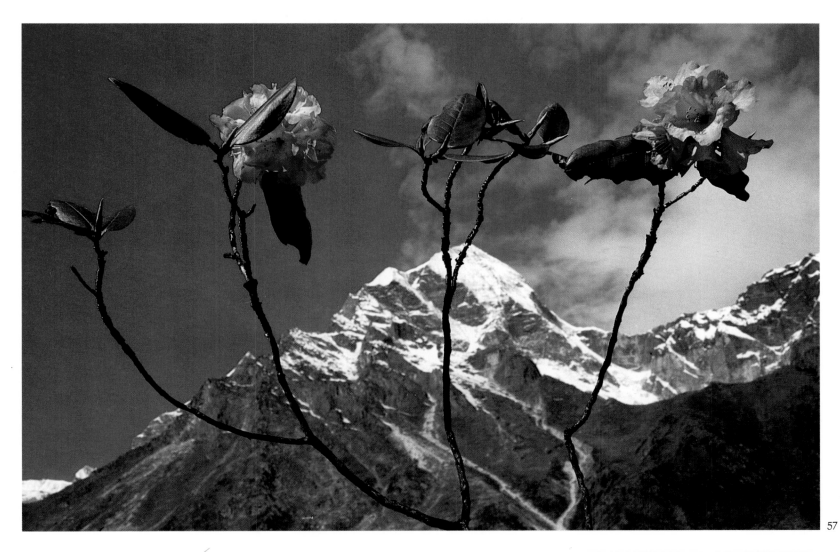

57 BELL RHODODENDRON ✓

Rhodendron campanulatum D.Don
Ericaceae

One of the most ornamental of its kind, this large shrub is seen from Kashmir to Tibet at 3,300-4,500 m in forests and alpine areas. Its leaves are poisonous to livestock and said to be used against rheumatism, and also mixed with tobacco and used as snuff against cold and hemicrania. A much-branched shrub, 2-5 m tall, it has shiny dark green oval leaves which are 8-15 cm long with round bases and brownish hairy undersurface. The flowers appear in clusters, from April-June, are mauve to purple, bell-shaped, about 4 cm across. The fruits are capsular with many seeds.

57a A close-up of a cluster of bell rhododendron showing the variations of colour.

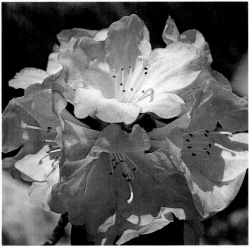

57a

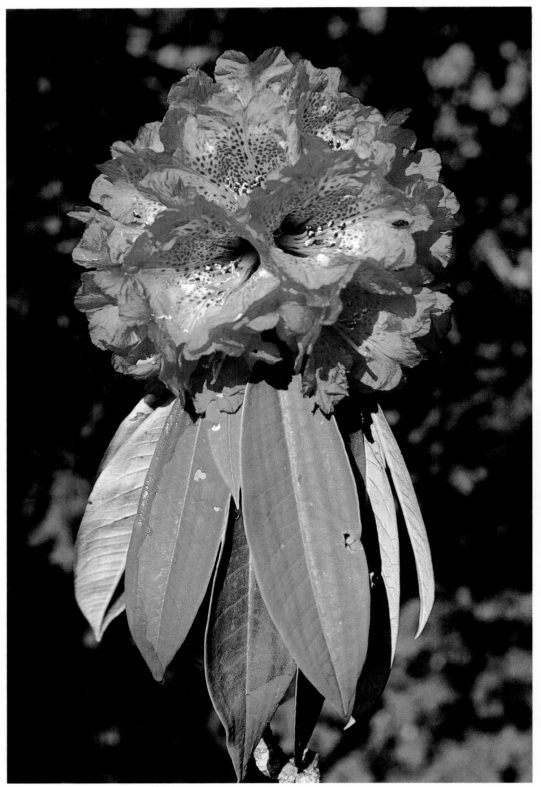

58 'LALI GURANS' OR TREE RHODODENDRON

Rhododendron arboreum Sm.
Ericaceae

F.Kingdon-Ward called it "a furnace of blood-red blossom". Sunbirds ravish the crimson flowers for nectar; Sibia birds pay court to the blossom in Burma. The flowers are eaten, or made into jelly and sherbet by the Himalayan people; they are also offered for worship in temples.

The most widely distributed Rhododendron tree in the Himalayas, it is also the earliest to flower, and is seen from Pakistan to Tibet and Burma at 1,500-3,600 m in forests. Normally reaching up to 8 m, some older trees are 12-15 m tall. The bark is buff coloured. The leaves are 10-20 cm long, lanceolate or oblong, narrowed at both ends, rugose or rusty tomentose, or silvery tomentum on the underside. The young leaves are considered toxic. Arranged in clusters of 15-20, the flowers, which bloom from February-May, range from near-white to pink to blood red; each flower is bell-shaped, 4-5 cm across, with five lobes showing prominent stamens. The fruits are capsules of about 3 cm, elongated, ribbed and 10-chambered, with brown seeds.

58a Picture shows the red-flowered 'Lali Gurans'.

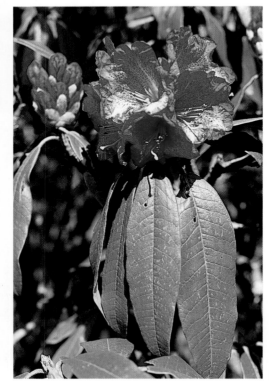

58

58a

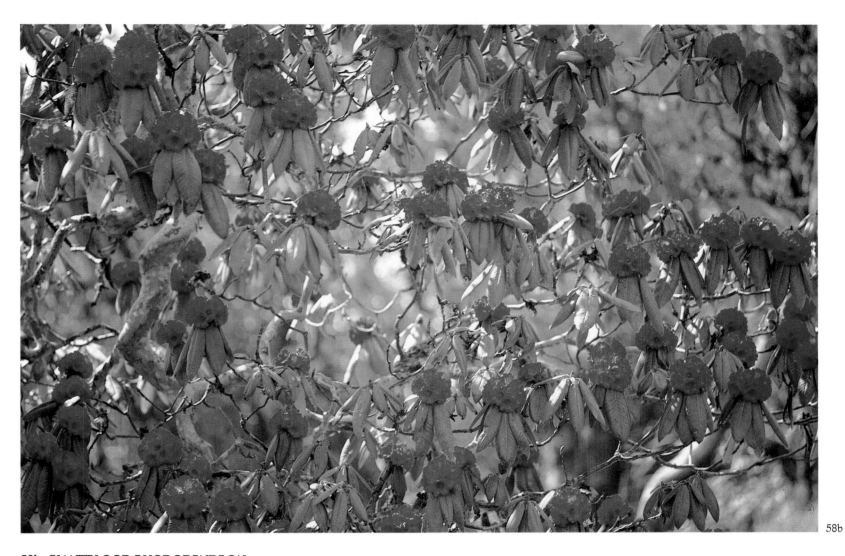

58b GIANTBLOOD RHODODENDRON
Rhododendron barbatum Wall. ex D. Don

Making a very pleasing picture, this shrub or small tree is seen at 2,500-3,500 m from Garhwal to Bhutan in forests along with *R. arboreum,* and is often more dominant. It grows up to 10 m, and has a plum-coloured flaky bark and bristly young shoots. In bloom from April-June, the flowers are bell shaped, blood red with black-crimson blotches at the base inside.

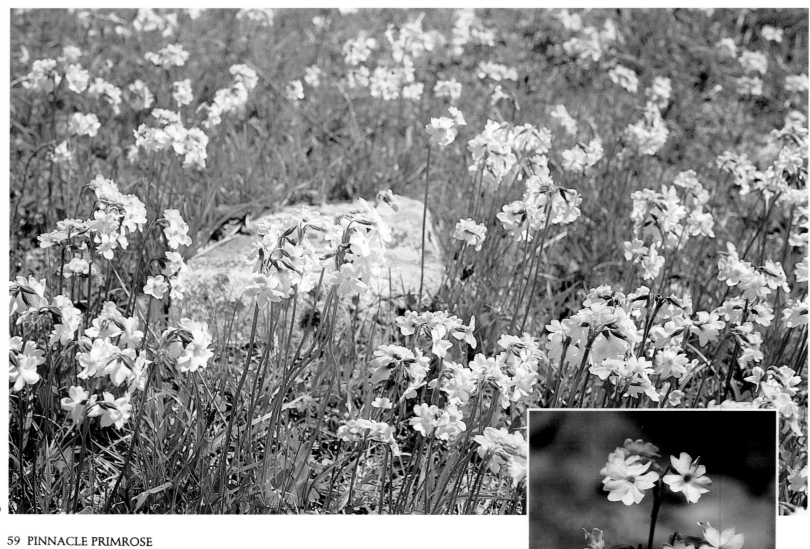

59

59 PINNACLE PRIMROSE

Primula munroi Lindley
 = *P. involucrata* Wall.
Primulaceae

Found on damp or marshy ground alongside streams, from Kashmir to Tibet at 3,000-4,500 m, this is a perennial, scapigerous herb, 10-30 cm tall, and is often gregarious. The leaves are 3-10 cm long, oblong, or ovate-cordate, or rounded; blunt or minutely toothed, with a 2-3 cm long smooth stalk. From June-August, a green or purple scape bears an umbel of 3-6 flowers, each 1-1.5 cm across, with a white corolla and a yellowish centre (eye), and purple tube; the petals are obcordate and ribbed; the lobes are emarginate. The fruits are oblong or cylindric capsules, shorter than the corolla; the seeds are large, tapering at both ends.

59a Picture shows a close-up of the white pinnacle primrose flowers with yellow eyes. Some flowers have a purplish tinge.

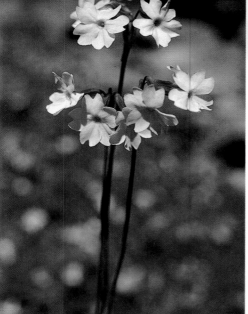

59a

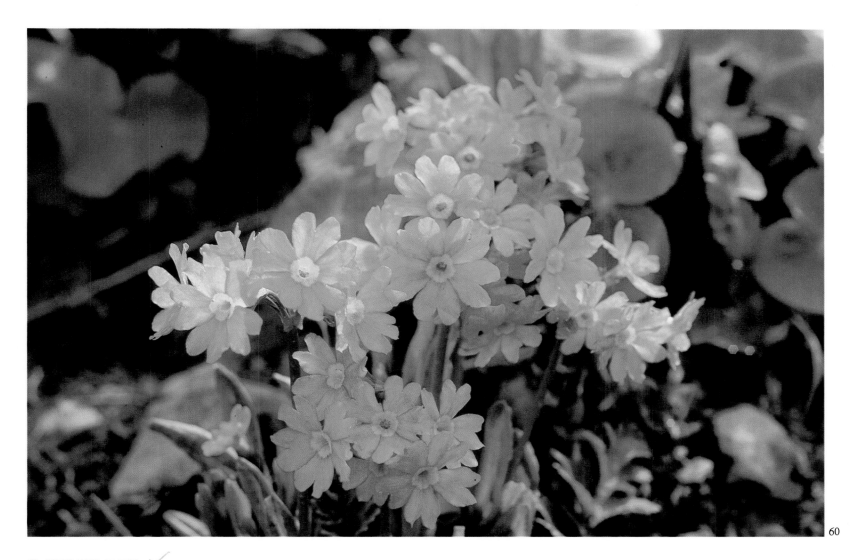

60

60 PINK PRIMROSE ✓

Primula rosea Royle
Primulaceae

Seen near melting snow and stream banks from Afghanistan, Kashmir to Himachal at 2,500-4,000 m, this is a distinctive perennial, often in large clumps. The leaves develop partially at flowering; they are numerous, ovate, virtually stalkless, tapering below into a winged leaf-stalk, arising in rosettes from an underground root-stock. The flowers, which bloom from June to August, are arranged in lax umbels of 5-6 or more pink to red flowers with distinctive yellow centres; the five petals are obcordate, and deeply notched. The fruits are globose capsules included in the hemispheric calyx.

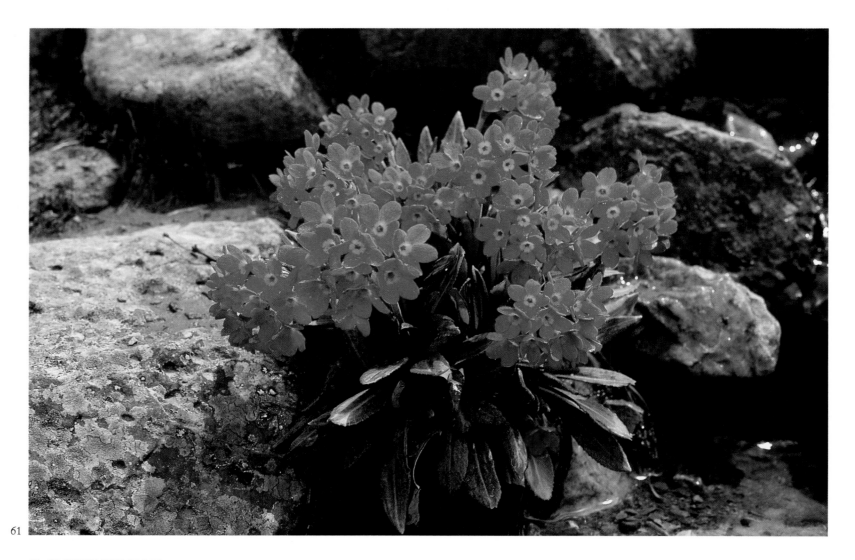

61

61 SMITH'S PRIMROSE

Primula atrodentata W.W. Smith
Primulaceae

Seen on alpine slopes from Kashmir to
south-east Tibet at 3,600-5,000 m, there seems
to be no justification for the name of this
pretty perennial 10 cm tall herb: atro-horrible,
dentata-toothed! The 1-4 cm long leaves are
spathulate, arranged in rosettes, with copious,
whitish or yellow farina on the underside. In
May and June, it carries fragrant
lavender-purplish-mauve flowers on a scape up
to 10 cm tall in dense rounded heads about
2 cm across with 20-25 flowers. Each flower
carries a distinctive white 'eye' with blackish
calyx lobes.

62 STUART'S PRIMROSE

Primula stuartii Wall.
Primulaceae

Locally known as 'Jowai' in Garhwal (Harkidun), this 20-40 cm tall perennial herb is seen on river beds and hill slopes at 3,000-4,500 m from Himachal to Tibet; it is often gregarious. The leaves are arranged in rosettes of 10-12, arising from an underground root-stock; they are lanceolate, tapering below on a short stalk, with yellowish farina on the lower surface. The fragrant flowers, which bloom in June and July, are conspicuous, bright yellow, arranged in an umbel 7-8 cm across of about 10-15 flowers. The petals are more or less rounded, occasionally with sharp teeth. The oblong and capsular fruits are 2-3 cm long, 5-valved with many subangular seeds.

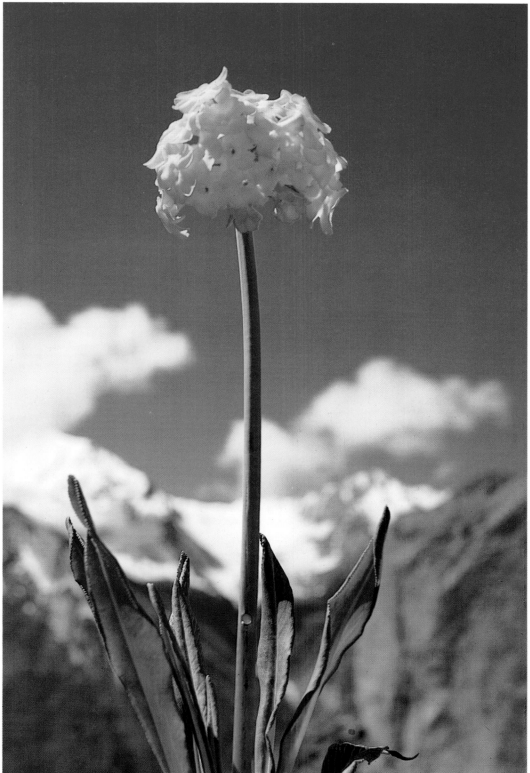

62

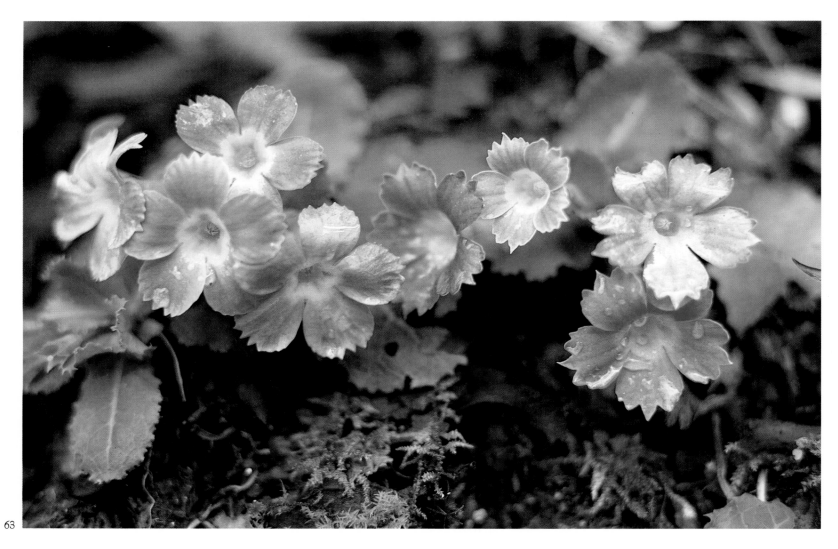

63

63 STALKLESS PRIMROSE

Primula sessilis Royle ex Craib.
Primulaceae

Common in forests at 2,500-3,500 m from
Garhwal to Sikkim, this is a variable, low
perennial herb without any villous
indumentum. The leaves are variable, in a
rosette formation at the time of flowering;
later they elongate to become ovate to
spathulate, 6 cm long or more, and are almost
stalkless. The flowers, which are on short
stalks, and not on a scape like the flowers of
other *Primula* species, bloom in April and May;
the petals are pink, and the yellow centre has a
thin white border; the outer margin is
unequally denticute. The fruit is a globose
capsule sunk in a broad calyx tube; the seeds
are large, sub-globose, black and papillose.

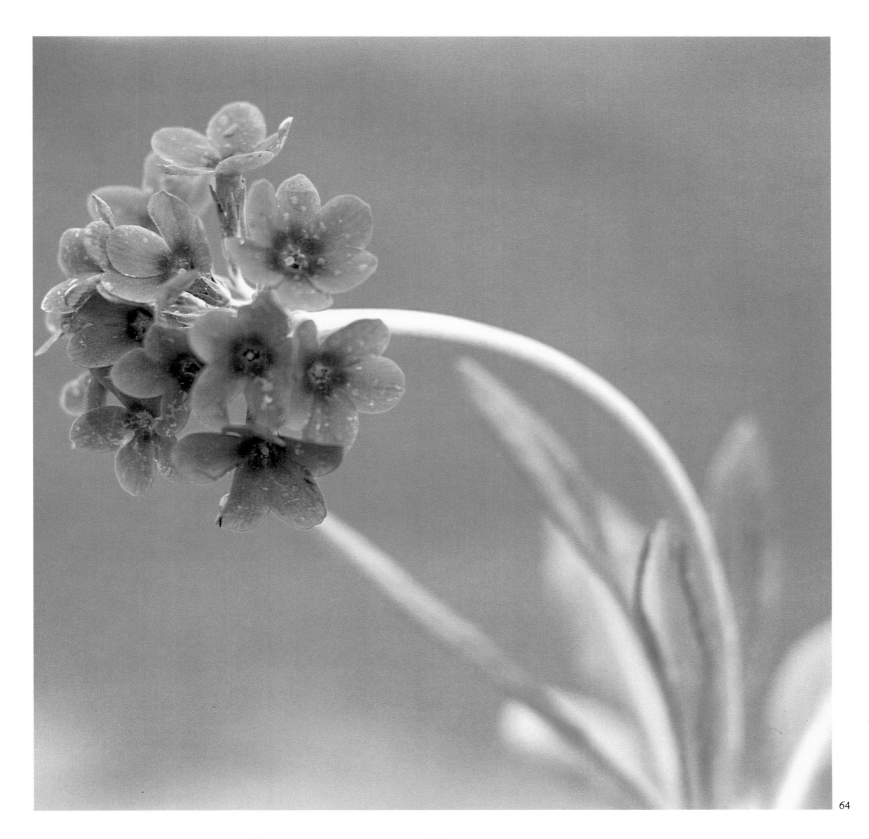

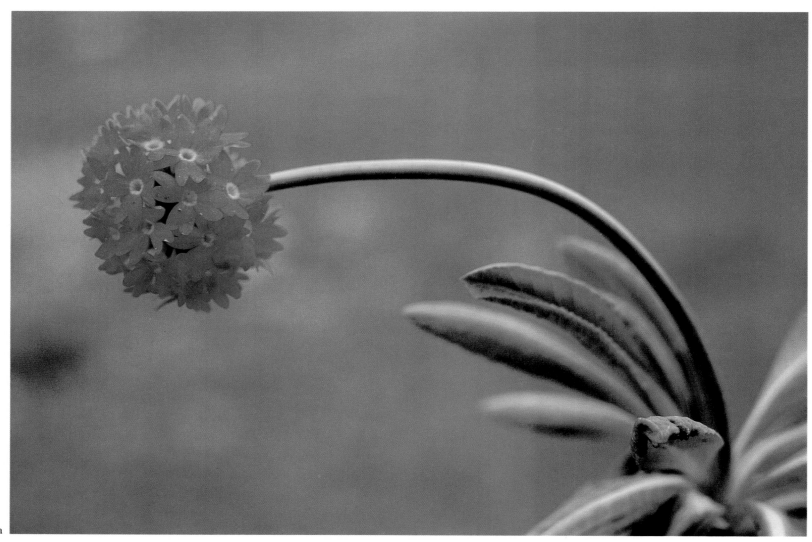

64a

Previous page

64 LARGE-LEAVED PRIMULA ✓

Primula nivalis var. *macrophylla* (D.Don) Pax
= *P. macrophylla* D.Don
Primulaceae

"Pale primroses that die unnamed, ere they can behold
Bright Phoebus in his strength
A malady most incident to maids."
— Shakespeare in *A Winter's Tale*

Found in damp areas at 3,300-4,800 m from Afghanistan to south-east Tibet, this is an often common and gregarious stout perennial herb with a short root-stock. This is undoubtedly one of the most polymorphic species of *Primula*; it is a very attractive and comparatively large species in this genus. Arranged in a basal rosette, the 3.2-4.4 cm long leaves are lanceolate to elliptic lanceolate, normally with white farina on the underside. The apex is acute, the margin entire to crenulate or denticulate. The flowers, which bloom from June to August, are held in a bunch on a scape up to 32 cm long, each cluster formed of 8-60 highly heteromorphic flowers varying in colour from purple, pink-purple, violet to lilac, with white to dark purple centres. The corolla tube is larger than the calyx, the limb bi-lobed. The fruits are 12-17 mm long, broadly cylindric; the seeds are 0.1 mm long, angular and pappilose.

64a A variable herb, different forms have the appearance of distinct species. Specialists studying this genus have expressed much difference of opinion about the best way to treat *Primula macrophylla/moorcroftiana* aggregate as there are intermediates causing some to unite the two. The purple-coloured form is often named *P.moorcroftiana* Wall.

65 STALKED SWERTIA

Swertia petiolata D. Don
Gentianaceae

Found on hill slopes and in woods, at
2,500-4,000 m from Kashmir to Tibet, this
plant is common in Kashmir, associated with
Primula stuartii, P. rosea, etc., near water
courses. An erect, perennial herb, 30-90 cm tall
with a hollow stem, usually unbranched. The
6 × 3 cm basal leaves are lanceolate, on long,
5-7 cm stalks with the base encircling the stem,
and are 5-nerved. The upper ones are narrow,
lanceolate, stalkless and acute. The flowers,
which bloom in July and August, are in whorls
of 3-5 on a peduncle, greyish white with
blue-green nerves on the petals, and with
rounded and fringed glands. The fruits are
10 × 5 mm capsules with polyhedral seeds
(not winged).

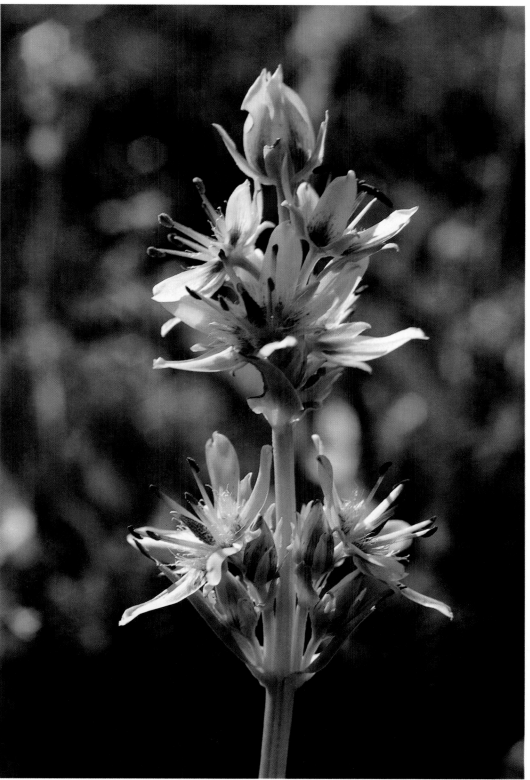

65

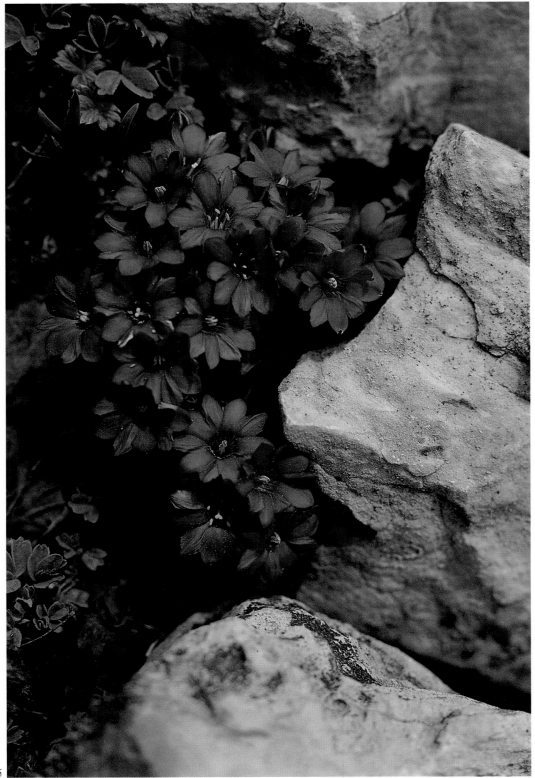

66 KASHMIR GENTIAN
Gentiana carinata Griseb.
Gentianaceae

"Blue as if that sky let fall
A flower from its coerulean wall"
— W.C. Bryant in *'To a Fringed Gentian'*

Common on hill slopes in Kashmir and in UP at 2,500-4,000 m, this is a 5-15 cm tall annual herb in compact clusters with erect branches bearing flowers. The leaves are simple and opposite; the lower ones are 2-3 cm long, oblong to lanceolate, sessile and persistent; the upper ones are smaller and curving outwards. The flowers, which bloom from May-August, are less than 1.5 cm across, tubular and dark blue, the 5 petals are bi-lobed, obcordate, and on a short darker tube, with scales at the mouth, and yellow anthers. The fruits are 0.5-2 cm long stalked capsules, ellipsoid, compressed, with subtrigonous, smooth seeds (not winged).

66

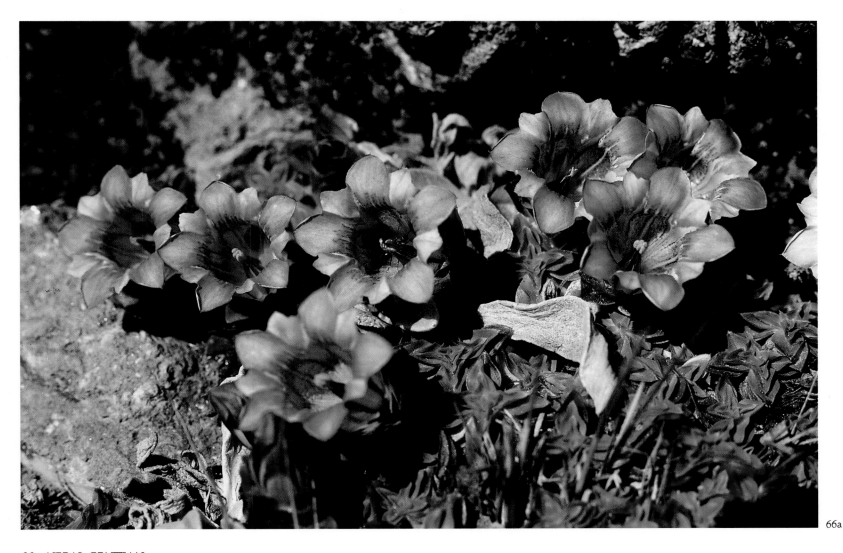

66a

66a NEPAL GENTIAN

Gentiana venusta (G.Don) Griseb.

This look-alike of the fringed gentian of the USA is seen amongst boulders on hilly slopes at 4,000-4,500 m in Nepal and Sikkim. A tufted perennial, its pale blue to whitish solitary flowers with darker centres appear on short branches from September-November; 5 petals join to form a bell or funnel with 10 rounded lobes.

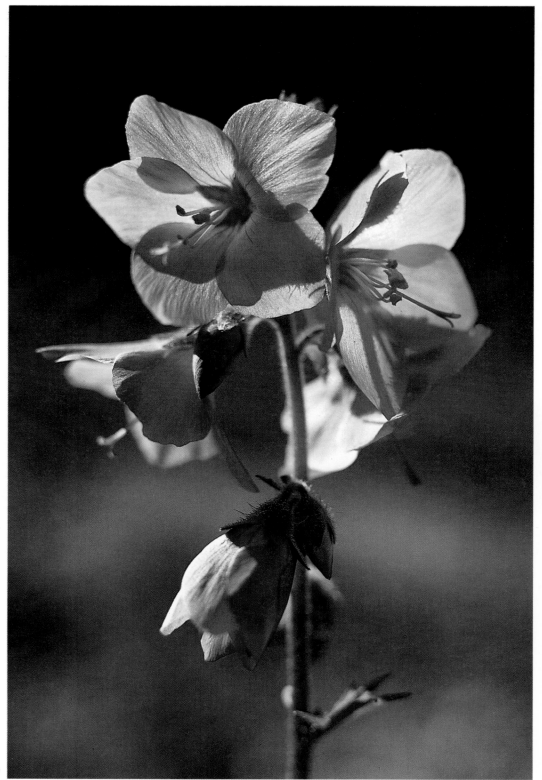

67 BLUE HIMALAYAN POLEMONIUM

Polemonium coeruleum Linn.
ssp. *himalayanum* (Baker) Hara
Polemoniaceae

A member of the Phlox family which is predominant in the temperate regions of the American continent, this is a perennial herb found in forests and open slopes in damp places at 2,500-3,700 m from Pakistan to Nepal. It has an erect, leafy, hairy and viscous stem, up to 1 m tall. The 3×1.3 cm long leaves are pinnate, with opposite ovate-lanceolate leaflets. The pale blue flowers blooming from June to September are arranged in terminal clusters of 5-6; the calyx is bell-shaped, with hairy, triangular lobes, the corolla with a short tube with 5 spreading lobes. The fruits are 3-valved capsules.

67a Picture shows a darker shade of the blue Himalayan polemonium

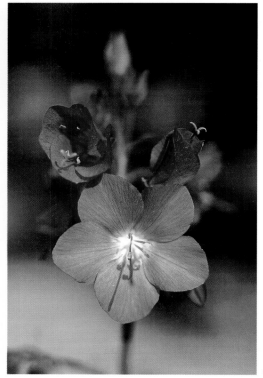

67

67a

68

68a

68 'GAO ZABAN'
OXTONGUE/BENTHAM'S ARNEBIA

Arnebia benthamii (Wall. ex G.Don) Johnston
= *Macrotomia bethamii* (Wall.) A.DC.
Boraginaceae

'Gao zaban' leaves and flowers are used in cordials and cooling drinks, and also used medicinally in the Unani system of medicine. In Europe, Borage, similar to 'Gao zaban', is among the most esteemed of 'cordial flowers', like the rose, violet and alkanet. Corago means 'I give courage', Borage in wine is a sovereign drink for 'melancholy passion'.
— J. F. Royle

Found on open dry hill slopes at 3,000-4,200 m from Pakistan to western Nepal, this is a strikingly hairy, perennial herb up to 1 m tall. The branches elongate when in fruit. The root-stock is stout and covered with old leaf bases. The 25 × 1.5 cm basal leaves are linear, and profusely hairy-bristly; the upper ones are much smaller, about 7 × 1 cm. The striking red-purple flowers in bloom from May to July, are in a dense spike, up to 30 cm long, showing themselves from the covering of leaves or densely linear hairy bracts. The fruits are 1 cm long nutlets, oblong, covered with small protuberances, on elongated spikes.

68a Picture shows the full plant.

69 SNOWY LINDELOFIA

Lindelofia longiflora (Benth.) Baill.
= *L. spectabilis* Lehm.
Boraginaceae

Seen on open slopes in the alpine western Himalayas at 3,000-3,600 m, and common in the Kashmir region, hardly any two examples agree in size and shape of corolla and calyx in their relative sizes. A variable, erect, perennial herb, it is 50-60 cm tall and covered with stiff hair. The basal leaves are 5-10 cm long, lanceolate and long-stalked; the upper are shorter stalked to stalkless, subcordate and embracing the stem. The intense blue flowers, which bloom from June-August, are in dense nodding clusters. The 0.5-1.5 cm fruits are ovate nutlets with marginal glochidia.

69a Picture shows a twig with leaves and flowers of the snowy lindelofia.

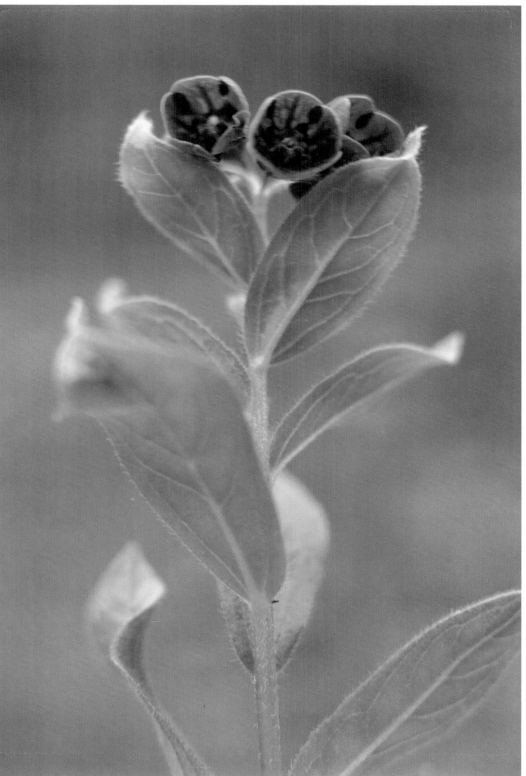

69a

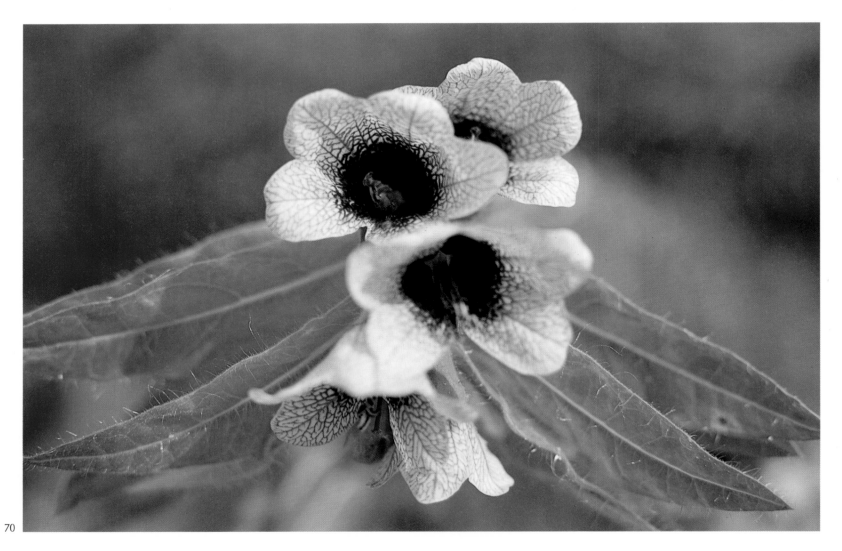

70 HENBANE

Hyocyamus niger **Linn.**
Solanaceae

The seeds of this plant are used medicinally, and the drug hyoscyamine is contained in the whole plant. The ancients associated it with death, and considered it to be an ill omen. They called it 'insane', believing that a person eating it became stupid. It is associated with witchcraft:

"And I ha'been plucking plant among Hemlock, Henbane, Adder's tongue."
— Ben Jonson

Found on waste land near cultivated areas, this herb is very widely distributed from Afghanistan to Tibet, temperate Eurasia, North Africa and America. An erect, coarse, pubescent, sticky annual, it has an unpleasant smell. The leaves are 15-39 cm long, linear lanceolate to elliptic, and sinuate; the lower ones are stalked, the upper stalkless and viscid. The flowers, blooming from May- September, are 2-3 cm across, cream coloured with a conspicuously purple centre and purplish veins; they are funnel shaped with triangular lobes, and held at the tip of the branch in a cluster. The fruits are globular capsules with a circumcised apex with many minutely pitted seeds.

71 FLANNEL MULMEIN

Verbascum thapsus Linn.
Scrophulariaceae

This plant is found from Afghanistan to Tibet at 1,600-4,900 m on hill slopes. Used in local medicine, it is considered useful in pulmonary ailments, and applied to parts of the body for relief from pain. It is a tall, erect woolly herb, generally non-branching, with a stout stem, and grows up to 1.5 m tall. The leaves are 15-45 cm long, alternate, oblanceolate, yellowish grey, tomentose, with an entire or crenate margin; the upper ones are smaller than the lower. The flowers, which bloom from May-September, are held in a slender, terminal, densely woolly, 15-25 cm long spike; with 5 spreading yellow lobes, they have 5 stamens, of which 3 are covered with white hair. The fruits are globose capsules, two-valved, with many rugose seeds.

71a Picture shows the flannel mulmein's natural habitat, on hill slopes.

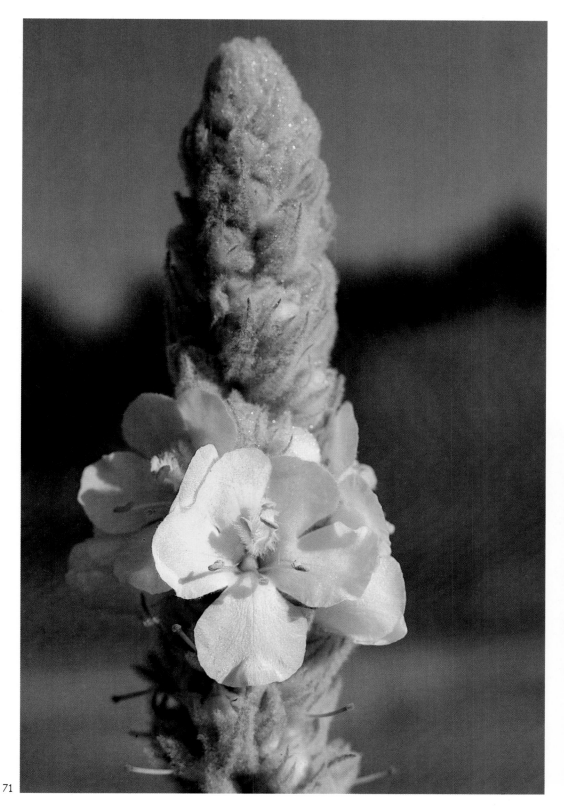

71

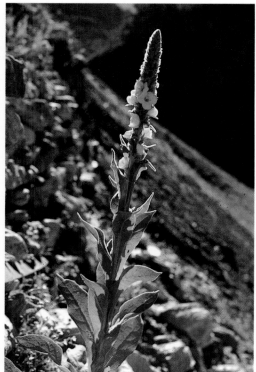

71a

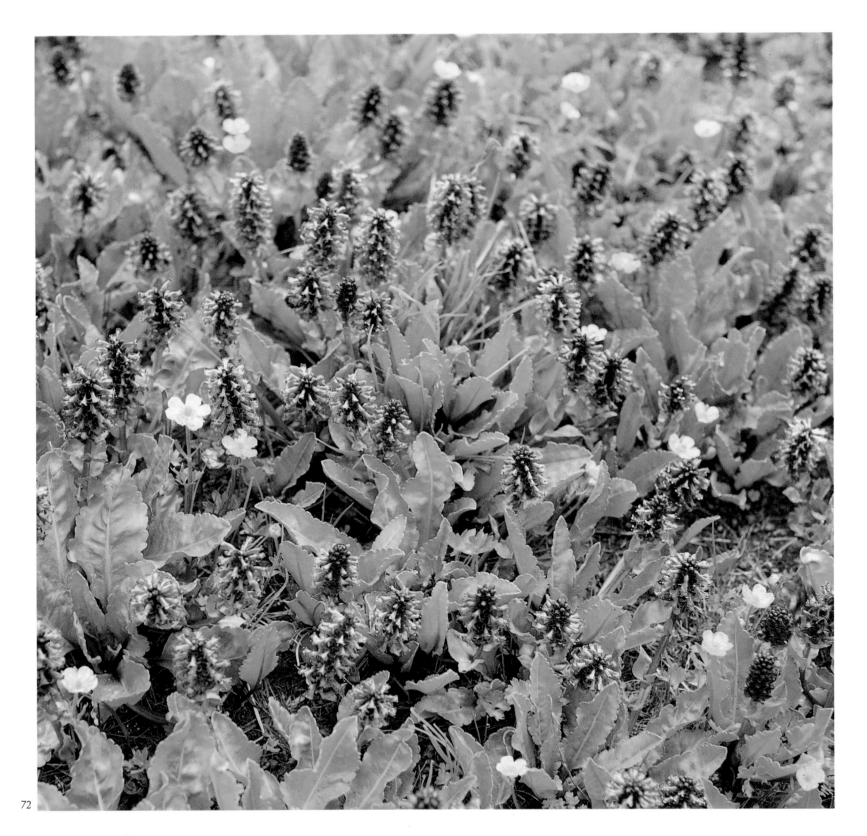

72 KASHMIR LAGOTIS

Lagotis cashmeriana (Royle) Rupr.
= *L. glauca* Gaertn.
Scrophulariaceae

Found on the Alpine Himalayas from Kashmir to Himachal at 3,300-5,500 m, this herb is gregarious on hill slopes. Perennial and fleshy, it is 10-25 cm tall; its root-stock is stout, with fleshy, thick rootlets. The leaves are fleshy, oblong or elliptic, with a crenate or toothed margin, 5-8 cm long, variable in breadth and margin, narrowing into a short stalk; the upper leaves are sessile and clasp the stem at the base, with margins entire. The flowers, which bloom from June-August, are bi-lipped, deep blue with a white limb, densely arranged on a terminal spike; the bracts are densely overlapping. The fruits are almost smooth 3 mm long drupes.

72a A close-up of the flowering spike.

72a

95

73

73 SALMON COLOURED LOUSE-WORT

Pedicuralis rhinanthoides Schrenk
Scrophulariaceae

Seen in damp meadows at 3,300-4,000 m from Pakistan to Tibet, this is a perennating herb with a root-stock, 10-25 cm tall, stout, with curved aerial branches. The basal leaves are tufted, linear-oblong, with 9-12 pairs of segments; the upper ones are scattered and short stalked. The flowers, in bloom from July-September, are purple, pink, or white, with salmon-coloured spots, forming dense racemes. The calyx is egg-shaped, hairy and toothed; the lower lip of the corolla is pale pink, 3-fid and with rounded lobes, the upper lip ends in a sickle shaped beak, slightly darker in colour.

73a The close-up shows the lower lobe of the corolla with darker veins and curved beak.

73a

74 JERUSALEM SAGE

Phlomis bracteosa Royle ex Benth.
Labiatae

Found at 1,200-4,000 m from Afghanistan to Tibet and common in Kashmir, this tall, stout herb is hoary and tomentose. The basal leaves are 5-10 cm long, variable in breadth, shallow-cordate with an ovate rounded tip; upper ones are sessile, lanceolate, acute and hairy with a crenate or serrate margin. The flowers, which bloom in July and August, are pink-purple and bi-lipped, arranged on an interrupted spike with dense whorls; the upper lip is hooded, the lower boat-shaped; the calyx is dark purple, with five teeth, and hairy. The fruits are ovoid nutlets with rounded tips.

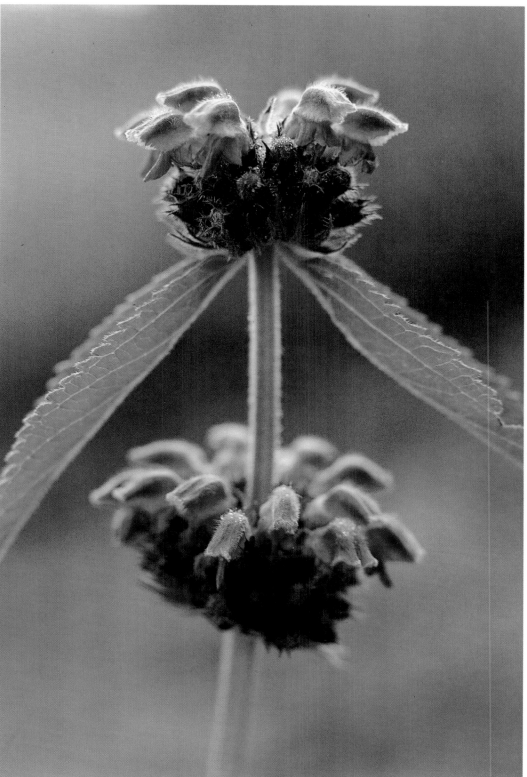

74

97

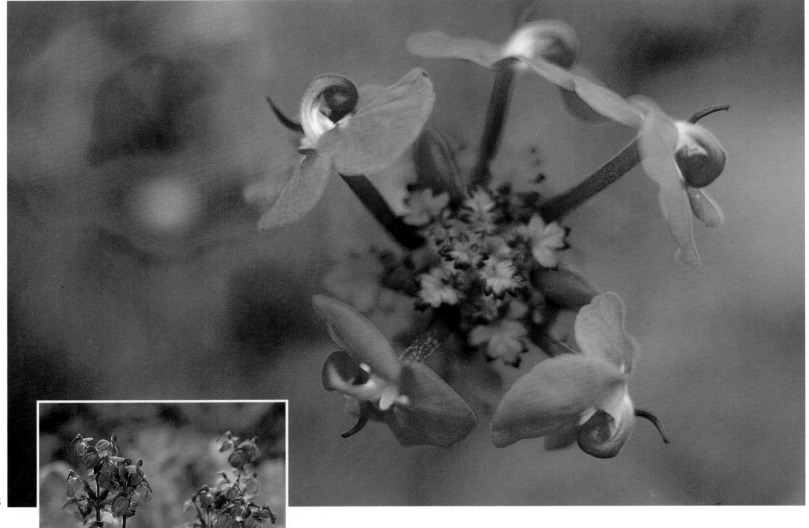

75

75a

75 LONG TUBE LOUSE-WORT
Pedicularis siphonantha D.Don
Scrophulariaceae

Seen on open slopes in the alpine Himalayas from Kashmir to Sikkim at 3,500-5,000 m, this is a perennating herb used locally as a diuretic. It is 5-25 cm tall, with a root-stock producing erect, serial branches. The leaves are 3.5 cm long, alternate, stalked, oblong, incised pinnatifid or pinnatisect. The flowers, which bloom from June-August, are axillary or on a terminal spike, each about 5 cm across, in the shape of a red or purplish tube with a whitish throat, the upper lip curved into a beak; the lower lip is 5-lobed; the calyx lobes are crested, with variable centres. The fruits are 1 cm long oblong capsules with up to 2 mm long obtuse seeds.

75a Picture shows the whole plant and the slopy terrain on which it grows.

75b PYRAMIDAL LOUSE-WORT
Pedicularis pyramidata Royle

Common in Kashmir, it differs from the long tube louse-wort in having densely arranged, darker pink (almost red) flowers, making it a more showy species of *Pedicularis*.

98

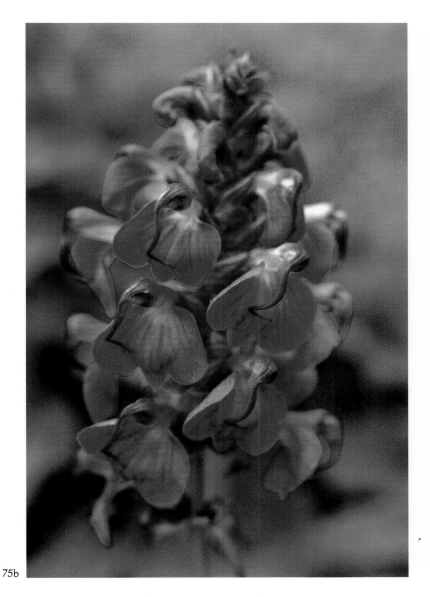

75b

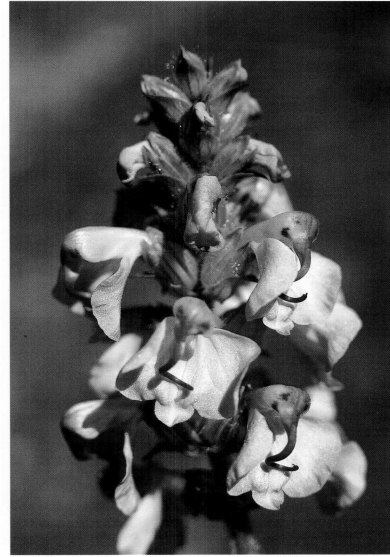

75c

75c COMB-LIKE LOUSE-WORT

Pedicularis pectinata Wall. ex Benth.
Scrophulariaceae

Found on hill slopes in the temperate
Himalayas at 2,500-3,500 m from Kashmir to
Kumaon, this is a tall, stout glabrous herb, up
to 35 cm tall. The leaves are 10 cm broad,
pinnately incised, appearing like a comb, with
a long stalk. In bloom from July-September,
12-15 pink flowers with prominent green calyx
are arranged on a 5-15 cm tall spike.

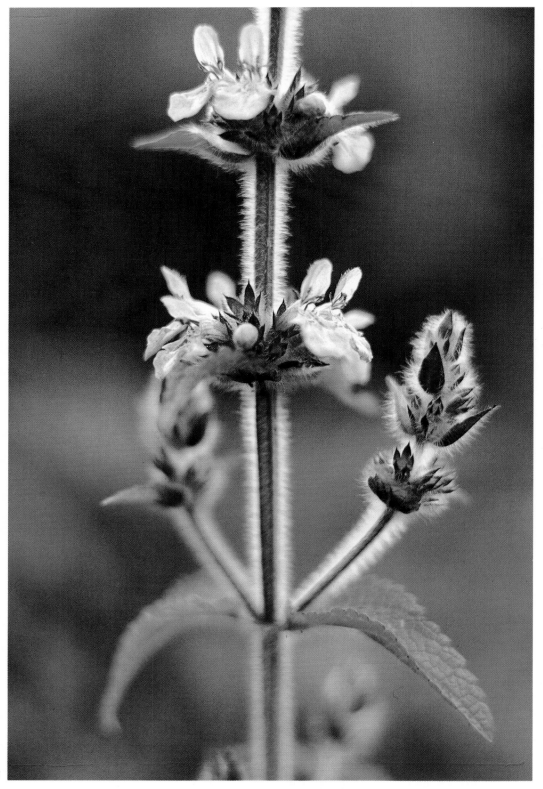

76 HIMALAYAN BETONY

Stachys sericea Wall. ex Benth.
Labiatae

'May you have more virtues than betony'
— Italian proverb

'He who is ill, should sell his coat and buy betony.'
— English proverb

Believed to have many medicinal virtues, this herb contains an alkaloid, stachydrine. It is found on open slopes and meadows at 2,000-4,000 m from Afghanistan to Bhutan, and is common in Kashmir. It is one of the most variable of herbs, tall, erect, and more or less silky villous. The leaves are shortly petioled, oblong-cordate, acute, with a crenate margin. In bloom from June-August, the flowers are in axillary whorls and terminal spikes; the whorls are many-flowered; the calyx teeth are spiny and red; the corolla is bi-lipped, pink, with purple spots. The fruits are smooth ovoid-obtuse nutlets.

76

100

77 HIMALAYAN DRAGONHEAD

Dracocephalum wallichii Sealy

Labiatae Seen on hill slopes from Himachal to Tibet at 3,500-4,500 m, this is a robust, tomentose herb with a 4-angled, erect stem. The basal leaves are 5-10 cm long, orbicular, cordate, and long petioled; the margin is crenate; the upper leaves are sessile. The bluish purple flowers with dark spots are in a large terminal whorl or in axillary, densely packed whorls, and bloom from June-August. The fruits are 2 mm long, linear-oblong nutlets with obtuse tops.

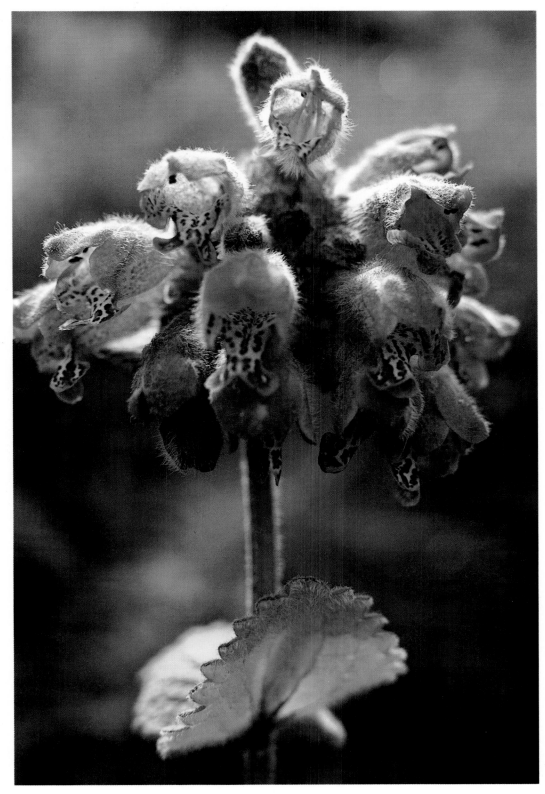

77

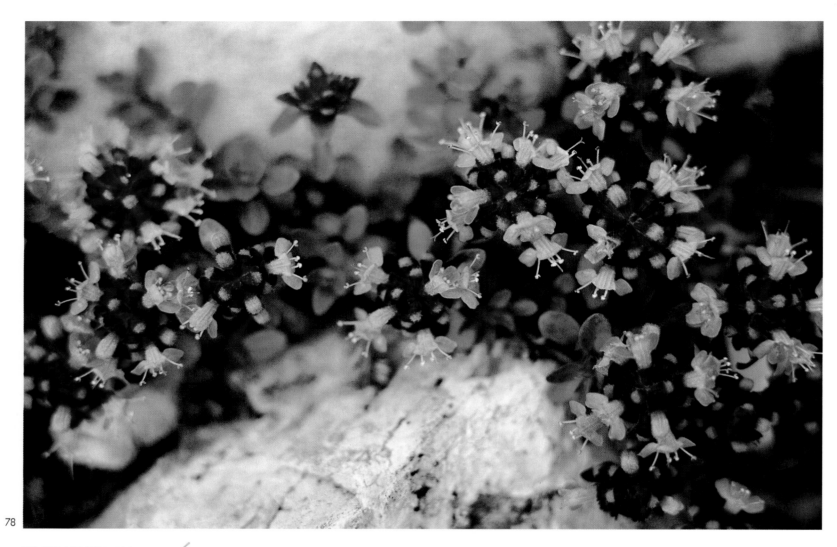

78

78 HIMALAYAN THYME ✓

Thymus linearis Benth. ex Benth.
= *T.serpyllum* Sm.
Labiatae

Seen on rocky slopes from Afghanistan to
Nepal and Tibet, this is a small, spreading
aromatic herb that is used medicinally, as a
vermifuge. Tufted, with many branches, it has
a woody root-stock. The leaves are small,
oblong elliptic. The purple flowers, which
bloom from April-September, are 5 mm across,
bi-lipped and villous, and arranged in terminal
spikes; the upper lip is flat, the lower is
3-lobed. The fruits are narrow, nearly smooth
3-angled nutlets.

79 KASHMIR SAGE

Salvia hians Royle ex Benth.
Labiatae

Seen in forests and open hill slopes at 2,400-4,000 m from Pakistan to Bhutan and common in Kashmir, this is a tall, robust, viscidly hairy herb that is 50 to 80 cm tall. The leaves are long-petioled, ovate-hastate, cordate, with a serrate margin. The deep blue flowers, which bloom from June-September, are in a spike-like cluster of distant whorls; each flower is about 4 cm long and bi- lipped; the lobed lower lip usually has a white tip. The fruits are 2 mm long nutlets.

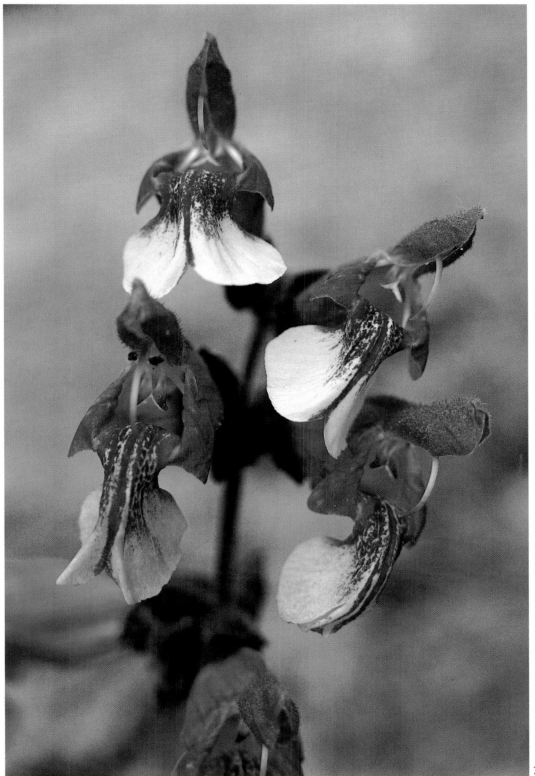

79

80 ROSE CARPET KNOTWEED

Bistorta vaccinifolia (Wall. ex Meissn.) Greene
= *Polygonum vaccinifolium* Wall. ex Meissn.
Polygonaceae

Common in Ladakh, this gregarious plant covering the ground or rocks, is seen at 3,000-4,500 m from Kashmir to Tibet. A tufted, glabrous, perennial herb, 5-10 cm tall, it has many creeping or trailing leafy branches; the root-stock is twisted, woody, and thick as a finger. The leaves are 1-2 cm long, short-stalked, small rounded, elliptic, tapering at both ends; the stipules are rigid, laciniate, with many brown nerves. The pink flowers, which bloom in August and September, are 3-4 mm across, and arranged in 3-5 cm long, pointed, dense spikes at the ends of erect branches. The fruits are nuts with tips, enclosed in perianth.

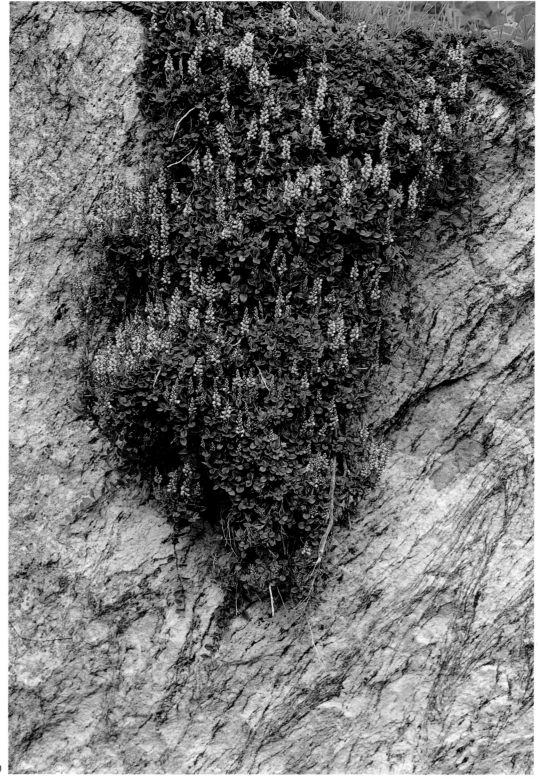

80

81 BELL-SHAPED KNOTWEED

Persicaria polystachya (Wall. ex Meissn.) Gross
= *Polygonum polystachyum* Wall. ex. Meissn.
Polygonaceae

Seen in light forests and on damp ground from
Garhwal to Bhutan at 2,500-4,000 m, this is a
perennial stoloniferous, robust, erect herb,
60-100 cm tall; the stems show dichotomous
branching and swollen nodes. The leaves are
8-15 cm long, grey, pubescent, leathery,
elliptic-ovate to lanceolate, acute with a
rounded lobed base. The flowers, which
bloom from July-September, are 3-5 mm
across, very fragrant, in a spreading terminal
panicle of white or pink spikes. The fruits are
5-7 mm long, 3-winged pale nuts, with exerted
tips.

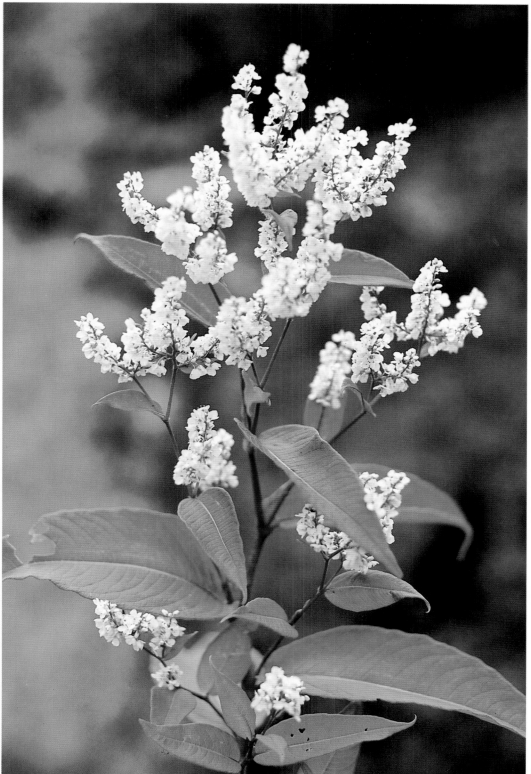

81

82 LARGE LEAVED KNOTWEED

Bistorta macrophylla (D. Don) Sojak
Polygonum macrophyllum D.Don
Polygonaceae

Seen among rocks in forests from Kashmir to Tibet at 2,500 to 4,000 m, this is a low perennial with trailing branches with an elongated root-stock and also erect leafless branches, 15-25 cm tall, with long internodes. The leaves are linear-lanceolate with a long pointed apex and an inrolled margin 3-8 cm long and 2-4 cm broad; the stipules are brown, papery and long, clasping the stem. The red flowers, which bloom from July-September, are in dense cylindric clusters, each cluster 2.5-4 cm long and on a short leafless stalk. The fruits are biconvex nuts in large envelopes.

82a HIMALAYAN KNOTWEED

Bistorta milletii Leveille
Polygonaceae

This is another knotweed, seen in open places among rocks. It has a stout root-stock and dense spikes of brilliant crimson flowers. The leaves are narrow, tapering to form a winged leaf stalk, 2-4 cm broad, 30 cm long and clasping at the base.

82b HIMALAYAN FLEECE FLOWER

Bistorta affinis (D.Don) Greene
= *Polygonum affine* D.Don

Seen on open ground and screes in alpine and subalpine regions from Kumaon to western Tibet at 3,000-4,500m, this is a low, trailing, densely tufted perennial herb with flowering branches 10-25 cm high. The leaves are glaucous, linear elliptic, lanceolate or oblanceolate. The dark pink to purple conspicuous flowers, in bloom from July-September, are arranged in a cylindric spike.

82

82a

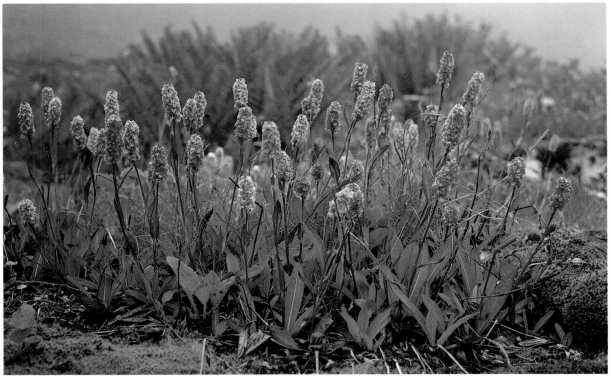

82b

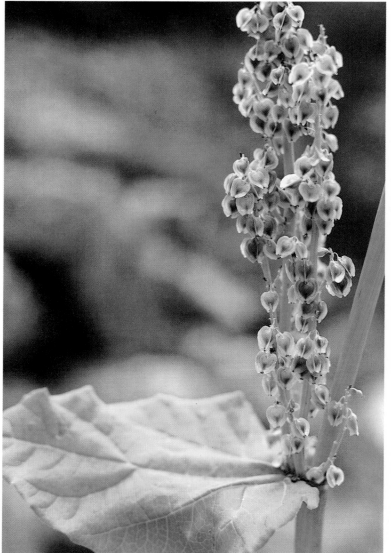

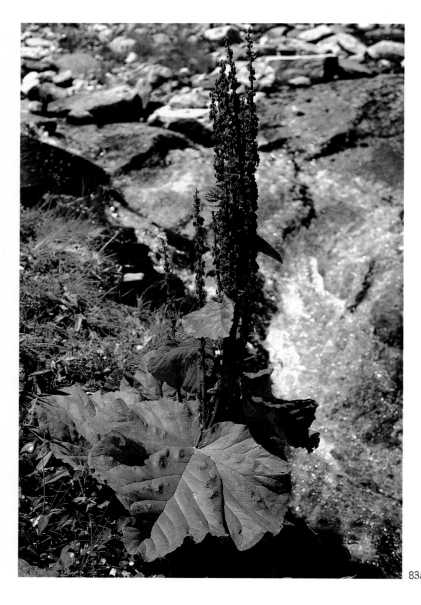

83

83a

83 NORTHERN RHUBARB — 'ARCHA' ✓ ?

Rheum australe D.Don
= *R.emodi* Wall. ex Mill.
Polygonaceae

Used medicinally, particularly to heal bone fractures, this herb is seen on stony slopes from Himachal to Nepal at 3,000-4,000 m. It is stout perennial with a green streaked stem, up to 2 m tall, and with a thick root-stock. The basal leaves are rounded, often about 60 cm across with 30-40 cm long stalks; the upper ones are stalkless and much smaller, ovate with a heart-shaped base. In bloom in June and July, the purplish red flowers are arranged in dense, branched clusters on 20-30 cm tall spikes. The fruits are 12 mm long nutlets with narrow wings, heart-shaped base and notched apex.

83a MOORCROFT'S RHUBARB ✓ ?

Rheum moorcroftianum Royle
Polygonaceae

Seen at 3,500-4,500 m from Himachal to Nepal, this is a perennial robust herb. The stout root-stock is covered by old leaf bases; all the leaves are basal; the leaf stalk is 5-15 cm long, with a leathery blade, fleshy, rounded, with a heart-shaped base 15-30 cm in diameter, held like an umbrella. The flowers, which bloom in June and July, are in numerous hairy spikes, 25-30 cm long, green at first, turning brownish red on maturity. The fruits are 8-10 cm long ovoid nutlets with narrow wings.

108

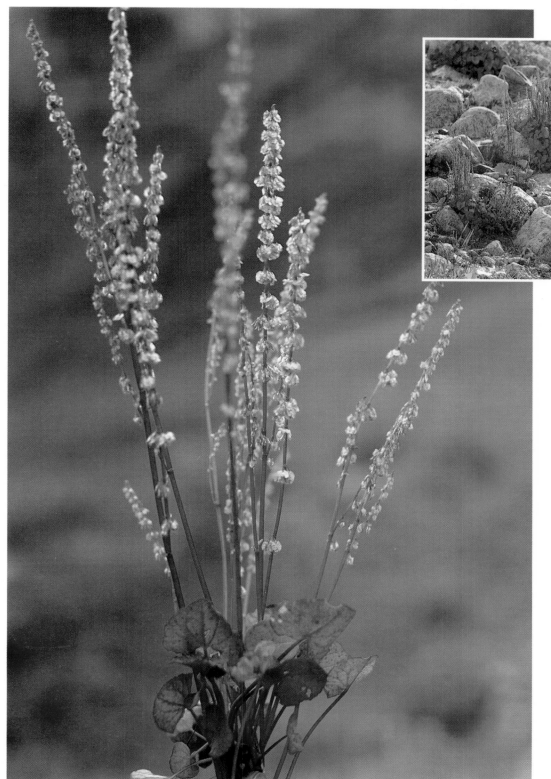

84a

84 MOUNTAIN SORREL

Oxyria digyna (Linn.) Mill.
Polygonaceae

Found on open hill slopes and on pasture land at 3,300 to 5,000 m from Pakistan to Tibet, this erect fleshy herb makes a most agreeable salad, and is also cooked. It has a stout root-stock and tufted succulent stems. The leaves are mainly basal, about 3-5 cm across, rounded or heart-shaped on a stalk, and often turn reddish. The pinkish flowers appear from May-July on long slender stalks of many whorls; each flower is about 2-3 mm across. The fruits are 2-3 mm, red, biconvex nuts, with wings up to 5 mm across.

84a Picture shows the stony terrain, the mountain sorrel's natural home, at the Valley of Flowers during August.

84

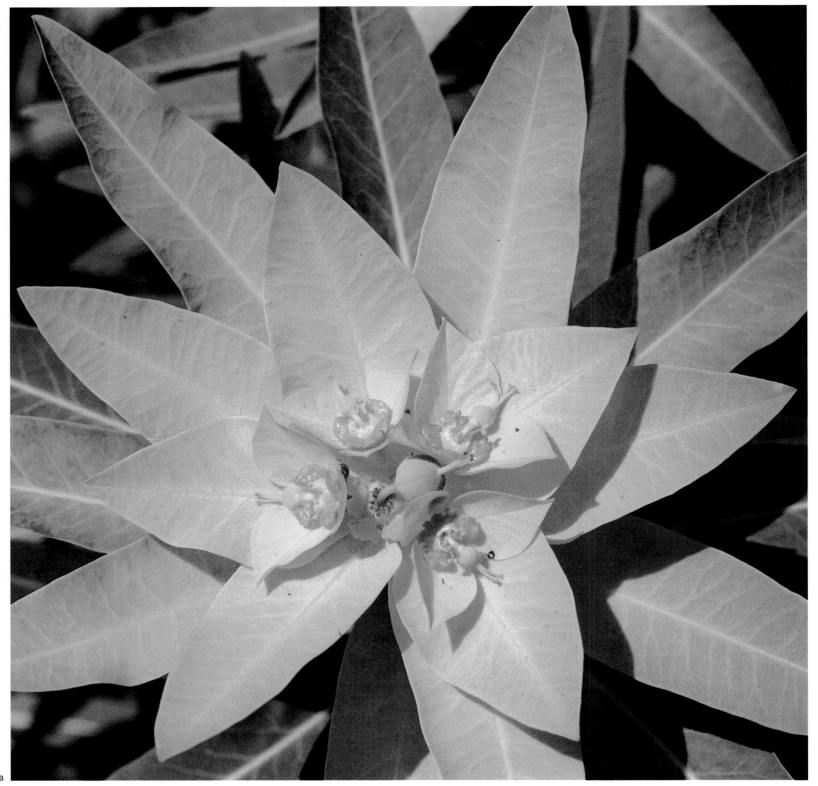

85a

85

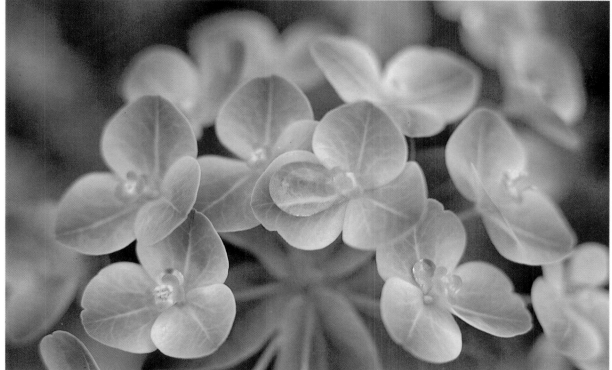

85b

86

Previous page

85 WALLICH'S SPURGE

Euphorbia wallichii Hk. f.
Euphorbiaceae

Seen on open hill slopes and pastures at 2,300-3,600 m from Afghanistan to Tibet, this is a tall milky erect, handsome perennial weed, 30-60 cm in height, growing in tufts with leafy stems; pubescent above. The leaves are 7-10 cm long, simple, alternate, linear, acute and milky. Seen in April and May, 3-8 lower showy golden yellow floral leaves subtend the groups of flowers. The fruits are 3-chambered capsules, globular, 8 mm across, hairy, and with blue-grey seeds.

85a A close-up of 5 terminal groups of flowers surrounded by the yellowish floral leaves. The green globular structure in the centre is the female flower raised on a stalk, surrounded by several tiny males in a cup-like envelope.

85b SUN SPURGE

Euphorbia helioscopia Linn.

Another spurge or milkweed in which each group of flowers, seen in April and May, is subtended by 3 floral leaves which are more rounded, and with a greenish yellow colour; seen at lower elevations near mountain bases.

86 THREE-KEELED CALANTHE

Calanthe tricarinata Lindley
Orchidaceae

Seen in light forests from Kashmir to Nepal and Tibet at 1,500 to 3,000 m, this is a terrestrial orchid, with a short leafy stem. The 3-4 leaves are 15-25 cm long, oblanceolate, oblong, acute and stalkless. The flowers bloom from April-July, held laxly on a tall 30-60 cm scape arising from amongst the leaves; 3-4 cm across, they are greenish yellow with a reddish brown lip, 3-lobed, with the mid lobe rounded with purple fleshy ridges and a wavy margin; the spur is absent. The fruits are drooping capsules.

87 HIMALAYAN LADYSLIPPER

Cypripedium himalaicum Rolfe
Orchidaceae

Seen on hill slopes and drier areas all along the Himalayas, from Simla to Sylhet at 3,000-4,000 m, this is a terrestrial Himalayan orchid with underground tuber and highly ornamental flowers. It has several leaves, alternate, plicate, on an erect 30-40 cm stem formed by leaf sheaths. The flowers, which bloom in June and July, are attractive to bees for their faint fragrance and are no less attractive to trekkers for their peculiar decorative form; with a subglobose, much-inflated lip, they are greenish, white with purple spots and streaks or slots, or sometimes all purple; the lateral petals are narrow. The fruit is an elongate capsule subtending the perianth.

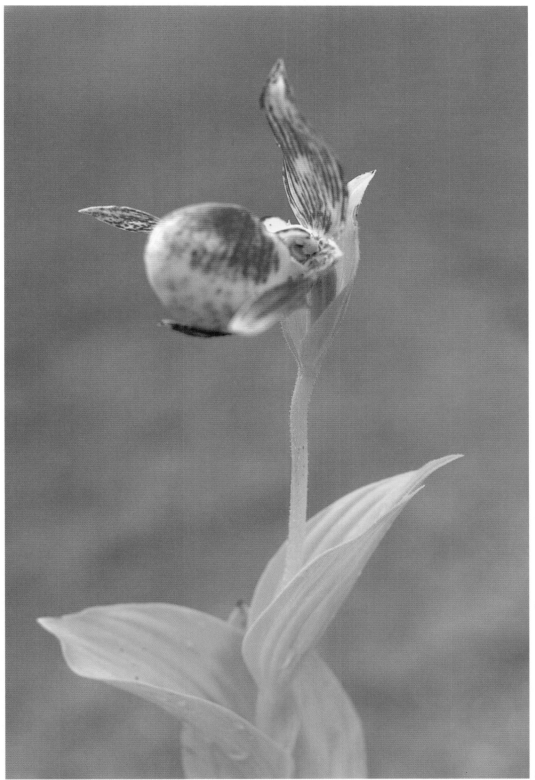

87

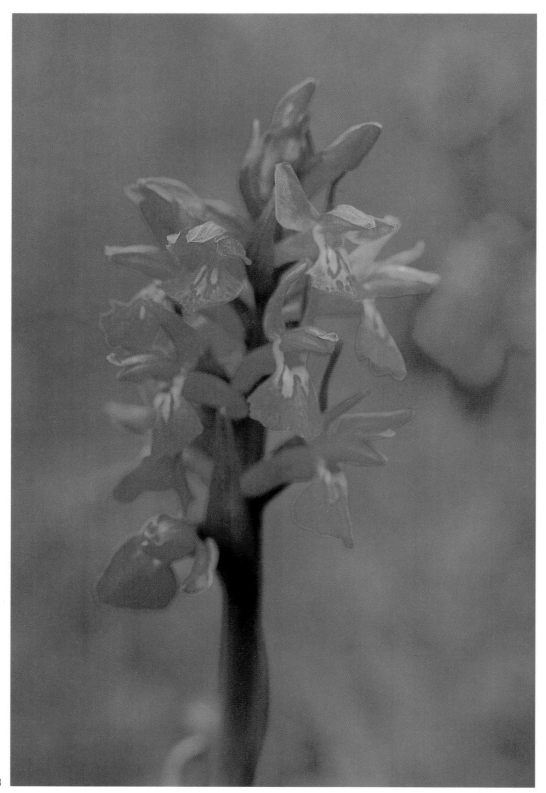

88 SPOTTED HEATH ORCHID

Dactylorrhiza hatagirea (D.Don) Soo
= *Orchis lalifolia* **non Linn.**
Orchidaceae

Considered medicinal, used as a tonic, also called 'Jiwas' or 'Panch Oule' or 'Salam Panja' locally, found on open meadows and marshes from Kashmir to Tibet at 1,800-4,000 m, this is a terrestrial Himalayan orchid with a curious, palm-like tuber. There are many 15-35 cm long oblong-lanceolate leaves on an erect, 30-90 cm stem; the upper floral leaves are smaller, almost acuminate. In June and July, 10-15 rosy purple flowers appear on a dense, cylindric spike; each flower is about 1.5 cm long with a stout curved spur with a darker colour; 3 petals form a hood and platform. The fruit is an elongated capsule with innumerable powder-like seeds bearing remnants of perianth.

88

89 INTERMEDIATE HABENARIA

Habenaria intermedia D.Don
Orchidaceae

Seen on grassy slopes from Kashmir to Tibet at 2,000-3,000 m, this is a tender, erect, terrestrial orchid, very graceful, about 30-60 cm tall, and very leafy. The leaves are ovate lanceolate, 10-15 cm long, strongly 3-nerved, sheating. In bloom in July and August, the flowers are about 5 cm across, held on a long, 8-20 cm spike; the petals are white or greenish, obovate, linear-falcate, and smooth; the 3-lobed lip is longer than the sepals. The laterals are deeply incised into many long segments like a stag's antler; the spur is larger than the seed pod. The fruits are 1 cm long capsules, stalkless, fusiform with thick ribs.

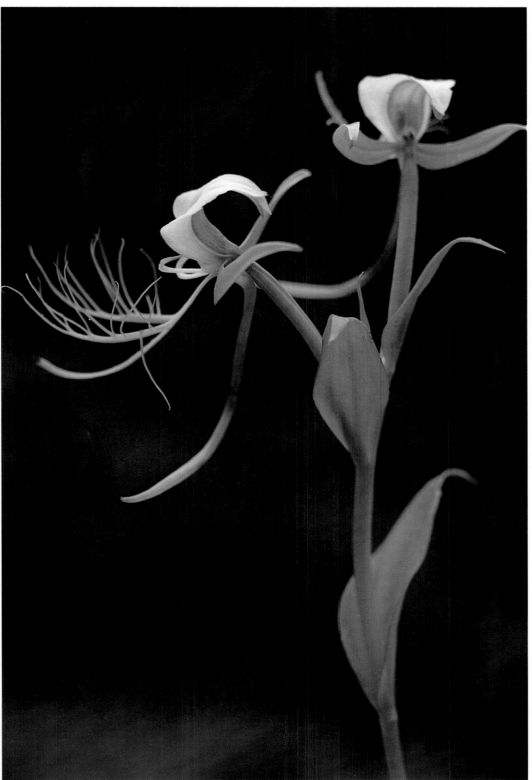

89

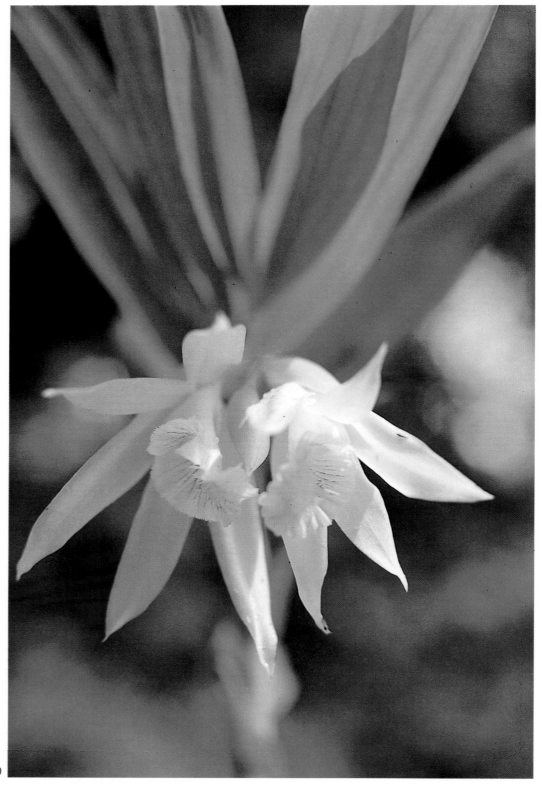

90 WHITE THUNIA

Thunia alba (Lindley) Reichb.f.
= *Phajus albus* Lindley
Orchidaceae

Seen in the tropical Himalayas from Garhwal to Sikkim at 800-1,500 m, this is a terrestrial or epiphytic variable orchid with a stout stem and short flowering scape, lateral on the leafy axis. The leaves are linear lanceolate or oblong, 15-40 cm long, plicate, densely tufted, soft and smooth below. The white flowers, in bloom during June and July, are arranged 4-8 on a stalk. With persistent bracts; the sepals and petals are oblong, lanceolate, acuminate, 6-8 cm long; the lip is white with yellow or purple-red veins. The fruits are 2-3 cm long capsules.

90

91 SPIKED GINGER LILY

Hedychium spicatum Ham. ex Smith
Zingiberaceae

The root-stock of this plant is used medicinally; it also contains an aromatic oil used in perfumery. Seen in the sub-tropical Himalayas from Himachal to Arunachal Pradesh, at 1,800-3,000 m, it is a stout rhizomatous herb, about 1-1.5 m tall. The leaves are 30-35 cm long and 12-15 cm broad, oblong-lanceolate, smooth, enitre. With an acute apex, and sheathing base. The flowers, blooming in July and August, are fragrant, white, with a deeply bi-fid lip; the basal part has a purplish ovary; the bracts are large and green. The fruit is a globose capsule, smooth, three-chambered, with an orange lining; the seeds are black with a reddish aril.

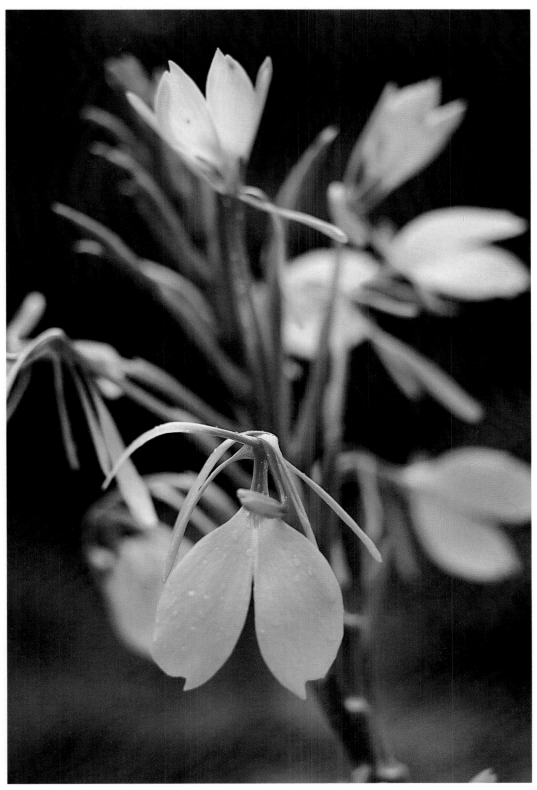

91

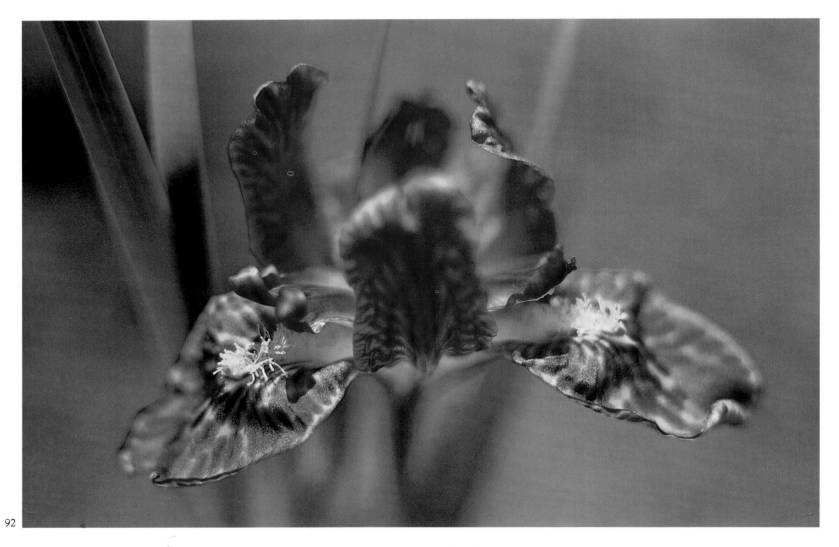

92

92 IRIS OF KUMAON ✓

Iris kemaonensis D.Don ex Royle
Iridaceae

'Iris' means deified rainbow, an apt description of the superb colouring and ethereal texture of the flower.

It is a regal looking but truly democratic blossom, jostling its fellows in the marshes that is indeed 'born in the purple'. Fleur-de-lys, a white European Iris, was adopted by the French sovereign Louis VII, as the emblem of his house. "It is the flower of Chivalry", says Ruskin, "which has a sword for its leaf and lily for its heart".

Seen on Himalayan grazing grounds, marshes and river banks at 2,000-4,500 m from Kashmir to Arunachal, this is a stout herb with an underground, creeping, rhizomatous stem. The

92a

118

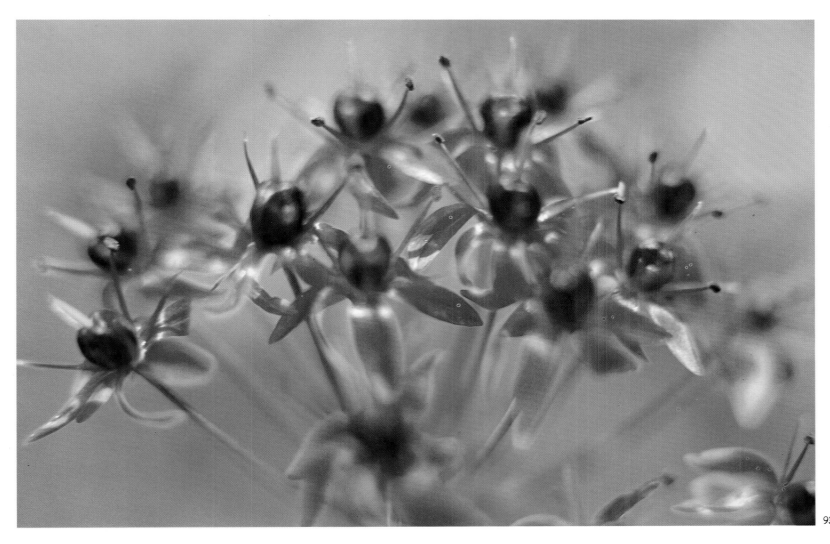

93

93 WALLICH'S GARLIC
Allium wallichii Kunth.
Amaryllidaceae

leaves are strap-shaped, erect, 30-35 cm ×
8-10 cm, sheathing bases forming a very short
stem above the ground. The flowers, in bloom
from April to July and pollinated by bees, are
solitary, lilac to purple with darker spots and
blotches, on a scape shorter than the leaves,
and with falls (claws) with conspicuous yellow
beards. The fruits are 3-4 cm long, beaked,
8-valved capsules without a stalk.

92a Picture shows clumps of Iris of Kumaon
along river banks and marshes in Kashmir.

Seen in forest clearings from Kashmir to Tibet
at 2,800-4,300 m, this is a bulbous,
foetid-smelling herb; the bulbs are very slightly
developed, clustered, covered by a
membranous, torn sheath; the roots are
fibrous. The leaves are numerous, narrow,
linear, flat, and longer than the triangular
scape. The purple flowers, which bloom in
August and September, have petals spreading
out like a star, and are arranged in an umbel,
5-8 cm across, held at the tip of a 30-75 cm
long stalk. The fruits are capsules turning black
on maturity, globular with a mark of the stylus
at the tip.

119

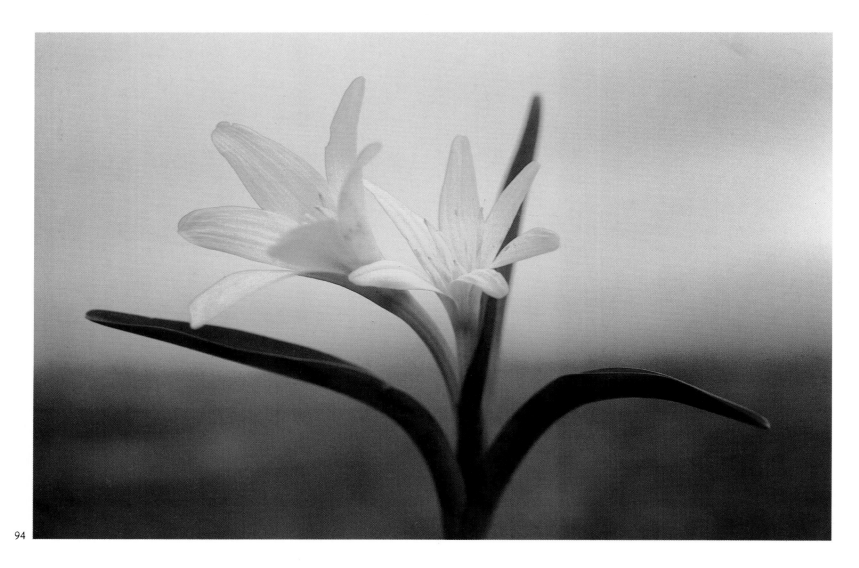

94

94 AUTUMN CROCUS

Colchicum luteum Baker
Liliaceae

Locally called 'Surinjan', and used in local
medicine, both the corms and seeds of this
plant contain a useful alkaloid — Colchicine.
The plant features in Kashmiri folk songs as a
harbinger of spring. A small perennial herb, it
appears soon after the snow begins to melt.
The cylindrical underground corm is covered
with brownish scales. The 15-30 cm long
leaves arise from the ground; they are linear
lanceolate and appear with the flower. The
flowers, which bloom from March-June, are
just one or two, 8-10 cm long and 3-5 cm in
diameter, with golden yellow petals, fused
below to form a tube. The fruits are capsules,
3-5 cm in diameter, 3-valved and many seeded.

95 DESERT CANDLE

Eremurus himalaicus **Baker**
Liliaceae

Found at 2,100-3,000 m in cold, dry, desert-like regions of central Asia from Afghanistan to Himachal Pradesh, this stately looking herb is 80-175 cm tall. Often gregarious, its stem carries a unique, dense flower cluster; the root-stock is fibrous. The 30-90 cm long and 2-4 cm broad leaves are erect, subulate, linear-lanceolate, and arise from the base. Blooming in May-June, the flowers are densely aranged in spikes 30-40 cm long; each flower is on a separate stalk and is 2.5 cm in diameter. The bracts are awn-shaped and papery; white petals have brown lines on the outside. The fruit is a rugose capsule; seeds are not winged.

95a Picture shows a close up of the flowering spike showing the structure of the flowers with white petals and the orange-yellowish centre formed of stamens and the ovary carrying the white tubular style. The flower-buds with short flower stalks are seen in the upper part.

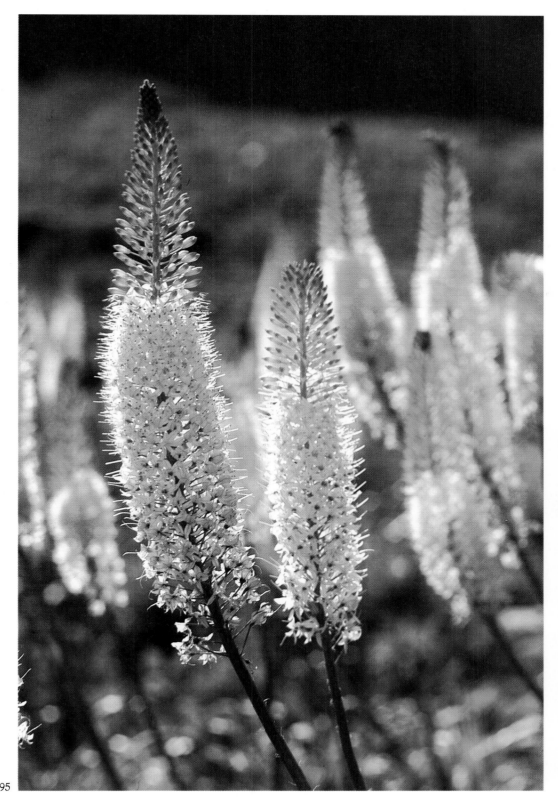

95

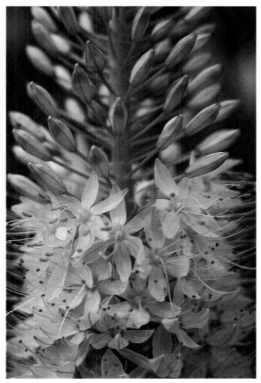

95a

121

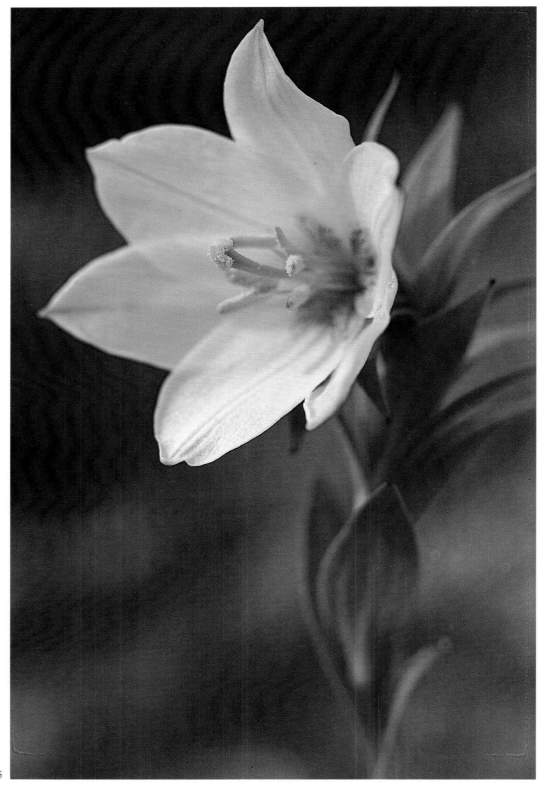

96 YELLOW LILY

Lilium oxypetalum (D.Don) Baker
= *Nomocharis oxypetala* (Royle) Wilson
Liliaceae

Found at 3,300-4,000 m on rocky slopes from Himachal Pradesh to west Nepal, this robust bulbous herb is 30-45 cm tall. It has a stout, leafy stem. Its leaves are prolific, elliptic-lanceolate, and 4-7 cm long, crowded at the tip of the stem. Blooming in June and July, its solitary flowers are pale yellow, cup-shaped and laterally held near the top of the plant; the petals have a mid-vein 4-5 cm long, spread from the base, and are bearded above the nectary. The fruit is a broadly oblong capsule of 2.5 cm length.

96

97 LEAFY LILY

Lilium polyphyllum D.Don
Liliaceae

This is the only species allied to the West
Asian Lilium group in the Himalayas, and is
found at 2,000-3,000 m in light forests from
Afghanistan to Kumaon. It is a bulbous herb —
bulbs with overlapping scales without an outer
cover — with a leafy stem, up to 3 m tall. The
leaves are linear to oblanceolate, 10-12 cm,
slender and many-nerved; the lower leaves are
often whorled. The flowers are fragrant, 5 cm
in diameter and are held on terminal racemes.
Blooming from June-August, they are dull
yellowish or greenish outside and white
within with long purple streaks; the segments
are oblanceolate, strongly reflexed or curved,
giving the flower a cup-shaped pretty
appearance. The fruit is an erect, 3-valved,
many seeded capsule; the seeds are vertically
compressed.

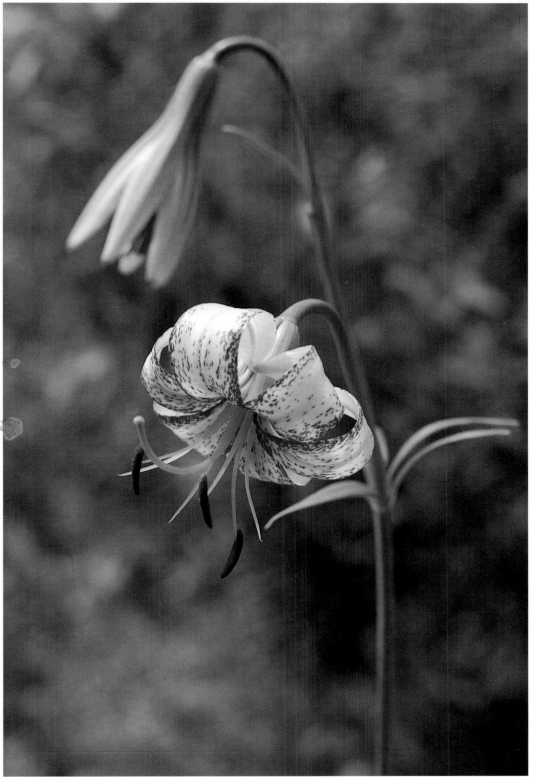

97

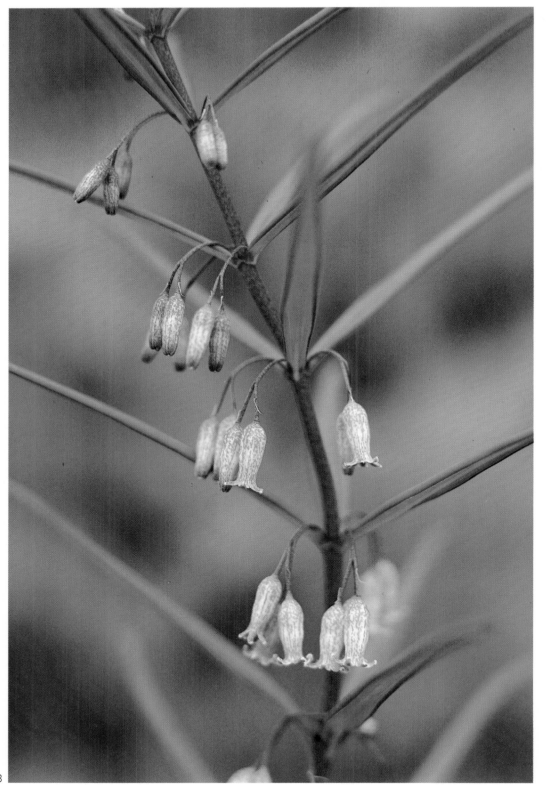

98 WHORLED SOLOMON SEAL
Polygonatum verticillatum (Linn.) Allison
Liliaceae

The root of this plant is used in local medicaments. Found at 1,500-3,700 m, in light forests and on open slopes, from Pakistan to Tibet, this is a variable, perennial herb with creeping rhizomes. The stem is leafy above and 1-1.2 m long. Its leaves are whorled, sessile, linear-lanceolate and glaucous below; the margin is inconspicuously ciliate. The flowers, which bloom from May-July, come in pendant, axillary clusters of 6-9 flowers and are variable in colour, from white to purplish. The fruit is a berry — red to purple — of 6 mm diameter, with 6-10 seeds; the seeds are globose.

99 JAQUEMONT'S 'JACK IN THE PULPIT'
Arisaema jaquemontii Blume
Araceae

Seen from Afghanistan to south-east Tibet at 2,400-4,000 m on rocky slopes, this plant is also common in upper forests in the undergtrowth.It is a herb with an underground perennating corm giving rise to an erect stalk bearing a leaf which is digitate with 5-8 narrow elliptic-ovate leaflets. A separate taller stalk is given out of the corm which bears the typical inflorescence above the leaf. It is surrounded by a hooded structure (spathe) which is green in colour with white stripes. The hood bears a long green or purple tail like upturned tip. The enclosed fleshy axis is short, cylindrical and purplish bearing minute male and female flowers from June-August. The ripened fruits turn red and are held on the swollen axis in the manner of a maize cob.

98

99a PURPLE OR SIKKIM 'JACK IN THE PULPIT

Arisaema costatum (Wall.) Martius ex Schott. Araceae

Endemic in Nepal & Sikkim in light forests at about 2,000-2,500 m, this is another very pretty of the two dozen species of this peculiar genus in the Himalayan region in which the inflorescence, seen in May and June, is held below the leaf. The purple spathe is strikingly beautiful with white stripes. It appears to be a variable structure with a longer appendage at times.

All *Arisaema* species have some toxic or irritating content. The underground corm, though edible, should not be eaten unless the toxic principles are removed by boiling in water and throwing away the decoction more than once.

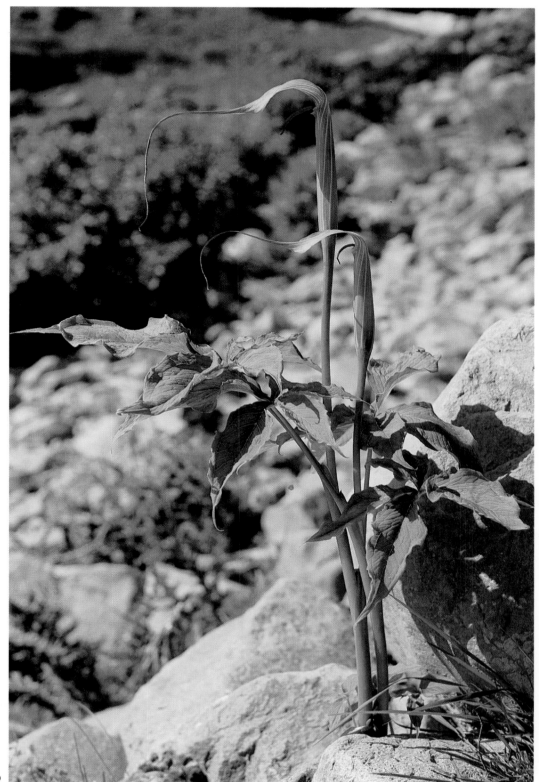

99

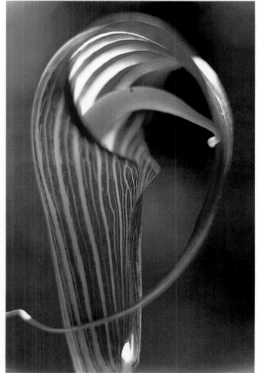

99a

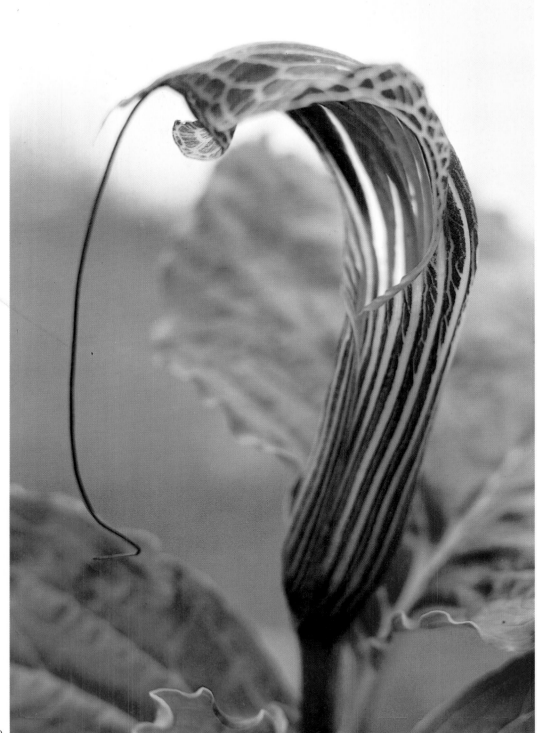

100 WALLICH'S SNAKE LILY ✓ ?

Arisaema propinguum Schott.
= *A. Wallichianum* Hk. f.

The corms of this genus, though rich in starch, contain some toxic substances and are sometimes used in native medicine. They hibernate during winter and give rise to new plants with the onset of the summer rains.

Seen in woodlands and open spaces from Kashmir to Tibet at 2,400-3,500 m, this is a stout herb with an underground corm. The single leaf is borne on a stout stalk about 30-60 cm long; the leaf blade in incised into 3 leaflets. The flowers, which bloom in May and June, are borne on a separate stalk on a fleshy axis, covered by an attractive, purple ribbed hood like that of a snake; the hood tapers to a tail-like tip; the stalks of leaf and flower are usually brown spotted. The fruits look like maize cobs, turning crimson on maturity.

100a Picture shows the whole plant with leaf held on the stalk and inflorescence arising from the underground corm in a light forest area.

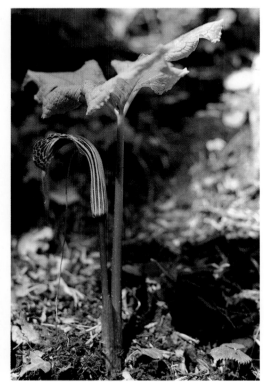

100

100a

LIST OF PLATES

22.	Barbed Thermopsis or Black Pea	*Thermopsis barbata* Royle
23.	Large-leaved Rose	*Rosa macrophylla* Lindley
23a.	A lighter pink version of the Large-leaved Rose	
24.	Red Nepalese Potentilla/Cinquefoil	*Potentilla nepalensis* Hk.
25.	Aruncus	*Aruncus dioicus* (Walter) Fernald
26.	Strachey's Bergenia	*Bergenia stracheyi* (Hk. f. & Th.) Engl.
27.	Himalayan Stonecrop	*Rhodiola imbricata* Edgew.
28.	Sikkim Stonecrop	*Rhodiola crenulata* (Hk. f. & Th.) *Ohba*
29.	Rosebay Willow-herb	*Epilobium angustifolium* Linn.
30.	Broad-leaved Willow-herb	*Epilobium latifolium* Linn.
30a.	The terrain where the Broad-leaved Willow-herb grows	
31.	Lax Willow-herb	*Epilobium laxum* Royle
32.	Kashmir Eryngo	*Eryngium bieberstinianum* Nevski ex Bobrov
33.	Candole's Orangeaster	*Pleurospermum candolei* (DC.) C.B.Cl.
33a.	Candole's Orangeaster in full bloom	
34.	Kashmir Giant Fennel	*Ferula jaeschkeana* Vatke
34a.	The full Giant Fennel plant	
34b.	Prangos	*Prangos pabularia* Lindley
35.	Himalayan Hogweed/Cow Parsnip	*Heracleum candicans* Wall ex DC.
36.	Wight's Elder	*Sambucus wightiana* Wall. ex Wt. et Arn.
37.	Long-leaved Morina	*Morina longifolia* Wall.
37a.	The whole Long-leaved Morina	
37b.	Yellow Morina	*Morina coulteriana* Royle
38.	Golden Rod or Woundwort	*Solidago virgo-aurea* Linn.
39.	Otto's Aster	*Aster asteroides* (DC.) O. Kuntze
40.	Lax Aster	*Aster flaccidus* Bunge
41.	Himalayan Edelweiss	*Leontopodium himalayanum* DC.
42.	Large-flowered Inula	*Inula grandiflora* Willd.
43.	Common Coltsfoot	*Tussilago farfara* Linn.
44.	Arnica-like Groundsel	*Cremanthodium arnicoides* (DC. ex Royle) R. Good.
45.	Ellis's Groundsel	*Cremanthodium plantagineum* Maxim forma *ellisi* (Hk. f.) R. Good
46.	Sheathing Groundsel	*Ligularia ampexicaulis* DC.
47.	Chrysanthemum-like Groundsel	*Senecio chrysanthemoides* DC.
48.	'Heem Kamal', Cottony Saussurea	*Saussurea gossypiphora* D.Don
49.	'Brahma Kamal'	*Saussurea obvallata* (DC.) Edgew.
50.	Himalayan Thistle	*Carduus edelberqi* Rech. f. ssp. *lanatus*
51.	Chicory, Succory, Blue Sailors	*Cichorium intybus* Linn.
52.	Common Dandelion	*Taraxacum officinale* Wigg.
53.	Sow Thistle	*Cicerbita macrorhiza* (Royle.) Beaub.
54.	Large Bell Flower	*Campanula latifolia* Linn.

55.	Roundleaf Asiabell	*Codonopsis rotundifolia* Benth.
56.	Lobed Cyananthus	*Cyananthus lobatus* Wall. ex Benth.
57.	Bell Rhododendron	*Rhododendron campanulatum* D.Don
57a.	A close-up of a cluster of Bell Rhodendrons	
58.	'Lali Gurans' or Tree Rhododendron	*Rhododendron arboreum* Sm.
58a.	The red-flowered 'Lali Gurans'	
58b.	Giant Blood Rhododendron	*Rhododendron barbatum* Wall. ex D. Don
59.	Pinnacle Primrose	*Primula munroi* Lindley
59a.	A close-up of the white Pinnacle Primrose	
60.	Pink Primrose	*Primula rosea* Royle.
61.	Smith's Primrose	*Primula atrodentata* W.W.Smith
62.	Stuart's Primrose	*Primula stuartii* Wall.
63.	Stalkless Primrose	*Primula sessilis* Royle ex Craib.
64.	Large-leaved Primula	*Primula nivalis* var. *macrophylla* (D.Don) Pax
64a.	The purple-coloured version of Large-leaved Primula	
65.	Stalked Swertia	*Swertia petiolata* D. Don.
66.	Kashmir Gentiana	*Gentiana carinata* Griseb.
66a.	Nepal Gentian	*Gentiana venusta* (G.Don) Griseb.
67.	Blue Himalayan Polemonium	*Polemonium coeruleum* Linn. ssp. *himalayanum* (Baker) Hara.
67a.	A darker shade of 1lue Himalayan Polemonium	
68.	'Gao Zaban' Oxtongue/Bentham's Arnebia	*Arnebia benthamii* (Wall.ex G. Don) Johnston
69.	Snowy Lindelofia	*Lindelofia longiflora* (Benth.) Baill.
70.	Henbane	*Hyocyamus niger* Linn.
71.	Flannel Mulmein	*Verbascum thapsus* Linn.
71a.	Flannel Mulmein's natural habitat	
72.	Kashmir Lagotis	*Lagotis cashmeriana* (Royle) Rupr.
72a.	A close-up of the flowering spike	
73.	Salmon-coloured	*Pedicuralis rhinanthoides* Schrenk
73a.	Close-up shows the lower lobe of the corolla	
74.	Jerusalem Sage/Louse-wort	*Phlomis bracteosa* Royle ex Benth.
75.	Long Tube Louse-wort	*Pedicularis siphonantha* D.Don
75a.	The whole plant and its slopy terrain	
75b.	Pyramidal Louse-wort	*Pedicularis pyramidata* Royle
75c.	Comb-like Louse-wort	*Pedicularis pectinata* Wall. ex Benth.
76.	Himalayan Betony	*Stachys sericea* Wall. ex Benth.
77.	Himalayan Dragonhead	*Dracocephalum wallichii* Sealy
78.	Himalayan Thyme	*Thymus linearis* Benth. ex Benth.
79.	Kashmir Sage	*Salvia Lians* Royle ex Benth.
80.	Rose Carpet Knotweed	*Bistorta vaccinifolia* (Wall. ex Meissn.) Greene
81.	Bell-shaped Knotweed	*Persicaria polystachya* (Wall. ex Meissn.) Gross

Some suggested treks
for a
grand flower-watch in the Himalayas

Kashmir

1. From Pahalgam as base to Amarnath,
 Sonasar, Harnag, Kolahoi Glacier, Tarsar
 and Marsar Lakes

 1. Pahalgam
 2. Chandanwari
 3. Sonasar Lake
 4. Sheshnag Lake
 5. Panchtarni
 6. Amarnath Cave
 7. Aru
 8. Harnag Lake
 9. Lidderwat
 10. Tarsar Lake
 11. Marsar Lake
 12. Kolahoi Glacier

2. Sonamarg to Wangat and Kangan via
 Nichinai Pass, Vishansar, Kishansar, Gadsar
 Satsar and Gangabal Lakes

 13. Sonamarg
 14. Nichinai Pass
 15. Vishansar
 16. Kishansar
 17. Gadsar

 18. Satsar
 19. Gangabal Lake
 20. Naranag
 21. Wangat
 22. Kangan

3. Gulmarg to Khilanmarg and Alpathar Lake

 23. Gulmarg
 24. Khilinmarg
 25. Alpathar Lake

4. Suru Valley off Kargil, and Zanskar

 26. Zojila
 27. Kargil
 28. Panikar
 29. Rangdom
 30. Lamayuru
 31. Alchi
 32. Leh
 33. Zanskar
 34. Padum

5. Kulgam to Konsarnag Lake via Aharbal Falls

 35. Kulgam

 36. Aharbal
 37. Kongwatan
 38. Konsarnag Lake

6. Sinthan and Margan Passes in South East
 Kashmir

 39. Kokarnag
 40. Wangat
 41. Sinthan Pass
 42. Margan Pass

Himachal Pradesh

1. Valleys and ridges above Manali
2. Rohtang Pass (Dashour Lake above the pass), Hampta Pass, Chanderkhani Pass, Kunzum Pass (also Chandratal Lake) and valleys around these passes
3. Valleys above Manikaran, Kulu

 1. Mandi
 2. Kulu
 3. Manali
 4. Rohtang Pass
 5. Dashour Lake
 6. Hampta Pass
 7. Kunzum Pass
 8. Chandratal Lake
 9. Bara Lacha Pass
 10. Naggar
 11. Chanderkhani Pass
 12. Kasol
 13. Manikaran

4. From Kaza in Spiti Valley to Mane, and Mane Lake

 14. Kaza
 15. Ki Monastery

16. Losar
17. Sijling
18. Mane
19. Mane Lake
20. Poh
21. Lari
22. Tabo
23. Samdu
24. Kalpa

5. From Chamba to Manimahesh, and to Sach Pass

 25. Pathankot
 26. Dharamsala
 27. Dalhousie
 28. Chamba
 29. Bharmour
 30. Manimahesh Lake
 31. Sach Pass

Uttar Pradesh

1. Valley of Flowers and Hemkund, from Govindghat near Badrinath

2. Kauri Pass, approach to Nandadevi Sanctuary and valleys within and around the Sanctuary

3. Tungnath, Rudranath, Madmasheshwar and the surrounding alpine meadows (Bugyals)

 1. Hardwar
 2. Rishikesh
 3. Deoprayag
 4. Srinagar
 5. Karanaprayag
 6. Chamoli
 7. Joshimath
 8. Govindghat
 9. Badrinath
 10. Ghangaria
 11. Valley of Flowers
 12. Hemkund
 13. Auli
 14. Kuari Pass
 15. Lata
 16. Nandadevi Sanctuary
 17. Gopeshwar

18. Rudranath
19. Tungnath

4. Valleys and ridges around Kedarnath, Vasukital, and (Gandhisarovar) Chorabarital

5. Panwali, on old pilgrim route between Gangotri to Kedarnath, and Sahsratal

 20. Sonprayag
 21. Madmaheshwar
 22. Kedarnath
 23. Vasukital
 24. Gandhisarovar (Chorabarital)
 25. Trijuginarayan
 26. Panwali
 27. Ghuttu
 28. Budha Kedar
 29. Sahsratal

6. Gangotri to Gaumukh and Tapovan

7. Dodital and valleys around Darwakal and Yamunotri

8. Har-Ki-Doon from Naitwar and side-valleys of River Tons

 30. Tehri

31. Dharasu
32. Uttarkashi
33. Gangotri
34. Gaumukh
35. Tapovan
36. Dodital
37. Darwakhal
38. Naugaon
39. Barkot
40. Yamunotri
41. Naitwar
42. Har-Ki-Doon
43. Mussoorie
44. Dehra Dun

9. From Gwaldam and Wan to Ali Bugyal, Bedni Bugyal and Roopkund

 45. Ghat
 46. Gwaldam
 47. Wan
 48. Bedni Bugyal
 49. Roopkund

Sikkim and Darjeeling

1. Sandakphu-Phalut ridge

 1. Darjeeling
 2. Ghum
 3. Sukiapokri
 4. Manibhanjan
 5. Batassi
 6. Tanglu
 7. Kala Pokhri
 8. Sandakphu
 9. Phalut
 10. Ramam
 11. Rimbick
 12. Palmajua
 13. Lodhoma
 14. Jhepi
 15. Bijanbari

2. Green Lake and valleys on either side of the
River Tista above Lachen upto Kongra La.
(Permission required from Defence
Ministry)

3. Pemyangtse to Jongri and meadows in the
training area of the Himalayan
Mountaineering Institute

 16. Gangtok
 17. Pamionchi
 18. Yoksam
 19. Dzongri
 20. Koktang
 21. Forked Peak
 22. Kabru (Thayabala)
 23. Onglakthang
 24. Gochak Peak
 25. Tongshyong Glacier
 26. Talung Glacier
 27. Kanchenjunga
 28. Singhik
 29. Lingtam
 30. Be
 31. Solang Lake
 32. Yaktang
 33. Green Lake
 34. Chungthang
 35. Lachen
 36. Yatang
 37. Thangu
 38. Gyagong
 39. Kongra La

Nepal (East)

1. Valleys in Khumbu, as from Namche Bazar and Thyangboche

 1. Lukla
 2. Namche Bazar
 3. Thami
 4. Marlung
 5. Chhule
 6. Khumjung
 7. Tengboche (Thyangboche)
 8. Pangboche
 9. Dingboche
 10. Ama Dablam
 11. Kangtega
 12. Cho Oyu
 13. Gokyo
 14. Kala Pattar
 15. Pumori
 16. Lhotse
 17. Nuptse
 18. Mt. Everest

2. Lamapokhri and meadows around Makalu Base Camp

 19. Biratnagar

20. Dharan
21. Dhankuta
22. Tumlingtar
23. Khandbari
24. Ahale
25. Lamapokhri
26. Num
27. Seduwa
28. Lamobagar Gola
29. Hatia
30. Honggaon
31. Barun La
32. Makalu Base Camp
33. Makalu

136

Nepal (West)

1. From Pokhra to Muktinath and Manang via
 Thorung Pass, Thonje and Dumre

 1. Pokhara
 2. Suikhet
 3. Naudanda
 4. Lumle
 5. Chandrakot
 6. Birethanti
 7. Ulleri
 8. Ghorepani
 9. Sikha
 10. Tatopani
 11. Dana
 12. Ghasa
 13. Lete
 14. Tukucha
 15. Jomsom
 16. Muktinath
 17. Thorung Pass
 18. Manang
 19. Nagawalbensi
 20. Chame
 21. Thonje
 22. Khudi

23. Besisahar
24. Tarkughat
25. Turture
26. Palungtar
27. Dumre

2. Gosainkund and Langtang Valley

 28. Kathmandu
 29. Sankhu
 30. Sundarijal
 31. Pati Bhanjyang
 32. Gul Bhanjyang
 33. Thare Pati
 34. Banepa
 35. Panchkhal
 36. Rowapati
 37. Bahunepati
 38. Malemchi Pul Bazar
 39. Thimbu
 40. Tarke Ghyang
 41. Malemchigaon
 42. Gosainkund
 43. Syabru
 44. Trisuli Bazar
 45. Betrawati

46. Manigaon
47. Thare
48. Sharpugaon
49. Ghora Tabela
50. Langtang
51. Kyangjin
52. Ganja La
53. Langsisa

GLOSSARY

achene: a one-seeded fruit, usually one of many in a fruiting head

aril: an appendage or outer, often fleshy, covering of a seed

biternate: twice ternate, i.e., twice divided in threes

bract: a little leaf or scale-like structure from the axil of which a flower often arises

carpel: female component of the flower

clavate: club-shaped

cordate: heart-shaped

corm: a swollen underground stem surrounded by a papery covering

crenate: with rounded teeth

dentate: toothed, with the teeth more or less perpendicular to the margin of the leaf

denticulate: smaller version of dentate

digitate: resembling a spread hand

ellipsoid: a solid object with an eliptic profile

emarginate: notched at the tip

entire: margin of a leaf without indentation

falcate: sickle or scythe-shaped

follicle: fruit which opens by a single split

glabrous: smooth, not hairy

globose: globular

glochidia: barbed hair or bristles

hastate: shaped like a spearhead with pointed basal lobes projecting outwards at an angle to the blade

indumentum: the hairy coverage of an organ

imbricate: overlapping

involucre: a collection of bracts or leaves surrounding a flower head

lanceolate: lance-shaped with the broadest part nearest the base regularly narrowed upwards to an acute apex

legume: pod

ligulate: with strap-shaped petals, as in the rays of the sunflower

linear: long and narrow with parallel sides

muricate: roughed by means of a hard point

ob: inverted, with the broadest part of the organ near the apex, and not as is more usual, near the base. Used as a prefix: thus obcordate, oblanceolate, obovate

ovate: with an outline like a hen's egg, with the broadest part towards the base

panicle: a branched inflorescence

pappilionaceus: butterfly-like flower

papillose: having minute rounded or cylindric protuberances

pappus: modified outer perianth — segments of the florets of the Compositae, either feathery, scale-like, bristle-like, or with simple hairs

perennating: alive but dormant in unfavourable seasons

petiole: leaf-stalk

pinnate: the regular arrangement of leaflets in two rows on either side of the stalk

pinnatifid: pinnately cut or divided into segments

pinnatisect: segmented deeper than pinnatifid almost to the mid-rib

plicate: plaited or folded lengthwise

polyhedral: many-angled

puberulous: pubescent

raceme: a simple unbranched, elongate inflorescence with stalked flowers, the youngest flowers at the apex

reniform: kidney-shaped

rufous: red or reddish

rugose: wrinkled

runcinate: coarsely lobed and with the lobes directed towards the base of the leaf

scape/scapigerous: flowering stem without leaves, all leaves arising from the root-stock

saccate: like a sac — a pouch or baggy cavity to an organ

serrate: margin of a leaf-blade with teeth like a saw

sessile: stalkless

sinuate: curving

spathulate: spoon-shaped

spur: tubular tail-like structure, usually secreting juice inside

stamen: male component of the flower

subsessile: almost stalkless

subtrigonous: almost triangular

stoloniferous: of a creeping stem occurring above or below ground produced by a plant which has either an erect stem or a rosette of leaves

tomentose: matted

tomentum: velvety covering

torus: convex, enlarged tip

umbel: a cluster of flowers whose spreading stalks or rays arise from the apex of the stem, like the spokes of an umbrella

viscid/viscous: sticky

BIBLIOGRAPHY

Anonymous
 Japanese members of Indo-Japanese botanical
 expedition to Sikkim and Darjeeling in 1960 —
 Report of Hoikusha Publishing Co. Ltd, Osaka
 1963.
 Wealth of India — A Dictionary of Economic Products
 Vols 1-11. CSIR, New Delhi, 1948-1976

Bennet, S.S.R.
 *Name Changes in Flowering Plants of India and
 Adjacent Regions.* Triseas Publishers, Dehra Dun,
 1987.

Blatter, E.
 Beautiful Flowers of Kashmir (2 Vols). Staples &
 Staples Ltd, Westminster London, 1928-29

Bole, P.V.(text) & Mehta, A.(photographs)
 'Himalayan Flowers', *Namaskar,* Vol VI, Issue 2,
 p14-18, 1986

Coventry, B.O.
 Wild Flowers of Kashmir (Series 1-3). Raithby,
 Lawrence & Co Ltd, London, 1928-29

Dickinson, Ash Don.
 Wild Flowers. Adapted from *Nature's Garden* by
 Neltge Blanchon. Doubleday, Doran & Co. Inc.
 New York, 1917

Hooker, J.D.
 The Himalayan Journals Vols 1&2. John Murray,
 London 1893
 The Flora of British India (Vols 1-7). L. Reeve & Co
 Ltd., Kent, England, 1875-1897

Kelsey, Harlan, P. & Dayton William, A.(Ed)
 Standardized Plant Names (2nd Ed).
 J. Horace McFarland Co, Harisburgh, Pa. (For
 American Jt. Committee on Horticultural
 Nomenclature), 1942

Kingdon-Ward, F.
 Plant Hunting in Manipur, Jonathan Cape, 30
 Bedford Square, London, 1952

Lancaster, Roy
 Plant Hunting in Nepal. Croom Helme, London,
 1983

Moldenke, Harold, N.
 American Wild Flowers. D.Van Nostrand Co Inc,
 New York, 1949.

Polunin, Oleg and Stainton, Adam
 Flowers of the Himalayas. Oxford University Press,
 Delhi, 1984

Roerich, Nicholas
 Himalayas - Abode of Light. Nalanda Publications,
 Bombay, 1947

Royle, J.F.
 *Illustrations of Botany and Other Branches of Natural
 History of the Himalayan Mountains and of the Flora
 of Kashmir.* W.H. Allen & Co, London, 1839

Smythe, F.S.
 The Valley of Flowers. Hodder & Stoughton,
 London, 1938 (Repritned 1947)

Stainton, Adam
 Flowers of the Himalaya - A Supplement. Oxford
 University Press, Delhi, 1988

Woodward, Marcus
 How to Enjoy Wild Flowers. (People's Library Series)
 Hodder & Stoughton Ltd, London, 1927

INDEX